McGill

a celebration

McGill
a celebration

PUBLISHED FOR

THE GRADUATES' SOCIETY OF McGILL UNIVERSITY

BY

McGILL-QUEEN'S UNIVERSITY PRESS

MONTREAL & KINGSTON • LONDON • BUFFALO

1991

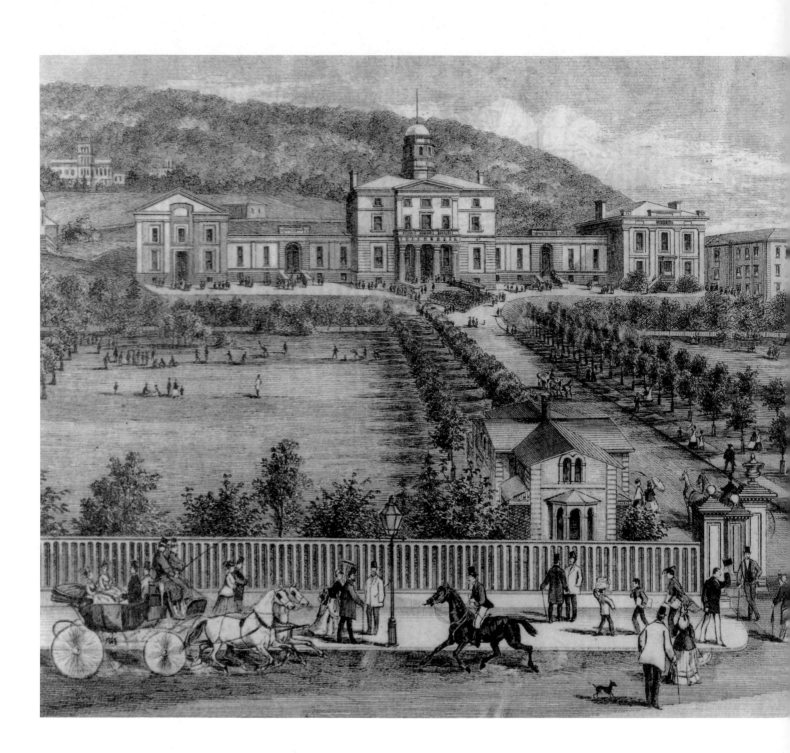

© McGill-Queen's University Press 1991

ISBN 0-7735-0795-7

Legal deposit second quarter 1991
Bibliothèque nationale du Québec

Printed in Italy

Canadian Cataloguing in Publication Data

Main entry under title:
McGill: a celebration
ISBN 0-7735-0795-7
1. McGill University – History.
LE3.M22M215 1991 378.714'28 C91-090010-8

Design
Miriam Bloom, Expression Communications

Editorial co-ordination
Carol Martin

Commissioned photography
George S. Zimbel, David Duchow,
Mark Ruwedel, and Pierre Charrier

Contents

McGill College University
Canadian Illustrated News,
29 May 1875

Open House, McGill ix
F.R. SCOTT

A Student's McGill 1
WITOLD RYBCZYNSKI

The Seed Becomes a Tree 11
ERIC McLEAN

Winning the Sheepskin 37
ROSA HARRIS-ADLER

Who Runs This Place Anyway? 63
STANLEY BRICE FROST

Stages in an Education 91
CONSTANCE BERESFORD-HOWE

A Torch for All Time 103
CAROL MARTIN

Writers at McGill 123
BRUCE WHITEMAN

The Classroom 139
LOUIS DUDEK

Discovering the McGill Treasures 143
GEORGE GALAVARIS

McGill and the Community ... and me 169
DONALD MacSWEEN

On Saying Goodbye to My Room
in Chancellor Day Hall 188
F.R. SCOTT

Celebrating the Future 193
MARGARET A. SOMERVILLE

Acknowledgments 208

About the Contributors 209

Credits 210

Open House, McGill

I stood by the Redpath Library
and watched the thousands of students
opening McGill's 150-year-old House
 students of all races and creeds
none of whom had fought on the Plains of Abraham
 or at the battle of Hastings
 no two dressed alike
 bright with colours as trees in October
 all gazing upward
 into the cool blue sky
cheering the girl and two boys who
 dropped
 from 4,000 feet
 with red-and-white parachutes
exactly upon a small patch of campus grass
 missing the trees and tall buildings
 controlling wind and gravity
 with swinging skill
 and speaking no language
save the language of motion

As they floated down
 we were all lifted
 Up

 F.R. Scott

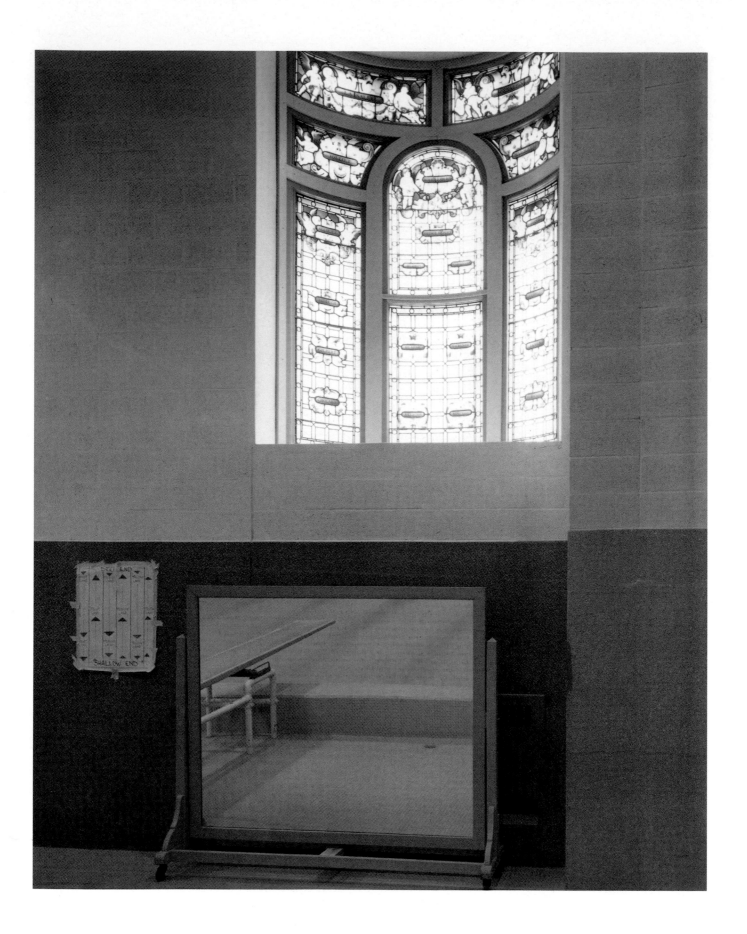

A Student's McGill

Witold Rybczynski

About a dozen years ago, I started playing squash with a friend at the Sir Arthur Currie Gym. In truth, it was not the game that attracted me; I am not what the French call a *sportif*. What I did enjoy was the ritual of the Saturday morning occasion, the highlight of which was a post-game beer at the Pines Tavern, at the time still a comfortable male preserve. I also liked the gymnasium, the cavernous locker room – another preserve – and the curious architecture of the courts, with their dark passages, midget doors, and reverberatory acoustics. The word gymnasium is derived from the Greek and means "training naked," and the freedom to stroll unclothed to the showers was also part of the pleasure of this ancient institution.

All grown men who indulge in sports are, to a greater or lesser extent, reliving their boyhoods. This was doubly true in my case because I had attended McGill as an undergraduate in the sixties, and the Currie Gym was a familiar, if not a cherished, place. Familiar, most of all, because it was the first building at the university in which I had set foot. Like all incoming students, I was obliged to line up with crowds of other eager freshmen on registration day to await my turn to fill out innumerable forms on one of the hundred or so card-tables that had been set up in the main basketball courts. I would return to this building in a few weeks to participate in the two sports that were then

facing page
Swimming pool, Sir Arthur Currie
Memorial Gymnasium.

right
The Word, a favourite hangout for
students looking for book bargains in
the "ghetto."

facing page
Architecture students enjoying a
seminar with Professor Radoslav Zuk.

a requirement for first-year students. I remember choosing badminton – it seemed an innocuous enough game – as well as, I think, swimming. Later I also made an effort to join the Rifle Club. I had never owned a gun which, I suppose, explained the attraction; several sessions in the dark and noisy firing range cured me of my fascination. Other than for the obligatory athletics though, I rarely went to the gym, except, that is, to write exams. Every spring, the same card-tables were brought out and the basketball court would be turned into a vast examination room. As the invigilators glided silently between the tables, we hunched over our exam books, an anxious eye on the

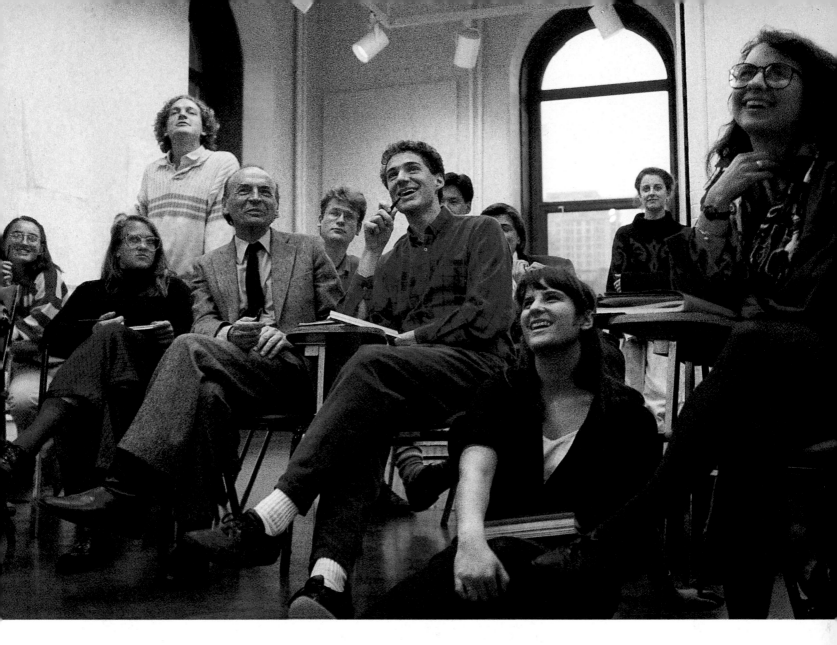

passing time. I sweated a lot more then than swinging at the bad-
minton bird.

The gym was "up the hill," at the top of University Street, that
cheerful gauntlet of dissolution – fraternity row. The gym marked the
northernmost edge of my campus world, just as Joe's Steak House
defined it to the south. The latter does not appear on the official map
of the university, but we all carry mental place-maps within us, maps
that bear little resemblance to reality. Like the Upper West Sider's view
of the world in Saul Steinberg's famous drawing that appeared on the
cover of the *New Yorker* and which showed everything beyond the
Hudson River and a narrow strip labelled "New Jersey" as a featureless
desert. These imagined maps are distortions; nevertheless, for the
individual, they are truer depictions than those of cartographers.

Looming large in my own place-map was the nondescript wing of
the McConnell Engineering Building which housed the School of

3

Architecture where I spent my days, and many of my nights. Appended to the school – that is how it appeared on my map – was the rest of the Engineering Faculty: a rabbit warren of anonymous classrooms and steeply sloping lecture halls, peopled by boisterous young men with dangling slide-rules on their belts. This was where I was inducted, more or less, into the mysteries of calculus, surveying, and soil mechanics.

Christopher Alexander, the American architect, maintains that every building, or group of buildings, has a heart; and when you enter that place you know that you have reached the centre of things. For me, the heart of McGill was unquestionably Moyse Hall. This had partly to do with its location, behind the Doric porch of the stately Arts Building and at the head of the main symbolic axis of the campus, and partly with its communal and convivial function. It was here that I saw *My Fur Lady* and the theatrical productions of the English Department. This was where eminent visitors to the university spoke. One evening Brendan Behan gave a reading; the Irish poet arrived late, obviously drunk, read a few verses, made suggestive comments about a girl in the front row, and nearly fell off the stage. Such occurrences were memorable enough, but what made a greater impression was that it was in Moyse Hall that I had my first experience of a great teacher. If memory serves, Economics 100 was a required course for all first-year students, and several hundred of us sat rapt in that classically decorated auditorium as Cyril James nimbly led us through the giddy sweep of economic history, from ancient times to today.

It was through this course, which had a long reading list, that I was introduced to the pleasures of the library. If Moyse Hall was the heart of the university, the Redpath Library was its brain, or at least its memory. I had always liked libraries, but this one was many times larger than the one-room, high school library where I had devoured G.A. Henty and Edgar Rice Burroughs. The first time I entered the stacks, a peculiar space with glass-block floors and low ceilings, I was overwhelmed by the sheer quantity of knowledge – and by the smell of old paper, which I enjoy still. Another pleasure of the library was the vast and silent reading room – Tyndale Hall, since lost in the course of renovations and additions – with its polished cork floor and stylized murals. Outside, the sunny terrace, happily still in place, provided a sort of academic corniche, fronting the campus green instead of the ocean. For a student from the outland of the Engineering Faculty, going to the library was also an opportunity to observe – sometimes even to meet – girls.

The place where I spent much time during my first three years at

Percy Nobbs
A sketch by Arthur Lismer.

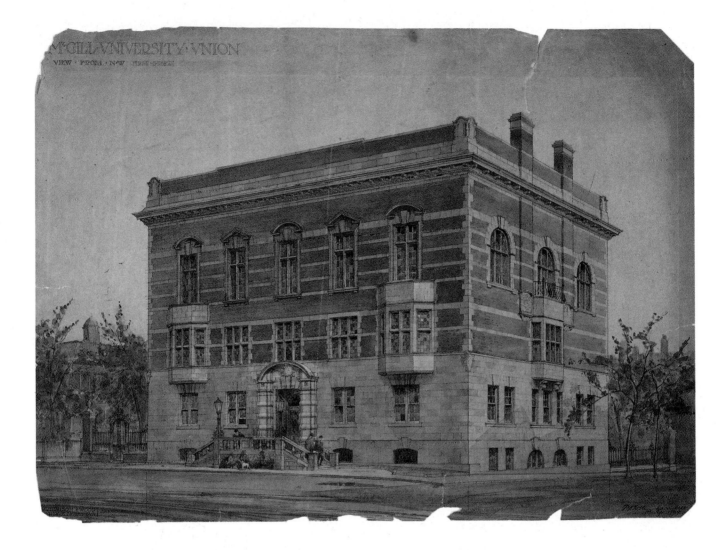

the university was the Student Union – now the McCord Museum. This most civilized of buildings, designed by Percy Nobbs in 1905, stood outside the campus proper, but that accorded well with its function, and with its autonomy. The classroom clearly belonged to the teacher, the library was a sort of no man's land, neutral and accessible to all, but the union was our own – I never remember seeing a professor there – neither of the city, nor yet quite of the university.

Although the union building had been designed for use as a student centre, it was patterned on a nineteenth-century men's club and incorporated the solid comforts of that type. On the ground floor was a cafeteria, which served indifferent but inexpensive food. A grand stair led up to the second floor, which contained the ballroom and several meeting rooms, but the real action was in the basement, which housed the offices of several student societies. I belonged to the Players Club,

Watercolour by Percy Nobbs of the Student Union Building on Sherbrooke Street designed by him while director of the McGill School of Architecture. The building opened in 1906 and was the centre for student activities for the next sixty years. In 1967 it became the home of the McCord Museum of Canadian History and the Notman Archives.

5

whose pokey quarters were across the corridor from the noisy newsroom of the *Daily*. Twice a year we put on plays – I recall *Under Milkwood* and *Fando and Lis* – moments of great excitement, even for someone who worked backstage, as I did.

I mentioned Joe's Steak House – my culinary education lagged my formal one – which marked the southernmost extremity of my mental map. Joe's was part of a cluster of extra-academic institutions along Metcalfe Street which included Ben's – apostrophe still in place – and a second-floor jazz club where I spent many Friday and Saturday nights. There were a few other such places – the Three Kings Studio in the Prince of Wales Terrace, the Vienna pastry shop across the street, the Hungarian restaurants on Stanley Street – which drew me out of the campus but which were really an integral part of my university world.

At this point, if I were drawing my map – the world according to a McGill student – I would get out my green Prismacolor pencil and shade in all the spaces between the buildings. That is how I remember it: grey stone buildings surrounded by grass and trees, and the sheltering flank of Mount Royal. Even Sherbrooke Street was green, for the great elms had not yet been struck down. That would complete my drawing, for there was not much to show beyond the green island of learning. Perhaps I would include, on the distant horizon, a country labelled "The Outside World"; but probably not, for it was not something to which I gave a great deal of thought at the time.

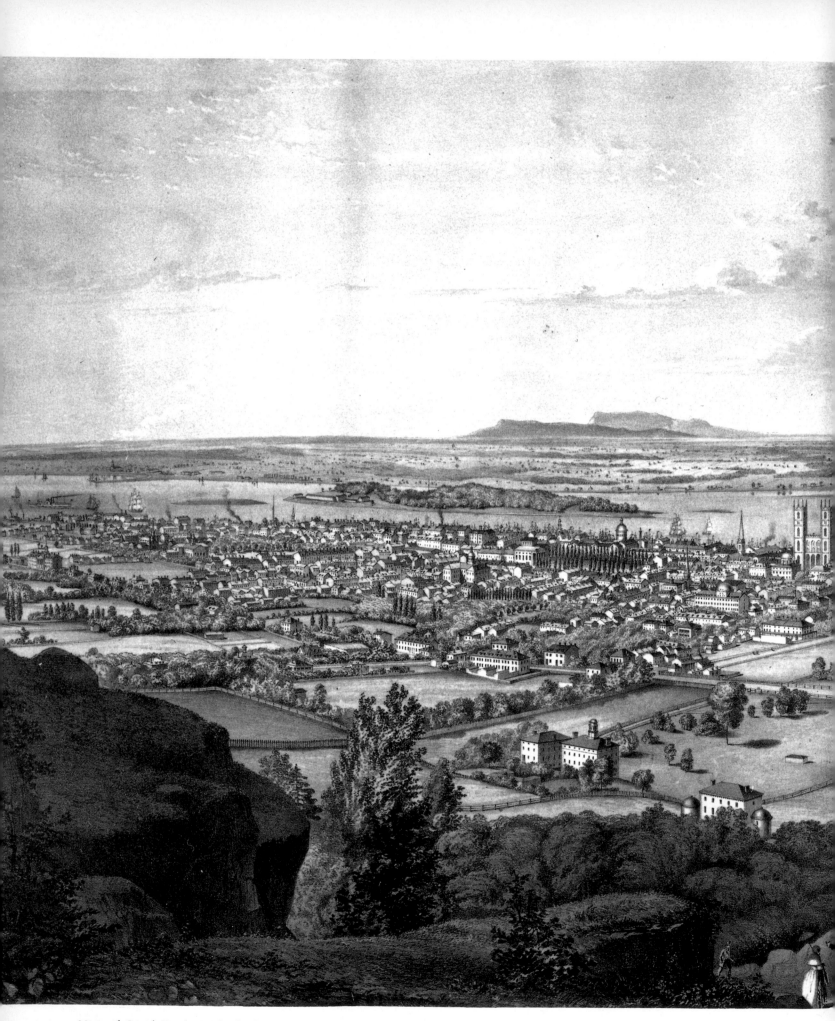

Montreal, Canada East *by E. Whitefield, 1852*

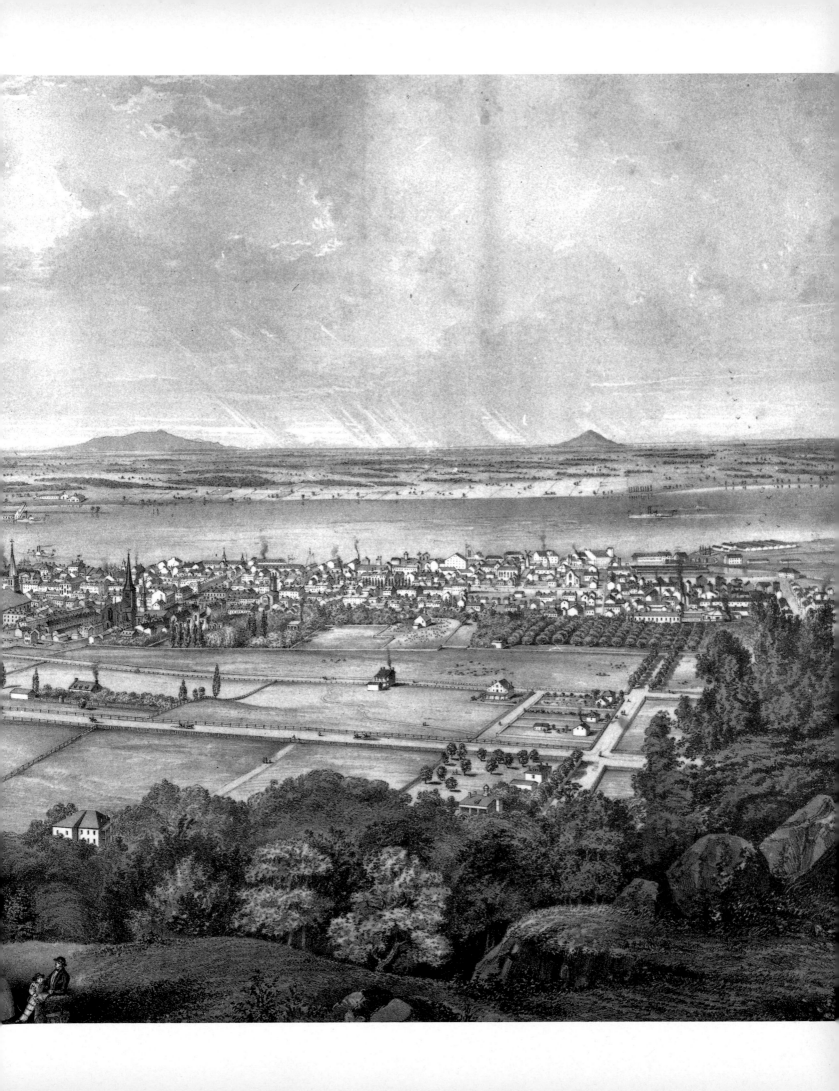

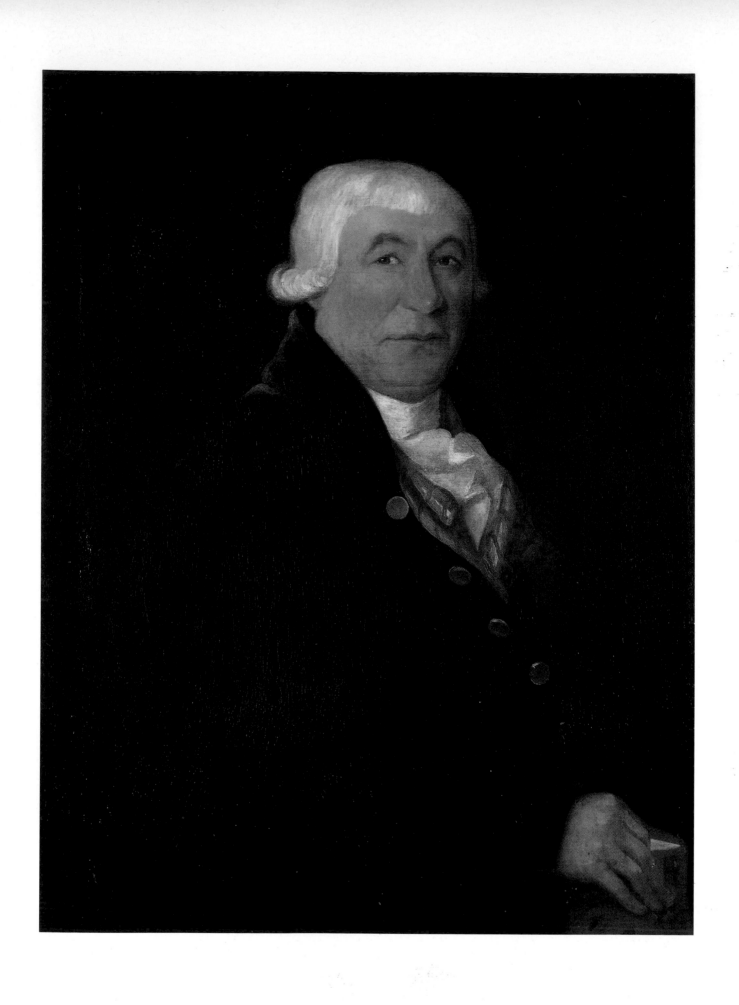

The Seed Becomes a Tree

Eric McLean

When James McGill drew up his will in 1811, he was a bit nervous. His brother John had died fourteen years earlier and it was only six years since his younger brother, Andrew, had been buried. When his sister, Isobel, died in 1808, James began to suspect that the McGills were not a long-lived family, and it was high time to decide on the final distribution of his considerable wealth.

He was quite right. He was sixty-seven at the time, but in two years an unexpected heart attack was to carry him off. If he had died without a will, the results would have been chaotic because he was one of the wealthiest men in the whole of Montreal at the time. Among the numerous bequests to his friends, his family, and various charitable organizations was a relatively modest sum of ten thousand pounds to be used in setting up a school or college that would bear his name. More significantly, the gift included a farm of forty-six acres on the side of Mount Royal.

McGill's bequest to the cause of higher learning was widely admired and enthusiastically applauded by the other leaders in the community, for education was very much on the minds of the English minority in Quebec at that time. A certain amount of training in letters, philosophy, and science was already available to the French-speaking youngsters of Montreal through the Roman Catholic religious orders,

facing page
James McGill
Portrait by Louis Dulongpré.
"This man's life reflects every important aspect of the confused and explosive period in which the prime elements of the Canadian nation were blown out of their original contexts and thrown together in the New World."
Hugh MacLennan, in McGill: The Story of a University

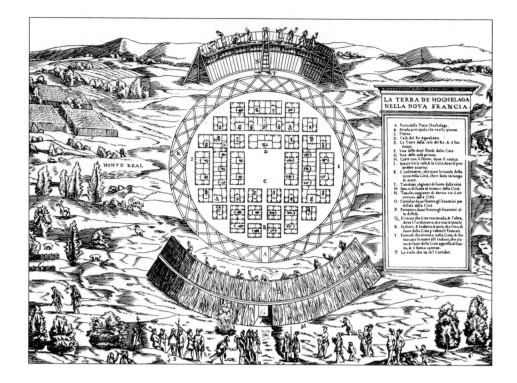

right
An early depiction of Hochelaga, the sixteenth-century Iroquois village on the site where Montreal now stands. Cartier visited here and climbed Mount Royal in 1535, probably passing through what is today the McGill campus.

below
James McGill's Beaver Club Medal Membership in the club was restricted to fur traders who had spent at least one winter in the wilderness of the Northwest.

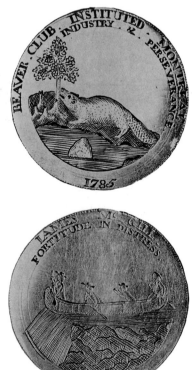

but there was no equivalent for English Protestant families. Those who had the means sent their children to the United States for their education, but Jacob Mountain, the first Anglican bishop of Quebec, regarded this practice as iniquitous. "You will see no doubt, Sir," he wrote to the colonial secretary in London, "all the mischiefs that may arise of sending our youth for education to the schools of Foreign America, a necessity which *at present certainly exists,* and to which I know some worthy and prudent parents reluctantly submit." In an attempt to correct this situation, Mountain and some of his friends in the government had lobbied resolutely for the passage of An Act for the Establishment of Free Schools in this Province. This resulted in the creation of "The Royal Institution for the Advancement of Learning" in 1801, just a dozen years before James McGill's death.

It was this institution that became a beneficiary of James McGill's will, and it was to this organization that fell the difficult task of realizing McGill's dream.

Although McGill's college would go on to become a world-renowned university, its beginnings were fraught with difficulties. Legal wrangling with the other McGill heirs and a constant shortage of funds led to delay after delay in the early years. But delays were dangerous. The bequest had a condition attached: if the Royal Institution for the Advancement of Learning failed to establish a

college within ten years of the donor's death, the gift would be nullified. Conscious of this, the members of the Royal Institution searched desperately for a solution to their problem. The first moves were to obtain in 1821 a royal charter, to appoint a principal and four professors, and to claim that this honorary staff constituted a college. More substance was given to this argument in 1829 by recognizing the Montreal Medical Institution as the college's faculty of medicine. Four doctors on the staff of the Montreal General Hospital gave lectures at No 20 St James Street, so the first home of McGill College was in Old Montreal.

Today, the location of the university seems ideal, and there are those who would point to it as an example of James McGill's farsightedness. The grounds are easily accessible from all parts of the city, and the green campus leading up to the Arts Building, the first structure to be raised on this land expressly for the university, is one of the major attractions of Sherbrooke Street.

At the time of McGill's death, however, this was the countryside and far from any amenities of the city. The McGill family used the farm as a summer residence. For people living in Montreal in the 1820s and 1830s, the trip up the mountainside to the McGill property could not have been easy. No streets had been developed that far north, except for St Lawrence Boulevard. Sherbrooke Street was a dirt road running

Burnside Place
James McGill built this summer residence for himself and his family on the slopes of Mount Royal, south of where Sherbrooke Street runs today. It was surrounded by orchards and gardens, and a small stream or burn ran through the property which was described at the time as being "about a mile from the town."

Burnside property bequeathed to certain parties in trust.

To convey the same to the Royal Institution for the Advancement of Learning.

Upon condition that Royal Institution in 10 years from Testator's decease, erect a University or College.

If an University or College, to be called McGill College.

The section of James McGill's will in which he bequeaths the Burnside property, consisting of forty-six acres and the buildings thereon, to the Royal Institute for the Advancement of Learning for the purpose of establishing a college to be called "McGill College."

from St Denis to Aylmer, where it disappeared. In the winter, with a full bed of snow on the ground, the trip would have been not only uncomfortable but hazardous. Indeed, when the Arts Building, designed by John Ostell, was completed in 1843, it was considered so remote, and the trip from Montreal so difficult, that it was able to attract only three students. The teachers were given permission to develop a vegetable garden on the campus, and for a while the greenery in front of the Arts Building even served as pasture for a professorial cow.

In 1852 disaster struck. The city of Montreal had decided to go ahead with its plans for a water reservoir on the side of the mountain, a project that required a good deal of blasting and excavation. One of

the explosions sent a number of boulders crashing through the roof of the Arts Building. Fortunately no one was hurt, but the teachers and pupils had to move into other quarters nearer to town. This was certainly one of the low points in the university's history, but within eight years things were looking up again. An enterprising board of governors had not only found the means to put Ostell's building back into operation, but it was made to lodge not only the Faculty of Arts, but the Faculty of Medicine as well.

THE PROPERTY THAT HAD BEEN WILLED to the new college was narrower and longer than what we know as the McGill campus today. The northern border of the farm lay just south of what is now Dr Penfield Avenue, curving up to Pine Avenue; then on the east side the boundary line ran from Pine Avenue all the way down University to Dorchester (now René Lévesque), which formed the southern border. Finally, on the west, the property followed the present Mansfield Street straight up to Penfield. In spite of the difficulty of access in the early nineteenth century, no one could deny the beauty of the location with its clear view down the gentle slope of Mount Royal to the old city and the St Lawrence River. Today the area might easily be the most valuable piece of real estate in the province of Quebec. Just imagine a property stretching from Mansfield to University, with the Sun Life Building and Place-Ville Marie on its southern border, and Dr Penfield and Pine Avenues forming the boundary on the north.

Eventually the university was forced to dispose of most of the land south of Sherbrooke Street, piece by piece, as the number of students increased and with them the need for greater operating funds. But apart from the financial situation, there were many unforeseeable developments, not only within McGill itself but in the surrounding community, which greatly altered the shape of the campus.

According to the *Montreal Atlas* published by A.W. Hopkins in 1879, McGill had by then sold off two-thirds of the original land bequest. The map shows the remaining property with only a small gatehouse at the Sherbrooke Street entrance, the Presbyterian Theological College part way up the west side, the Arts Building towards the rear of the campus, and in the northeast corner, the Medical Building. Nothing else. An engraving published in the *Canadian Illustrated News* some four years earlier (and reproduced here on the contents page) suggests a more elegant campus. It includes the same buildings as the Hopkins survey, but to the west of the Arts Building we can see the small stone tower of Dr Smallwood's observatory, and

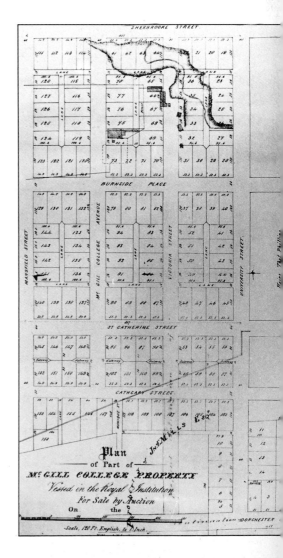

Advertisement announcing the sale by auction of the McGill property south of Sherbrooke Street. The severe financial problems the college found itself in during the 1860s required extreme measures.

15

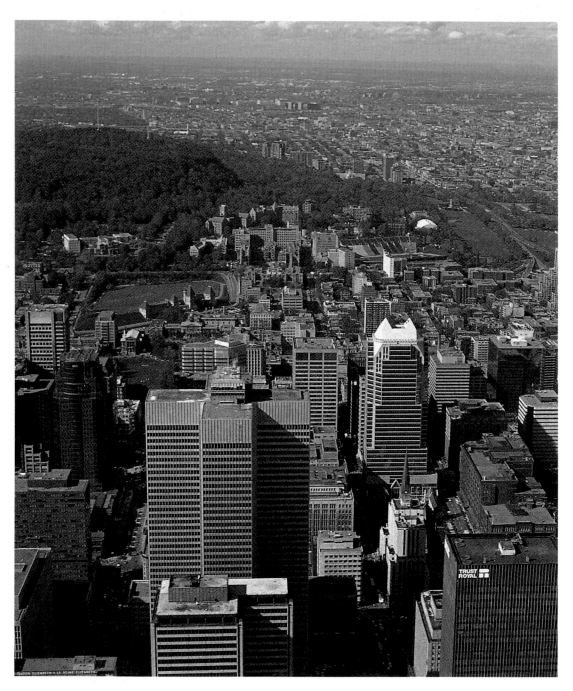

A map (facing page) indicating the boundaries of the McGill property before the land sales, and a bird's-eye view of the same part of Montreal today.

16

PLATE 19

on the main part of the campus the artist has included the rows and rows of trees lovingly planted by Sir William Dawson when he was the principal of McGill from 1855 to 1893.

During the next three decades, a totally random succession of new buildings of varied and imaginative design were built to accommodate the increased needs of the expanding university. McGill at this time was sustained financially by the benevolence of a few far-sighted patrons and, to a lesser degree, by fees paid by the scholars. There was no assistance from the city, the province, or the federal government. This was a privately operated university, and it remained so until 1960. But there was no shortage of patrons in the latter part of the nineteenth century and the beginning of the twentieth. In fact, they seemed determined to compete with each other in generosity.

Some of McGill's greatest philanthropists were most active towards the end of the century. In 1880 Peter Redpath contributed the Redpath Museum designed by Hutchison and Steel to house the university's geological and natural history collections, and eleven years later he added the Redpath Library. In the 1890s, Sir William Macdonald financed the construction of the Macdonald Physics Building, the Macdonald Chemistry Building, and the Macdonald Engineering Building in the unique row of structures on the east side of the campus that housed the scientists who would place McGill in the forefront of this field of study. Two disastrous fires struck McGill in 1907, destroying both the medical and the engineering buildings, but Sir William did not hesitate to pay for the reconstruction of his engineering building, and Lord Strathcona contributed a new home for the Faculty of Medicine.

In his 1925 study of McGill architecture, Professor Ramsay Traquair wrote: "By 1899, the campus had assumed very much the

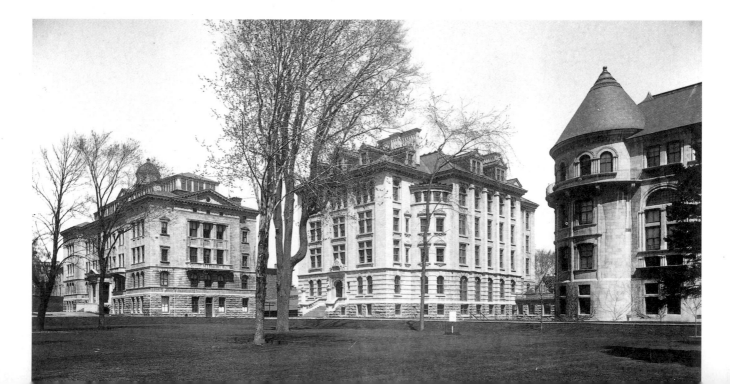

appearance which it has today. The buildings had grown up naturally about the square central space without too much formality or too exact a symmetry. The campus owes much of its beauty today to Principal Dawson's tree planting and to the fine grey color of the Montreal limestone which has been used in all the buildings. This has unified the otherwise individual buildings in a very satisfactory way, and it is to be hoped that no other material will ever be admitted to the grounds."

Traquair's hope has been largely respected within McGill's central campus. The Victorian limestone home of Thomas Workman, another of McGill's generous benefactors, used to stand on the southeast corner of the grounds, where University crosses Sherbrooke, and for many years it was occupied by the Faculty of Music. When it was discovered in 1940 that the structure had deteriorated to a dangerous

right
Jesse Joseph House
The McCord Museum occupied this building from 1922 until it was demolished in 1954.

facing page
Thirty-four-foot totem pole from the McCord collection.

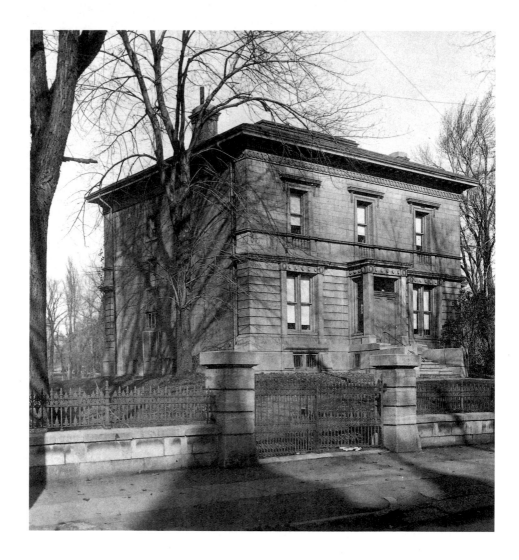

degree, it was demolished. Musical studies then became the university orphan and moved from shelter to shelter for more than thirty years until a permanent home was found in Royal Victoria College. In 1966 the much-needed Otto Maass Chemistry Building was built where the Workman house had stood. To conform with the other buildings on the campus, it was sheathed in a light limestone.

On the southwest corner of the present campus stood another handsome limestone building, once the residence of the Jesse Joseph family. For many years it housed David Ross McCord's bequest to McGill, perhaps the most important collection of objects, images, and documents relating to Canada's history to be found anywhere in the country. It had not been open to the public, however, since the mid-thirties and, until the university found the means to develop a proper museum project, the collection (which by then included the cele-brated Notman photographs and glass negatives) lay about in boxes and cupboards, jealously guarded by Dr Alice Johannsen, the former director of the McGill University Museums. But this building, too, was badly neglected, and when it was beyond repair and could no longer offer the protection required for the McCord collection, it was demolished in 1954.

The collection was then moved to another house that had been willed to the university – the home of A.A. Hodgson, on Drummond Street at the corner of McGregor (now Dr Penfield Avenue). There it continued to hide in limbo for more than a decade, until the redoubt-able Isabel Dobell succeeded in marshalling the support and the funds needed to re-design the interior of the old Student Union Building. When the collection, now under Isabel Dobell's direction, was finally displayed in the newly refurbished building, Alice Johannsen paid it a visit, which she described as follows: "The 34-foot totem pole, once in the old Medical Building, rises majestically in the foyer. On all sides were objects which I had known and loved and cared for, now painstakingly displayed and beautifully documented. It was as though I, too, had joined the ranks of those other disembodied spirits, and now could see the results I had only dreamed of in the lonely dusty days of the old Joseph House."

For all its efficiency and logic of design, the bulk of the new McLennan Library wing which rose on the site of the old Joseph house in 1969 could hardly be said to conform with Traquair's wish for limestone. It is a reinforced concrete structure, but its colour does reflect the grey of the older campus buildings, and its scale conforms with that of its neighbours. Concrete was used with somewhat more

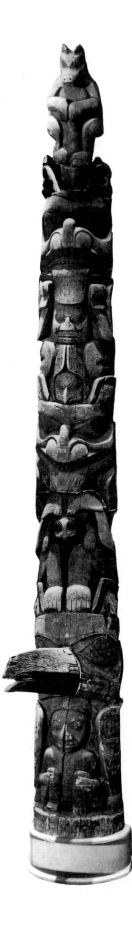

imagination by the late Ray Affleck, one of Canada's best-known architects and a graduate of McGill. He was largely responsible for the design of the Stephen Leacock Building, erected in 1965 just north of the former Presbyterian College. It climbs the slope on the west side of the campus then turns the corner behind the Redpath Museum to join the Arts Building complex.

The one structure that might startle Traquair, were he alive today, would be Burnside Hall, a fifteen-storey building (three of them underground) rising immediately to the north of the Otto Maass Building. It houses meteorology, geography, mathematics, computer science, and McGill's Computer Centre. The choice of the Burnside name is somewhat ironic. It was taken from the summer home of James McGill, but it would be difficult to imagine two buildings with less in common.

CONSIDER, NOW, THE THREE BLOCKS bounded by Mountain Street on the west, McTavish Street on the east, Pine on the north, and Penfield on the south. None of this lies within James McGill's bequest; in fact, it is part of Simon McTavish's old farm. But nearly all the buildings within this area now belong to McGill University. The list includes the Education Building, the Powell Student Services Building, Lady Meredith House, the McIntyre Medical Sciences Building, the Stewart Biological Sciences Building, Chancellor Day Hall, and a dozen others.

The land facing onto Sherbrooke between McTavish and Peel, where the elegant Prince of Wales Terrace once stood, is now the site

facing page
Stephen Leacock Building

below
Prince of Wales Terrace
This elegant block was demolished in the early 1970s to make way for the Samuel Bronfman Building.

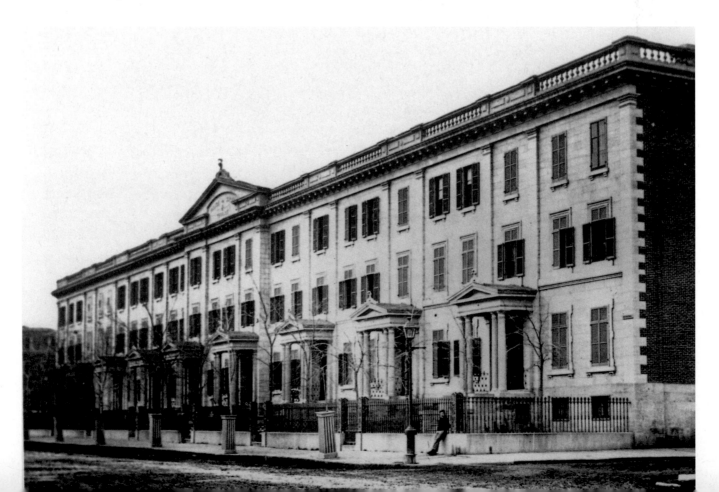

of the Samuel Bronfman Building, housing the Faculty of Management. The west side of McTavish Street now belongs to the university in its entirety and includes Peterson Hall, the University Centre, and the Faculty Club, among other buildings.

On the other side of the campus, east of University, lies one of Lord Strathcona's many generous gifts to the university – Royal Victoria College. In his study of the university buildings, Traquair wrote: "In 1899 Lord Strathcona, who had for long interested himself in the education of women, built Royal Victoria College, from the designs of Mr Bruce Price ... The design, with its strongly pronounced gables and shallow bay windows, shows clearly the influence of the contemporary English work of Mr Norman Shaw." Price, an American, was highly regarded in the United States at the time, and his other achievements in Canada were to include the Chateau Frontenac in Quebec City, the Windsor Station, the Viger Hotel and station, and the James Ross house on the northwest corner of Peel Street and Dr Penfield Avenue. Traquair's comment seems to suggest that Price had mended his ways, passing beyond the extravagance of Richardson Romanesque, still so popular with the young architects at the turn of the century, to adopt what he regarded as the more mature approach of Norman Shaw.

Strathcona spared nothing to give his new ladies' college the importance he felt it deserved. A large elaborately carved stele featuring Queen Victoria's crest was acquired from the Houses of Parliament, Westminster Palace, and it was installed at the west end of the long arched portico that runs across the front of the building at the entrance level. Then, rising in the middle of the entrance stairway is a bronze statue of the young Queen Victoria enthroned, slightly more than life size – the work of her gifted daughter, Princess Louise, Duchess of Argyll. For a Scottish highlander, Strathcona had developed an unusual fondness for the British royal family!

When the university finally dropped the policy of separating the sexes. the need for this specialized college began to diminish, and in

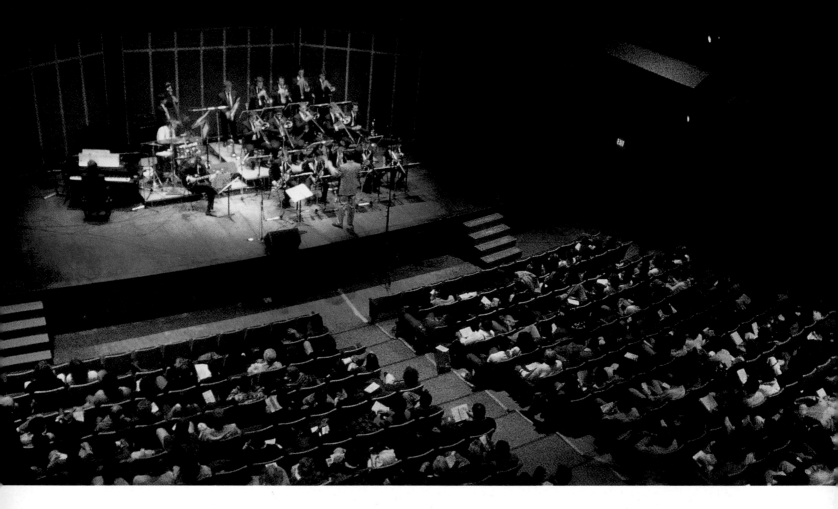

McGill's Bachelor of Music in Jazz Performance is the first and only degree of its kind in Canada. Above, the award winning Jazz Ensemble 1 performs in the Pollock Concert Hall designed by John Bland for the Strathcona Music Building.

1971 the Faculty of Music and the McGill Conservatorium moved in. Thus, for the first time in more than three decades, the study of music was given a proper setting. The assembly hall and dining room to the rear of the building were transformed in a particularly ingenious way by John Bland, then director of the School of Architecture, to provide a larger and more appropriate concert space, and this work was generously underwritten by the Maurice Pollack Foundation.

THE EXTENSION, WIDENING, AND PAVING of Sherbrooke Street in the second half of the nineteenth century had greatly enhanced the value of properties climbing the slopes of Mount Royal, and the lords of Montreal commerce and industry began to build themselves sumptuous houses in the area, a region that came to be known as the Square Mile. However, with the disappearance of servants and the rise in both assessments and rates over the years, the financial burden of maintaining such properties greatly increased, and a number of the descendants of these families either sold or gave their lands and houses to the neighbouring university, in the interests of higher education – and lower taxes. Familiar examples of such mansions are the house of James Ross, on the corner of Peel and Penfield, and the house of his son, John Kenneth Ross, across the street, as well as Sir Henry Meredith's house on the corner of Peel and Pine.

The university bought the Baumgarten house on McTavish Street as a residence for the principal of McGill. As it turned out, only one principal occupied it; Sir Arthur Currie lived there for seven years from 1926 until his death in 1933. Two years later, a group of architects associated with the university drew up plans to adapt the building as a club for the members of the various faculties, a function it has continued to fill. Then in 1948 J.W. McConnell, president of the St Lawrence Sugar Company and the publisher of the *Montreal Star,* bought the James Ross property and donated it to McGill. It now houses the Faculty of Law. McConnell also bought the austerely beautiful Purvis house (now Purvis Hall) at the southeast corner of Peel and Pine. Designed in 1907 by Robert Findlay, its arches and fine iron work reflect the revival of interest in classical English architecture, in contrast to the romanticism of the Victorian era.

More recent additions to the university properties were two fine buildings on Drummond Street above Dr Penfield Avenue, among the best examples of Square Mile architecture. In 1955, the University bought the mansion at the very top of Drummond Street, just to the west of the stairs that lead up to Pine Avenue. The home of the wealthy Montreal contractor, J.T. Davis, this house was designed by the Maxwell brothers in 1909. Then, about twenty years ago, McGill bought the splendid Beaux Arts palace erected at the turn of the century for Charles Hosmer. The designer was again Edward Maxwell. Both of these mansions have been adapted as classrooms and laboratories for the Faculty of Medicine.

It was chance that placed the McGill campus in the middle of an area that was to be developed by the richest of the Montreal families. And in one sense it was chance that placed the mansions of these families at the disposal of the university: chance that included two world wars, radical changes in the social structure, and an unforeseeable inflation in land values and taxes that made these marvellous buildings totally impractical as residences.

Most Montrealers, whatever their origins, came to regard the Square Mile as one of the distinctive features of the city, and one that should be preserved. While it was obvious that such mansions were no longer practical as single family dwellings, the increasing number of demolitions licensed by the city administrators roused indignant opposition which was exacerbated by the numerous high-rise apartment buildings that replaced the stately homes, steadily diminishing the profile of Mount Royal.

If McGill University has become the proprietor of many of the

Just thirty-five kilometres east of Montreal, the 3000-acre Gault Estate, Mont St Hilaire, contains one of the last virgin forests of the St Lawrence lowlands. Rich in minerals and plant and animal life, it is an important area for scientific research. A Nature Conservation Centre is open to the public.

houses in the Square Mile, however, it has not been through any deliberate policy of historical or architectural preservation. If that had been the case, it might have given more careful consideration to the demolition of the Joseph, Workman, and Reford houses and, in particular, the Prince of Wales Terrace. No, what induced McGill to acquire the mansions of the Square Mile was the fact that universities, like churches, are not subject to taxation: the families might not be able to afford their homes, but McGill could. (For a time, there was also a city by-law forbidding the construction of apartment houses in the area, which meant that even if a family abandoned one of these homes, it would hold little interest for the real estate speculator. This situation, of course, brought down the market value of these properties.) But there were other factors that aroused McGill's interest in the Square Mile as well. The ample proportions of these buildings lent themselves to classroom and laboratory adaptations, and their proximity to the main campus must also have counted. Regardless of the motives that led to its purchases, McGill will likely be credited with having saved some of Montreal's finest architectural achievements.

MOST OF THESE BUILDINGS are on land of near neighbours of the original James McGill farm. However, the university has also acquired, either through gifts or purchases, a number of properties farther afield that have been of great importance to its development. Macdonald College, opened in 1907, was Sir William Macdonald's largest single contribution to McGill University. It consisted of 600 acres near Ste Anne de Bellevue at the southwest end of Montreal Island. There he had built a large central building, residences for male and female students, and other houses for staff and the principal. This was to be the centre for the Faculty of Agriculture, the training of school teachers, and the School of Household Science. Macdonald also provided two million dollars as an endowment for the new college ... a particularly generous amount at that time. Various additions have since been made to the university's West Island holdings, most notably Stoneycroft Farm and Morgan's Woods (now the Morgan Arboretum) the gift of J.W. McConnell in 1945.

A more recent addition to the off-campus holdings of McGill University was the estate of Brigadier-General Andrew Hamilton Gault

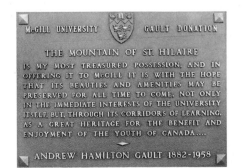

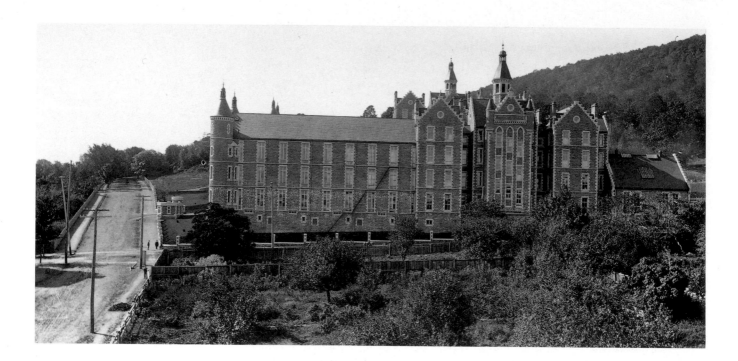

Royal Victoria Hospital in the 1890s, originally modelled on the Edinburgh infirmary, was a "Florence Nightingale edifice with the dormitories of the Crimean War."

who died in 1958. The property, about 3000 acres in extent, occupies the crest of Mont St Hilaire, about 30 kilometres east of Montreal. This was Gault's summer home, of which he was particularly fond, and he willed it to the university in the hope that "its beauties and amenities may be preserved for all time to come." The Gault estate has been used in two ways: a part of it is open to the public as an unspoiled park in which guided nature tours are offered on a regular schedule. The rest of the land – the larger part – is left untouched as a wilderness area for botanical and ecological studies.

McGILL UNIVERSITY DOESN'T OWN a hospital, but it collaborates with ten of them around the city. In fact, it does everything in the field of medicine except own a hospital: it trains doctors, nurses, and other hospital technicians; it operates clinics in association with several of the major hospitals in Montreal; and it is unlikely that there is a hospital in the community that does not have someone from McGill on its staff.

From the very beginning of the university, when the Montreal General Hospital helped to put together McGill College's first classes, these two institutions have maintained a close association. The hospital first moved from Craig Street to Dorchester, where it continued to expand by throwing on a wing here or an extra storey there. Then, in the 1950s the municipal government decided to cover the entrance to

the railway tunnel under Mount Royal and to widen Dorchester as a main thoroughfare, a project that would lead eventually to the high-rise development of the boulevard including the Queen Elizabeth Hotel and Place Ville-Marie. The directors of the Montreal General Hospital decided, for a multitude of reasons, that it was time to move. A site was found on the side of Mount Royal, where Pine Avenue crosses Côte-des-Neiges, in the northwestern corner of the Square Mile. This was to be a much larger and more up-to-date hospital than the one on Dorchester, and the cost was covered to a large extent by a number of generous donors.

On the opposite side of the Square Mile, the Royal Victoria Hospital had already been established for some seventy years. Lord Strathcona and Lord Mount Stephen were its principal benefactors. The architect was a Mr Saxon Snell, whose plan took some seven years in the building. His inspiration was the Edinburgh Infirmary, an idealized Florence Nightingale edifice with the dormitories of the Crimean War. So unrealistic was his design that he proposed a system of heating for the hospital which employed open fireplaces through-out the wards. And, indeed, the building was put up with a multitude of open hearths and smokestacks in the British style. The patrons of the Royal Victoria Hospital soon recognized the folly of this plan and demanded that the chimneys be drastically reduced in number. Those which remained were blocked at the top and at the hearth, and a sensible central heating system was installed. The Royal Victoria was later expanded with the addition of the Ross Pavilion, and with Ravenscrag, the mansion which Sir Hugh Allan, founder of the Allan steamship line, had built for himself near the crest of Mount Royal in the 1860s. It was willed to the university by Sir Hugh's son, Sir Montagu Allan, on condition that it commemorate his father. Although the Royal

Ravenscrag
The former residence of Sir Hugh Allan, this is now home to the Allan Memorial Institute of Psychiatry.

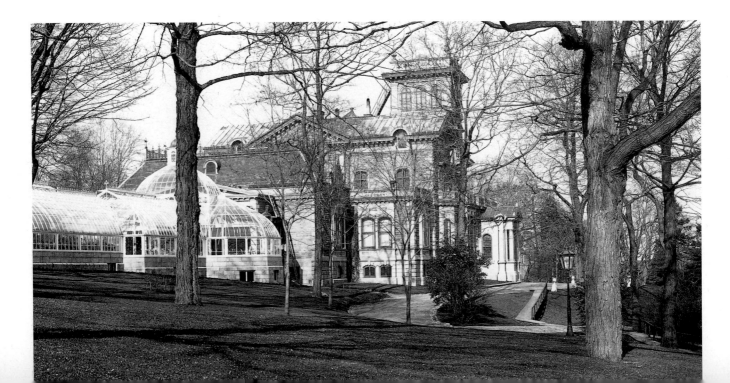

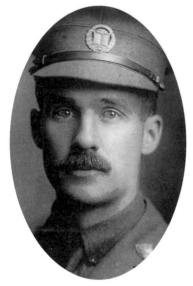

Captain Percival Molson
A graduate of McGill and a talented
athlete, he was killed at the front in
1917. His will provided the funds for
the stadium named in his honour
and described by architect Ramsay
Traquair as "the most beautifully
placed athletic field in America."

Victoria Hospital is not, strictly speaking, a part of McGill University, it is definitely a part of the McGill campus area, with the Lyman Duff Building and the Montreal Neurological Institute as its closest neighbours.

The Montreal Neurological Hospital and Institute was an initiative on the part of the university administration itself, which succeeded in raising the money for this vitally important project with the help of the Quebec and Montreal governments and a local fund-raising campaign. The largest single donation, however, one million dollars, came from the Rockefeller Foundation.

The campus itself extends by some twenty-five acres to the north and east of these medical buildings through another of William Macdonald's generous gifts. The area, still known as Macdonald Park,

is occupied today by student residences, Molson Stadium, and the Currie Memorial Gymnasium.

AND SO THE CAMPUS IS COMPLETE. From a hesitant and uncertain start in 1823, McGill University has gone on to become a centre of learning, renowned throughout the world. No one, certainly not James McGill, could have imagined what would eventually result from his gift. The metaphor used by Father Vimont in his sermon to the French colonists when they first landed in Montreal in 1642 would not have been inappropriate: McGill's bequest, too, was a "seed that would develop into a magnificent tree."

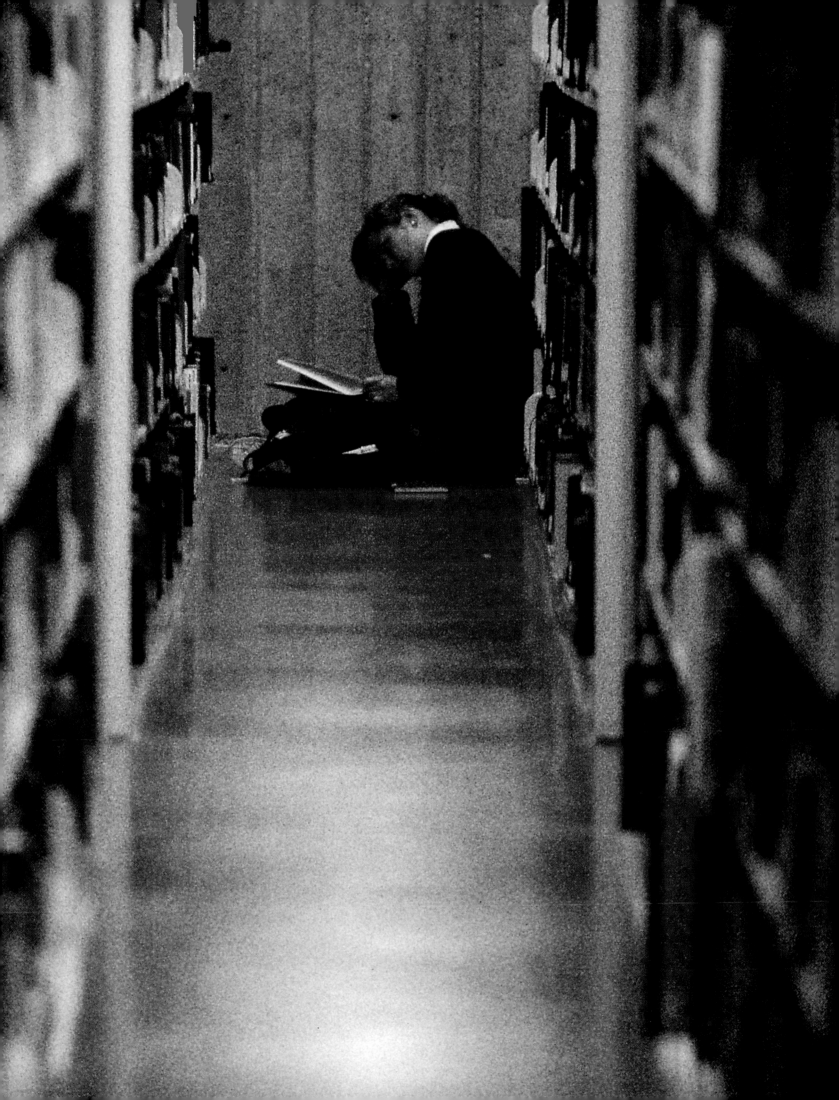

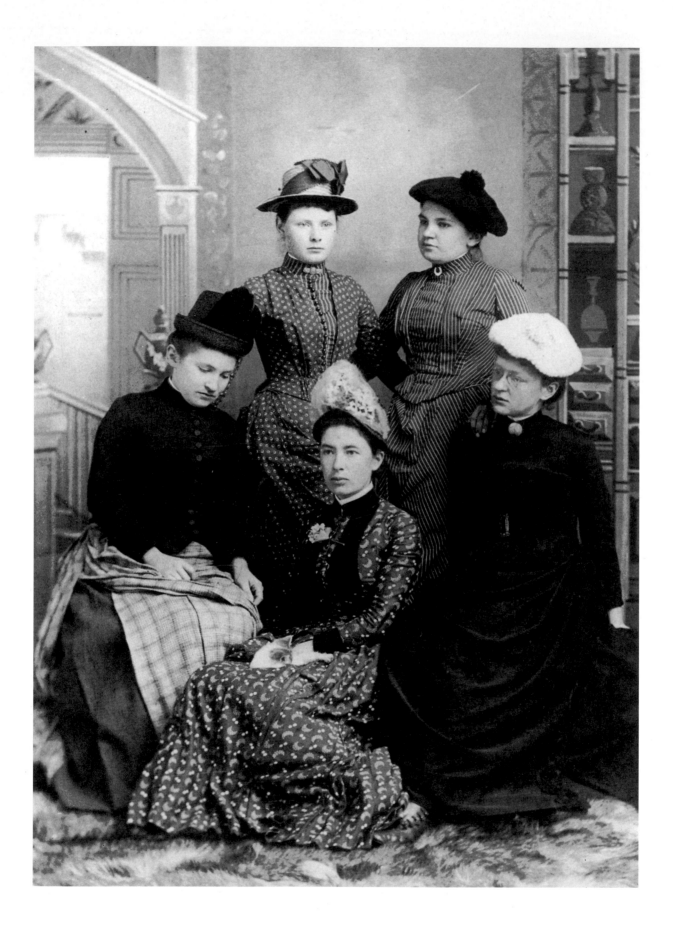

Winning the Sheepskin

Rosa Harris-Adler

When first I saw a sheepskin,
In Johnson's hands I spied it,
I'd give my hat and boots, I would,
Just to have been beside it,
Oh! when examinations past,
We've skinned and fizzled through
With lectures done and prizes won,
We'll have a sheepskin too.

McGill drinking song,
circa 1882

T he prized sheepskin, rolled up tight and handed out with a flourish at every graduation ceremony! So precious that those early McGill scholars would have forfeited their boots and hats for one, bitter Montreal Februaries aside. Symbol of the pride and accomplishment – of the dedication and youthful commitment – of every student who ever entered the Roddick Gates with life dreams still emerging.

There are an estimated 100,000 McGill alumni around the world today whose dreams took shape in the years they spent behind those gates – part of a long strand of humanity winding back to the first intrepid twenty who began their studies at McGill in 1843. Their stories are the core and fibre of the university. And it is their role as active graduates which has given McGill a sublime continuity.

One of the early dreamers was to become the world-renowned

facing page
Donaldas from the late 1880s in the charming hats and dresses of the day. At top right is Maude Abbott. She had to go elsewhere to earn her medical degree because McGill was not yet accepting women students in its medical faculty, but her life's work was at McGill where she was curator of the Medical Museum and assistant professor of medical research. Abbott was renowned for her work on congenital heart disease and is the only person to have received two honorary degrees from McGill.

Donald A. Smith, Lord Strathcona His interest in the education of women led him to support the "Donalda" program for the education of women at McGill and, later, to pay for the building of Royal Victoria College (facing page).

Canadian physician, Sir William Osler, a vivacious prankster who graduated from the Faculty of Medicine in 1872. Osler chose to study medicine at McGill because it already had a world-wide reputation in that field. His intellectual curiosity was nurtured during McGill's first golden age, when William Dawson was principal. In 1874, Osler attended a seminar with Charles Darwin in England and later met with the scientist. He wrote of the meeting: "[Darwin] spoke much of Principal Dawson of McGill for whose work in fossil botany he has great regard. I remember how pleased I was that he should have asked after Dr Dawson."

Osler's loyalty to his Montreal alma mater was enduring. He returned to teach at McGill in the Faculty of Medicine after he did postgraduate work in England, and he remained at McGill until 1884. Even long after he had left the city, eventually to become a professor of medicine at Oxford University, his proprietory interest in McGill remained.

It was this kind of proprietory interest that led to the establishment of the Graduates' Society, formed in 1857 and incorporated in 1880. At the time of its incorporation, the society stated that its objective was "to afford the members thereof the means, by united efforts, to more effectively promote the interests of the University and to bind the graduates more closely to one another and to the University." It was an aim that continues to be pursued to the present day.

Montreal women of that Victorian era also longed for the right to trade their hats and boots for a sheepskin. But it was only in 1884 that women were allowed entry to McGill; the first female graduates earned their degrees in 1888. These were the so-called Donaldas, nicknamed

Household science students at Macdonald College 1913, in their green and white striped gingham uniforms. Not visible in the picture are the obligatory boots. Boots and uniforms, considered to be dated and discriminatory, were a source of irritation to the young women.

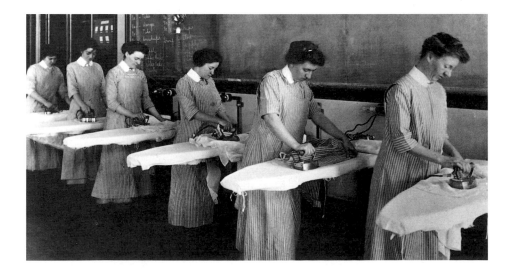

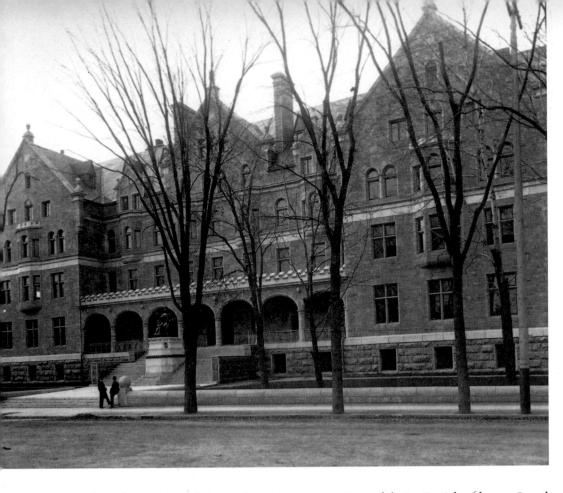

for their benefactor, businessman Donald A. Smith (later Lord Strathcona), who had contributed $50,000 towards the establishment of a college for women at McGill. In his honour the Donaldas formed the Delta Sigma Society in 1889 – using the Greek letters for his initials; it would shortly become the Alumnae Society for women graduates and is still thriving today.

Octavia Grace Ritchie was among the original group of Donaldas. A photograph of her at twenty with her sister Donaldas shows her in stiff and proper Victorian dress with the requisite bustle and a delicate lacy hat resting uneasily atop an intently serious head. Close behind her was Maude Elizabeth Seymour Abbott who would graduate with a B.A. from McGill at twenty-one in 1890. Both ardently sought the right to be admitted to the Faculty of Medicine, actively raising funds with other alumnae so that a separate medical school for women could be established on campus.

Ritchie was the valedictorian of McGill's first class of women graduates. In her fiery address she protested: "The doors of the Faculty of Arts were opened four years ago; those of Medicine still remain closed. When will they be opened?" For a time, it looked as though this impassioned canvassing would bear fruit. But their efforts got them nowhere. Both women went on to earn their medical degrees through Bishop's University which at the time had a campus in Montreal. It would be thirty years before the doors to McGill's Medical School

Hilda Oakeley
She was the first warden of Royal Victoria College.

would open to welcome women. And it was only in 1922 that the first women doctors would graduate from the institution. The Great War opened the way to change, according to Jessie Boyd Scriver, one of the first five women doctors graduated from McGill. She recalled the experience in a book of McGill memories edited by Edgar Andrew Collard:

> In Great Britain women graduates in medicine were filling the gaps in medical jobs both at home and abroad ... In Canada, the desire to contribute to the war effort was widespread ... There was no thought of storming the doors of the Medical School, nor of petitioning for the admission of women ... Our one thought was to obtain a good medical training wherever it could be had ...
>
> That first year [1917] was one of varied experiences. The students accepted our presence with amused tolerance and even sought to have one of us as class secretary ... Members of the teaching staff, who were ever ready with counsel and advice, exercised a benign surveillance but did not fail to remind us that we were on probation.

The Faculty of Law's first female graduate was Annie Macdonald Langstaff, who earned her degree with honours in 1914, only to be refused admission to the Quebec Bar. In a speech which presaged the

above top
Jessie Boyd Scriver
She graduated from McGill in 1922, one of the first five women doctors to do so. Scriver was noted for her research on sickle cell anaemia and her contributions to prophylactic child care.

above
Annie Macdonald Langstaff
She was the first woman lawyer to graduate from McGill's Faculty of Law but was never able to practise because of the discriminatory Quebec laws of the day.

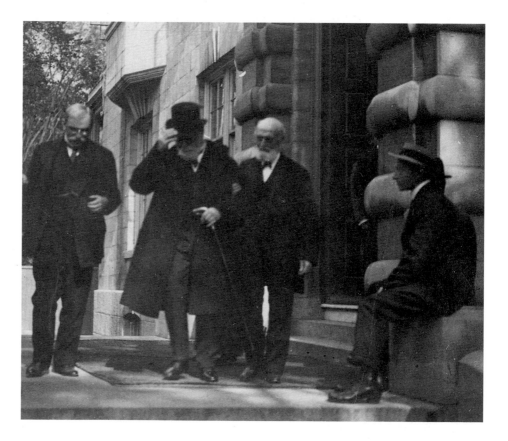

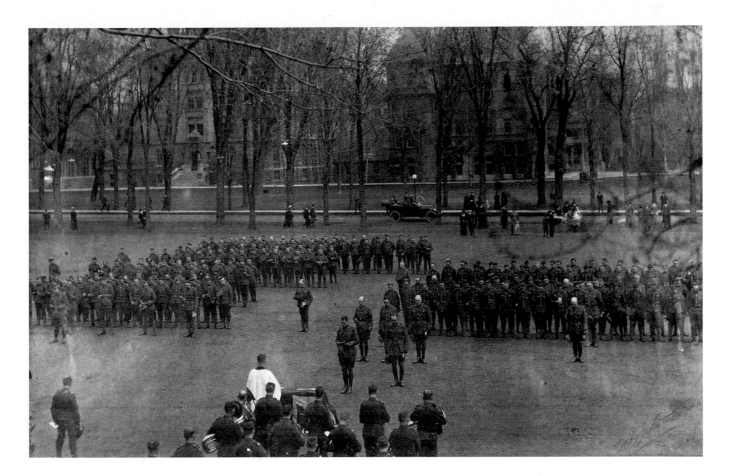

women's movement by over fifty years, she said of her plight: "It is all very well to say that women's sole sphere should be the home, but it shows lamentable blindness to economic conditions which one would think were potent. The plain fact … is that many women have to earn their living outside the home, if they are to have homes at all."

In the second decade of the century there is no doubt that there was a new leniency towards women at McGill, perhaps as much out of expediency as out of forward-thinking attitudes, for Canada was involved in a conflict whose scale was unlike anything the world had ever experienced. In consequence, any new approach that might help the war effort was deemed worthy. Even before the First World War broke out McGill had begun to mobilize for the cause: in 1912, for example, the first Canadian Officers' Training Corps had been established on campus. And following the declaration of war in August 1914, the Graduates' Society took on an important role, organizing the McGill Provisional Battalion to give volunteers a knowledge of military matters prior to their enlistment.

The horrific drama that was to be played out at Vimy Ridge and

above
The first Canadian Officers'
Training Corps was established at
McGill in 1912.

facing page
Sir William Peterson, Lord
Strathcona, and Sir William
Macdonald at the opening of the
Student Union Building on
Sherbrooke Street in 1906.

There are lots of trees and flowers
and the birds run riot all the
time : larks and nightingales
everywhere.

Speaking of larks reminds me of
the enclosed — it has had a (I
say it modestly) surprising vogue
and has been a good deal copied.
It came out in Punch last year.
and

The mail is just ready, so I
abridge. My love to you both,
and I look forward to the happy
days when I shall see you.

Yours
Jack

Letter from the front from John McCrae in which he refers to the success of "In Flanders Fields." Dr McCrae had come to McGill as a fellow in pathology. He served as a member of No 3 Canadian General Hospital (McGill) and died in France early in 1918.

Ypres and in other parts of Europe snuffed the life out of all-too-many emerging dreams. Of the 3,059 members of the McGill community who saw action in World War I, 363 did not return. Among them was Percival Molson, a scion of the famous family of brewers which had contributed much to the university. Captain Molson, killed at the front in 1917, had been an avid athlete as a student, and in his will he left $75,000 to McGill specifically for the construction of a sports arena – today's Molson Stadium.

As young men returned from battle McGill's enrolment surged, and the student population grew by 50 per cent. But the cloistered innocence of the prewar campus was gone forever. The world had been forced to grow up with brutal abruptness.

Still, perhaps in response to the melancholy years which preceded them, McGill was not immune to the deafening roar of the desperate good times of the 1920s. Student hijinks competed for attention with studies and activism. It was an era when the *Red and White Revue* – an annual satirical show put on by students – came into its own. "Never will I forget," reminisced Fred Gross in the Collard book of memoirs, "the vision of Izzy Asper, dressed in pink tights and a bouffant ballet skirt, galumphing gracefully through a forest (at least one or two) of potted rubber plants (or perhaps they were aspidistras)." One opening night, a drummer – "who had no doubt been fortifying himself at the Pig 'n Whistle on McGill College with the then favourite brew,

Frontenac Blue – joined the fray with such wild abandon that nobody could hear the music, which was probably just as well."

But for all the frolic, it must have been an exceptional time to be at McGill – for the student body reflected many of the changes that were taking place in Canadian society between the wars. The social and ethnic backgrounds of the students were increasingly varied, and there were new attitudes brewing on campus. These were epitomized by a group of articulate poets and scholars who shunned what they believed was the kind of imperialism that had kept Canada little more than a British colony. This was the era of the McGill Movement – which included students such as Frank Scott and Arthur Smith who produced the *McGill Fortnightly Review* between 1925 and 1927. In the pre-dawn hours in the campus coffeehouse known as the Pit, course books and half-full cups strewn about, the dour, bespectacled Scott and the analytical Smith would grapple with socialist theory, the nature of poetry, Canadian identity. Then they would pronounce in verse, editorials, and articles. It was a heady time.

The *Fortnightly* was an audacious journal, often protesting the smothering role of British imperialism on Canada's future. It attracted intellectual writers such as A.M. Klein and Leon Edel. The latter, still in

"At the time the Charleston and Black Bottom were de rigueur, but we also danced a thing called the drag." Fred W. Gross remembers the music of the twenties in E.A. Collard's collection, The McGill You Knew.

short pants when he entered McGill at the age of sixteen, would later write of the *Review:*

> Smith and Scott had in them qualities of discreet rebellion: they could not tolerate sham; they were verbal "activists" ... They didn't have to blow up buildings. They simply wrote shattering verse. They deflated. They debunked. We were called bohemians, rebels, Communists, smart-alecks. But we were read ... Perhaps literary history will see that within the echoes and imitations and fumblings of our young spirits and minds at McGill, within our exuberance and aggressions and wit, there was something as genuinely Canadian, something as local and rooted, as Bloomsbury was in Gordon Square in London.

Edel would go on to write the definitive biography of Henry James and become one of the major literary biographers of the twentieth century; Frank Scott, later McGill's dean of law, would become a renowned poet, lawyer, activist, and a pre-eminent influence on Canadian letters and culture; and Arthur Smith became one of Canada's finest poets. They were sculptors of Canadian thought, and theirs is a commanding legacy.

The exuberance of these years came to an end with the Great Depression. The musings of socialist students about poverty gave way to the grim realities of confronting the sudden poor, as visible throughout the streets of Montreal as elsewhere in the world. "Apple sellers on St Catherine Street, suicides on St James," wrote Phyllis Lee Peterson in the *McGill News* of her time as an undergraduate. "Students leaving college wholesale to look for jobs that were so scarce. The bright, gaudy canvas of the campus fading into sombre grey behind us."

Because there were so few jobs to be had, however, many students had no choice but to stay in school and to live as frugally as they could. Others survived the depression years with little financial difficulty. Some, such as J. Alex Edmison, who was president of the Students' Society in 1931 and graduated from law in 1932, elected to volunteer to help the destitute. "I met many ... transients when involved as a volunteer with the Bureau for Homeless Men and also the Prisoners' Aid and Welfare Society," he recalled in a poignant memoir. "I became associated with the University Settlement of Montreal, where one soon got acquainted with the devastating effect of the Depression on children. (While these years of extracurricular activities did sore damage to one's legal studies, I am forever grateful for the invaluable lessons learned in trying to cope with people in times of their distress.)"

As best they could in hard times, students of the 1930s made their

"Indeed I have always found that the only thing in regard to Toronto which far-away people know for certain is that McGill University is in it."
Stephen Leacock cited in
Colombo's Canadian Quotations

Lecture hall in the Redpath Museum

stay at McGill memorable and joyful. Because the undergraduate population was relatively small, numbering just above 3000, there was a strong sense of community. Students were fiercely loyal to the faculties in which they were registered and generally relished the intimacy of their small classes. They would gather in the Student Union to discuss the idiosyncrasies of their professors – Stephen Leacock was a favourite topic – and the concerns of the day. And they would revel off campus in notorious nearby watering holes such as the Pig 'n Whistle, the Corona, and the Club Tavern. It was an age of roadsters with rumble seats, raccoon coats, neck ties, fedoras, tweed jackets, spats, flannels, and beer jackets. Proms were still held, plays still mounted, faculty teas still arranged – all against the bleak backdrop of economic hardship and rising world tensions.

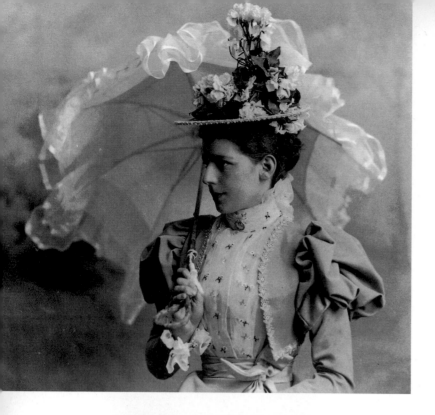

Students and student life

46

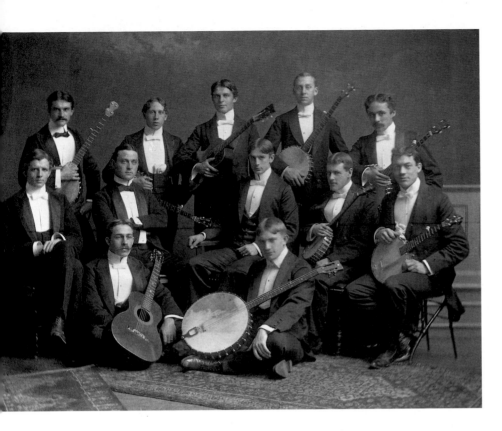

CUSTODIAN OF THE CLASS YELL

47

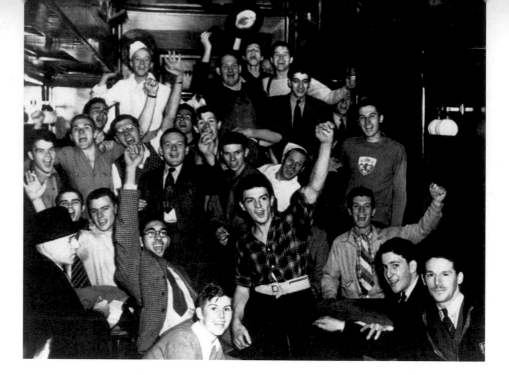

As their contribution to the war effort, some 500 students from McGill took the "harvest train" in the fall of 1942 to pinch hit for western farmers in the grain harvest.

Those tensions came to a head in September 1939, when Hitler marched into Poland and World War II began. Again McGill faced the gruelling duty of preparing for its part in the war effort. The Canadian Officers' Training Corps' enrolment burgeoned to 1400. Enlistments among McGill students were high. Eventually, over 3500 McGill students and graduates became part of the army, navy, and air force and about 2000 more participated in auxiliary services. Their roles were varied and important. Among them, for example, was Sgt Dorothy May Boyce, who received a B.SC. in 1940 and put it to use as a member of the Royal Canadian Electrical and Mechanical Engineers. After the war, she returned to McGill to become one of the first women to join the Faculty of Engineering. Then there was Lt Roger Kee Cheng, an engineering graduate of 1938, who was parachuted into the mountains of Borneo to help organize guerrilla attacks against the Japanese.

Meanwhile, those who remained at home were pressed into service as well. A compulsory Red Cross programme for women students was begun which gave them physical and first aid training. Many would go on to perform community work with hospitals and the Red Cross throughout the war. And Macdonald College became the site of a training centre for the Canadian Women's Army Corps.

There is also a poignant photo from that era, showing a group of raucous young men with Adam's apples and peach fuzz crammed into the spacious parlour car of a train, some proudly wearing sweaters with McGill crests emblazoned on them. With their raised fists and broad smiles, they look for all the world like rowdy undergraduates on their way to watch a football game at Queen's or Bishop's. In fact, they were off to the prairies and points west to assist with the wheat harvest in the autumn of 1942. When the "harvest train" pulled out of Montreal, some

500 students, mainly from the Faculty of Arts and Science, were on their way, largely to Manitoba and Saskatchewan, but also to Alberta and British Columbia. Participants recall that the young Montreal scholars did not always make the best of farm hands and there were many good-natured complaints about the work. But in a matter of three weeks, the harvest was brought in and the students returned to McGill to resume their studies.

Among the wartime "graduates" of McGill, there were two world-renowned heroes. It came about like this. In 1944, Franklin Roosevelt and Winston Churchill were to meet in Quebec City to discuss various aspects of strategy and war-related issues. McGill wanted to award them honorary degrees and Principal James proposed that they visit the university after their meeting. Such a visit could not be fitted into their schedule in Canada. McGill therefore decided to hold a convocation in Quebec City to confer the degrees on Roosevelt and Churchill. Agreement to this plan arrived only at the last possible moment. Caps and gowns were hastily prepared and diplomas inscribed. It was a display of the esteem in which McGill held these two leaders and a strong message of solidarity and support for the Allies. That support was also reflected in bitter statistics. When the war was over, some 300 people with McGill connections had lost their lives in the conflict.

When the war ended, many former students eagerly took up their

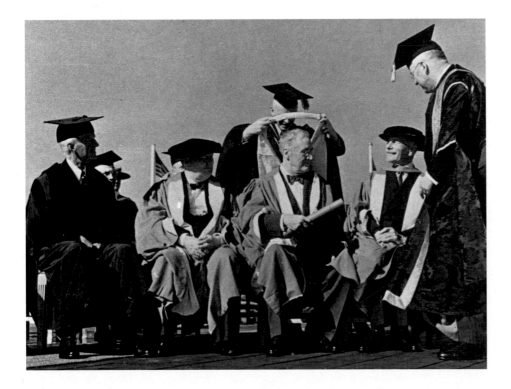

Winston Churchill and Franklin Delano Roosevelt received honorary degrees from McGill at a special convocation held in Quebec City on 16 September 1944.

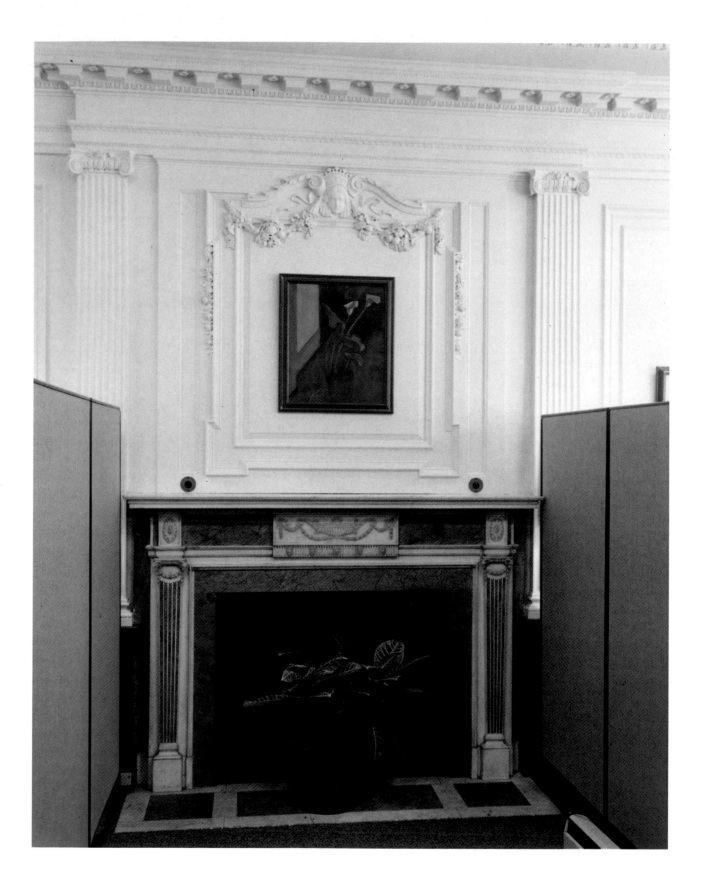

50

studies once again – and scores of veterans who had not attended university before the war decided to enrol. McGill chose virtually to guarantee admission to any qualified veteran from Canada, Great Britain, or the United States. The horrible reality of Nazi Germany had also driven home the need for more enlightened attitudes at home, and the de facto quota system that had limited Jewish enrolment at McGill in the interwar years was brought to an end in the 1940s.

The returning veterans were the first wave of a skyrocketing enrolment, with the number of students rising from 3,933 on VE Day to 6,366 in the autumn of 1945 and 8,237 in the 1946–7 session. If McGill had lost its Victorian innocence after the Great War, it sacrificed its intimacy in the years after World War II. Hordes of veterans descended on campus, looking to start new careers, new lives – bringing their dreams through the Roddick Gates.

In the Collard collection, Michael Townsend sets out the contrast. Before the war, he recalls:

> the crowded but cozy reading room ... in the Arts Building ... the smokers at the McGill Union on Sherbrooke, which were crowded and noisy and in which freshmen were supplied with five McGill brand cigarettes or Grads ... the times spent sitting in the sun on the Arts Building steps discussing with other members of a recently completed class the implications of what we had heard ... When we came back in the fall of 1945, the volume of our return irrevocably changed the character of the university, and our classes were of course marked by large numbers, changed learning conditions, and in many of us a new-found maturity ... I think that the war was a watershed in university days and the quality of life there was never recaptured. I think that, perhaps we are the poorer for it.

Women continued to consolidate their gains at McGill in the postwar period, entering previously forbidden faculties such as engineering. One outstanding graduate of the era was Blanche Lemco van Ginkel who won the Lieutenant Governor's Bronze Medal and the McLennan Prize for achieving the highest academic standing over two consecutive years. She became a town planner, won a Grand Prix in Vienna in 1956, and eventually became dean of the School of Architecture at the University of Toronto.

In the early and mid-fifties there was a resurgence of energy and spirit on campus as postwar confidence and a booming economy brought renewed optimism to all aspects of Canadian life. Students no longer enjoyed as contemplative, intimate, and sequestered an environ-

facing page
Marble fireplace on the ground floor of Martlet House, an elegant building with oak panelling, decorative carved heraldic animals, brightly coloured wooden friezes, and moulded plaster ceilings. Since 1972 this has been the home of the Graduates' Society of McGill University and the McGill Development Office.

RED & · WHITE REVUE

ment as they had once had, but they did develop a certain big city sophistication. It was this atmosphere that made possible the 1957 version of the *Red and White Revue* entitled *My Fur Lady*. In an earlier time, Frank Scott and Arthur Smith had urged Canadians to cast off their British baggage. Now, a new generation – students such as Brian Macdonald, Timothy Porteous, James Domville, Donald MacSween, and Erik Wang – was tired of the influence the United States seemed to be having on a Canada still in the process of finding itself. That influence had been particularly reflected in the recent editions of the *Red and White Revue*. The annual satirical show was laden with American references; it had a strong flavour of imported humour.

The situation particularly disturbed Tim Porteous who would go on to head the Canada Council. He urged his young classmate, the professional dancer, Brian Macdonald, to choreograph the revue and encouraged some of the cleverest minds on campus to write the material. The plot was a take-off on the Grace Kelly–Prince Rainier nuptials and the name, of course, a play on the title of Broadway's current hit. But the material was pure Canadian, covering such subjects as Westmount snobbery and the antics of the Senate. The success of the show was unprecedented – for one thing, it actually earned the Students' Society some money! And it was impossible to buy a ticket – even from a scalper. The group then decided to try to give the revue a commercial run and turned to the Graduates' Society for financing. Its

executive secretary, Lorne Gales, went out on a limb and arranged a $4000 loan. The run was a wild success.

By the sixties McGill was flooded with students, as the postwar baby boomers, the biggest demographic bulge in the history of the world, came to college age. By the late sixties, classrooms with fifty first-year students or more were all too common. The sheer press of the young was overwhelming – not just on the McGill campus but throughout the world. A robust economy in North America had given youth more freedom than ever before. And the young, looking at such problems as racial discrimination and the Vietnam War, were questioning common values.

It was a time of psychedelic dances at the Student Union on McTavish, a time of anti-war protest – and a time when casual drug use became commonplace. But it was also a time of serious social commitment. To the blaring sounds of Jimi Hendrix and the Beatles from the Union jukebox, students would discuss the war in Vietnam, the environment, the women's movement, the rights of francophone Québecois, and the running of McGill. The revolutionaries among them would have been just as inclined to throw their hats and boots at the once-

The McGill Daily

Established in 1911, it is the oldest student daily in the British Commonwealth. From the early days, when student sports were its main concern, the paper has matured to become an important source of information and comment on the issues of the day for its university audience. A stint on the Daily *is considered almost the equivalent of a degree in journalism, and many of its alumni have gone on to careers in the field. The* Daily *now publishes a weekly edition in French.*

coveted sheepskin as to trade for it. Many dropped out, discouraged by their apparent inability to "change the system."

Throughout it all, the student body generally tried to steer a straight course between the hyperbolic activism of its more radical members and the arch-conservatism of the more reactionary. Coming to the fore to help steer that course was Charles Krauthammer. He replaced John Fekete as editor of the *McGill Daily* at a time when the paper had sorely tested the university community's patience with the rhetoric of revolution. "The Daily is under the present editorship," Krauthammer wrote in his first editorial, "because it is committed to publish a pluralistic paper ... No one has a monopoly on the truth." Krauthammer, who became a paraplegic as the result of a swimming accident, would later go on to win a Pulitzer Prize for Distinguished Commentary in 1987 for his writing in the *New Republic* and *Time*.

The more sober 1970s and 1980s saw the return to a relative calm on campus which prevails even now. Still, while today's atmosphere may be more conducive to education, some mourn the apparent lack of student activism. The truth is, however, that the McGill community is as active in social causes as ever – and perhaps more focussed in some ways than the generation which graduated in the sixties.

Older McGill graduates such as Val Fitch and David Hubel have

McGill News

First issued in December of 1919, it is now published for graduates four times a year. Its colourful pages cover new developments on the campus, look back on the university's history, review books by graduates and teachers, and generally report on things of interest to those connected with McGill.

The Macdonald Journal

Founded in 1940, the Journal *is published quarterly by the Extension Service of the Faculty of Agriculture. It serves as an attractive source of up-to-date information on agricultural programmes and research at the college, from space station farming to the latest news from the Quebec Women's Institutes.*

brought great honour to their alma mater; Fitch received the Nobel Prize in 1980 for his work in physics and Hubel received one for medicine in 1981. More recent graduates such as Judy Kronick are quietly turning their careers to the task of improving their world: she is an instructor for the hearing impaired at Pierrefonds Comprehensive High School. By and large, then, the current McGill students and recent graduates are committed women and men, the former having found a home, fully 100 years after they were first admitted, in every faculty and club on campus. By 1970, the Alumnae Society had successfully lobbied for representation on the university senate and on the advisory council for part-time education at McGill. The society continues to play an active role in fund-raising and in women's advocacy within the university.

In fact, the passionate interest of both alumni and alumnae says much about the impact McGill has had on its students. Many graduates develop a lifelong association with the institution which nurtured and instructed them in their youth. They kept their boots and hats and won their sheepskins the hard way, through scholarship and devotion. Their stories are singular and absorbing, their relationship to McGill a testimony to their appreciation of the richness their student years added to their lives. The strand of humanity that is McGill moves on into the twenty-first century.

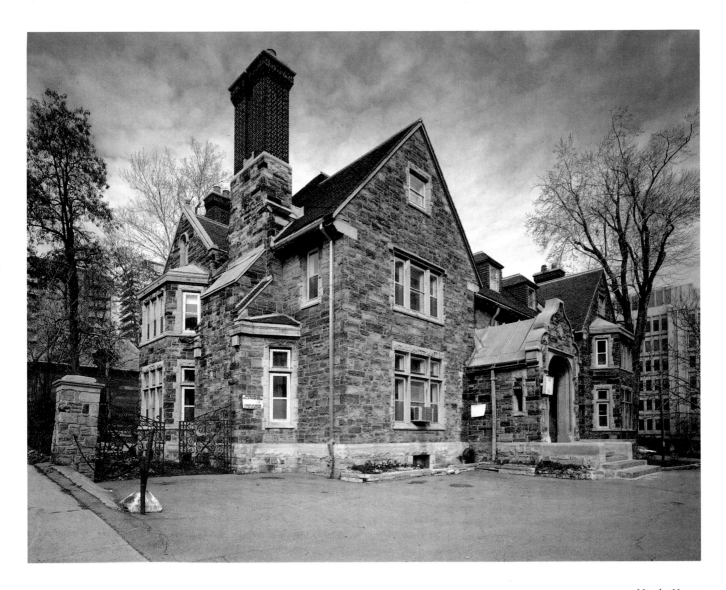

Martlet House

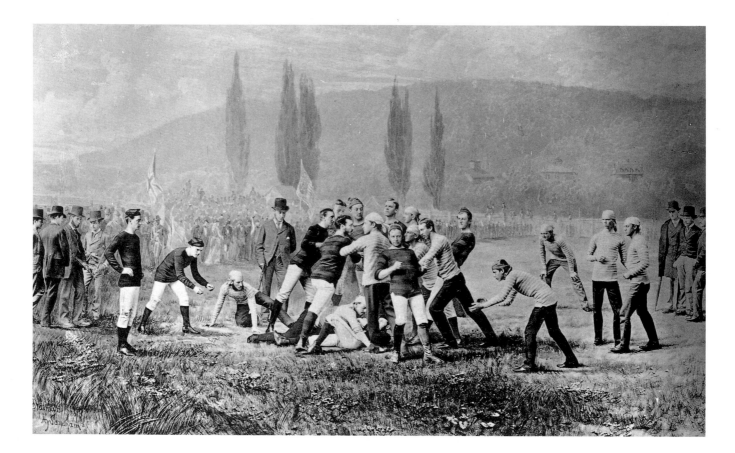

*Harvard versus McGill 1874.
This photograph is one of William
Notman's famous composite shots, in
which each figure is posed and
photographed separately. Harvard
and McGill played three games that
year, the first ever international
football games. The game had been
invented at McGill as an offshoot
of rugby.*

William Molson
One of McGill's early benefactors,
he provided the funds for the
completion of the Arts Building in
the 1860s.

of diversity harmonized into unity is still impressive. Robed in those mediaeval garments and flaunting those proud colours is as mixed a bunch of men and women, of conflicting interests, ulterior motives, and high ideals, as you could find in the company of Chaucer's pilgrims or on a cruise ship sailing down the St Lawrence. They walk together in the one procession because they share in the common cause.

LOOK FIRST AT THE GOVERNORS, in their black gowns with blue facings. They were the founders of our university, Montreal businessmen who needed education for their children and who were prepared to create and sustain the institutions which could supply that need. Led by that outstanding fur trader, general merchant, and bold entrepreneur, James McGill, they have been down through the years amazingly generous: the Molsons, the Redpaths, the Strathconas, the Macdonalds, the Birks, the McConnells, the McLennans, and a long, long list of other names, less well known, but each significant in their day, men such as James Ferrier, Thomas Workman, Hugh Graham, Edward Beatty, Walter Chipman, and Greville Smith.

Their motivations were admittedly seldom simon pure. In eighteenth-century Montreal, still unincorporated and only newly removed from frontier conditions, the need for some form of public education was clamant. Families urgently needed schools and colleges for their sons. (A hundred years later they realized they needed them for their daughters as well.) So McGill decided to endow a college, but our revered founder was moved not only by a sincere concern for young people (a concern evidenced by his care for them during his life)

64

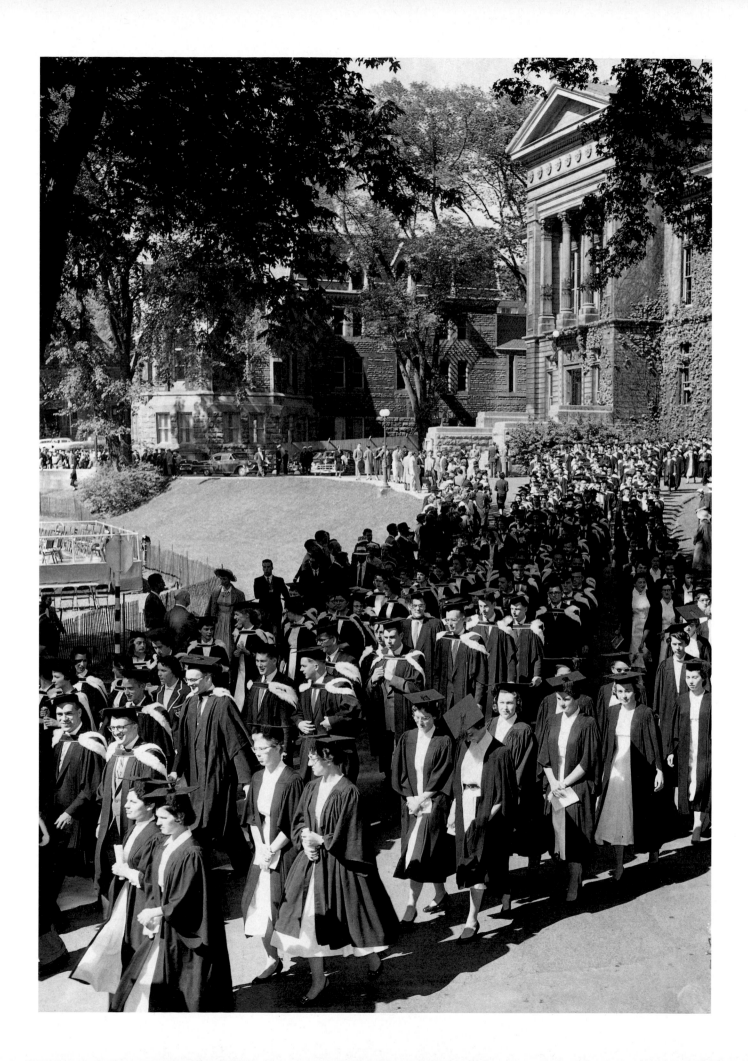

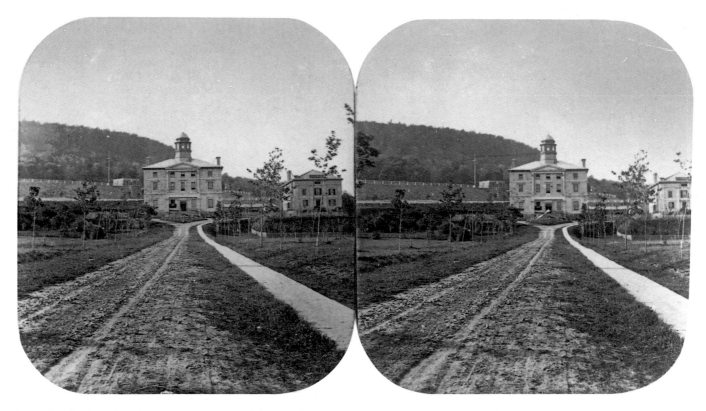

but also in part by the persuasions of the Reverend John Strachan that he "should do something for the glory of God and to leave a name behind him for following generations." He was careful therefore to stipulate that the said college must bear his name. Those who followed James McGill in the academic procession as governors of his new university were doubtless moved by a similar mix of motivations: proprietorial instincts, the warm glow of public esteem, the sweet smell of success – for to become a governor of McGill was and is a blue ribbon of career achievement. But the founder's genuine interest in the welfare of young people remains paramount. That is still what distinguishes McGill governors.

That concern was demonstrated in 1869, for example, when the Board of Governors would not or could not find the money and Peter Redpath offered to pay personally $200 a year in additional salary to the librarian to permit the library to be open daily from 10 in the morning until 4 in the afternoon, "except for a break in the summer if need be." Students, he believed, should not be cut off from their books.

Almost one hundred years later, in North America generally, relations between universities and the business world had soured very badly. Student activist leaders had made "the industrial-military-political complex" the main target of their abuse and had shown great

above
The Arts Building in 1859 – note Principal Dawson's sapling elms. This is one of the Notman stereoscopic photographs which produce a three-dimensional effect when seen through a viewer.

facing page
The chapel in the William and Henry Birks Building.

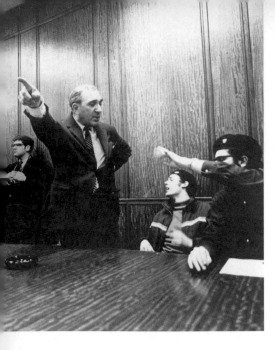

Student activism from the sixties to the eighties.

above
Professor Maxwell Cohen listens to arguments at a meeting of the Board of Governors in the tumultuous sixties.

skill in scoring their hits. Consequently, in business circles "university" had become a dirty word. Here in Montreal the same atmosphere prevailed. In the *McGill Student Handbook* for 1969, the McGill Students' Society published photographs and career profiles of the members of the board, listing their industrial and commercial interests. In particular they pointed to what they considered the governors' direct and indirect involvement in the Vietnam War. Those who compiled the list intended it as a rogues' gallery. Not even the principal was spared: his offence was participation in the affairs of Bell Canada.

The Faculty of Management was particularly vulnerable. It was a new venture and it was looking for its first dean. But who would want the job? The head of this enterprise must attempt to build bridges both within the university and with the downtown community; in return he could expect scorn and abuse from the student activists and a negative reaction from Montreal business. At that point Howard Ross, who was rounding out a successful career as president of the accounting firm his grandfather had founded, resigned as chancellor and member of the Board of Governors to undertake the unpropitious task himself. How thoroughly he succeeded is well known; but by his resignation as

governor and acceptance of the deanship, the sincerity of his commitment to the cause of education was put beyond question.

In those difficult times there were many others who equally demonstrated their belief in education and their faith in McGill by *not* resigning – men like Stuart Finlayson, who served long hours in what was then the thankless job of chairman of the board; Conrad Harrington, who against all odds raised funds for McGill in those unfavourable times and later served as chancellor; Anson McKim, who gave unstintingly of his time and expertise to help fashion the university's new pension plan; George Currie, who chaired a painstaking review of McGill-Queen's University Press; Peter Laing, whose concern for McGill far exceeded his responsibilities as university solicitor; and many more who stayed with the ship (and as often as not paid handsomely for the privilege!). Let it be said of them all: "In their day and generation they played their part well."

By the end of the 1960s it was nevertheless clear to everyone that the time had come for radical change. The selection of twenty-five or thirty successful businessmen who would meet behind closed doors was no longer a proper way to constitute the governing body of a university, even though five of them were chosen by the Graduates' Society. McGill was expanding greatly, experiencing significant changes in the ethnic mix of both its academic staff and its student body, and was increasingly supported by public funds. First, there should obviously be some women board members, and so in 1970 Claire Kerrigan became the first woman to be invited to join the governing body. At the

overleaf
Imposing entrances to the Faculty Club on McTavish and the Macdonald-Harrington Building on the main campus.

body. At the same time a determined effort was made to invite nominations from traditions other than the "white, Anglo-Saxon, Protestant" one; members of the Jewish and French-Canadian communities were among those who were first approached. These advances were so long overdue that the subsequent election to the board of Joy Shannon, or of Chief Judge Alan Gold as chairman of the board, or of Jean de Grandpré as chancellor, passed without comment – other than on their exceptional qualifications for their respective offices.

But these changes, desirable as they were, did not touch on the greatest need. Simply put, it was no longer appropriate that the principal should act as the only channel of communication between the board and the university at large. The proceedings and the powers of the board had to be opened up to the university community as a whole. It was agreed as a first measure that five members of Senate should be elected by that body to the board, and they were to be by common consent four faculty senators and (this was the radical notion!) one student senator; then the students demanded their own place in the decision-making body and were given four seats; finally in 1975 representatives of the non-academic staff were also seated. At the same time the board's meetings were opened to the university public. By these and similar developments the old atmosphere of oligarchic secrecy was dispelled.

Many observers thought that these changes, radically altering the structure and in particular destroying the exclusivity of the board, would lessen the interest of Montreal business executives in the running of the university: membership of the board could no longer be viewed as the entrée to an élite club. But this has not proven to be the case. Men and women like Fred Burbidge, president of Canadian Pacific, Rowland Frazee of the Royal Bank, Paul Desmarais of Power Corporation, Gretta Chambers, the influential Quebec journalist, Joan Dougherty, a former member of the Quebec legislature, Alex Paterson, QC, and Richard Pound, vice-president of the International Olympic Committee – these are a few of those who have served splendidly in the James McGill tradition in the years since the reforms came into effect.

The Board of Governors is now composed of some twenty-seven members of the Montreal community at large, seven representatives who speak for the professors, seven student members, and three non-academic staff representatives. Each of these groups has its own responsibilities or, to put it rather more realistically, its own interests to protect

facing page
Traditional elegance and modern functionalism live side by side in the Faculty Club, formerly the Baumgarten house, on McTavish.

and promote. Sometimes these interests are conflicting and compromises have to be found. That makes meetings of the board interesting and at times even lively. But over the past twenty years, retaining the leaders of business and the professions as the preponderant membership of the board has proved its worth. McGill continues to receive sound advice and seasoned leadership, and the public is assured that the university continues to do what it was founded to do, that is, to offer to each new generation a first-class education.

NO ONE NOWADAYS RECKONS to look to the lay members of the board for academic innovation and leadership. In the 1840s, led by James Ferrier and Peter McGill, the board provided vigorous leadership in all areas of the university's concerns. The governors called for commercial subjects and laid new emphasis on languages and law. But then John William Dawson was appointed principal in 1855. Dawson at once became a full colleague of the men who had appointed him, and he shared their basic

William Dawson
When he arrived at McGill in 1855 to take over as principal, he described the campus as he first saw it – unfinished, partly in rubble, overgrown by weeds and bushes and pastured by cattle. Dawson was the key figure in the development of McGill as a university of international excellence. He was knighted by Queen Victoria in 1884.

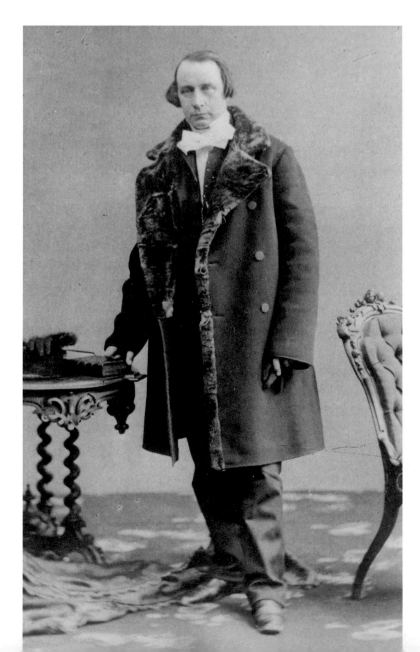

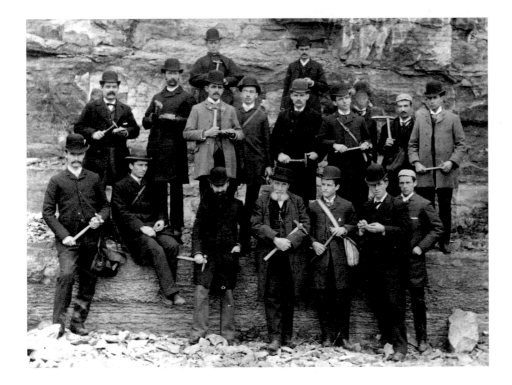

Dawson, front row centre, with his geology group in a quarry at Lachine in the 1890s. Throughout his thirty-eight years at McGill, he continued to teach the geology and palaeontology courses, as well as various other classes from time to time.

concern for education wholeheartedly. He also quickly became the main source of academic initiative and leadership. The role of the governors in the academic area became to supervise and confirm rather than to initiate. That function passed to the principal and his colleagues, meeting in the Senate.

As we watch the academic procession pass by on convocation day, we see that the principal comes last of all, side by side with the titular head of the university, the chancellor. The principal has that place of honour because it is appropriate to his office, and in almost every incumbency, it has also been appropriate because of the quality of the man in office. McGill has been extraordinarily fortunate in its principals, for each has been in his own way an outstanding personality, a man of intellect and vision.

Dawson himself was a giant of a man. Primarily he was a scientist, in the golden age of burgeoning disciplines when a "naturalist," as he preferred to call himself, could be a botanist, a zoologist, an ichthyologist, an ornithologist, a palaeontologist, and a geologist, all combined in one. Although he settled in later life for palaeontology and geology, he never lost his interest in those other fields, and as opportunity offered he was quick to make junior appointments and assign to younger minds those parts of his responsibilities he could no longer adequately care for himself. But Dawson still had time to interest

himself, alongside his scientific preoccupations, with education on the grand scale. He envisaged a system of primary schools in towns and villages feeding their brighter pupils into district high schools, and these in turn passing their more advanced pupils on to academies and colleges, which would take their curricula and their standards from the university at the apex of the pyramid, whither they would in due course send their best qualified students. To make the whole scheme a reality, he set up the McGill Normal School to provide qualified instructors in primary and high schools and instituted the McGill High School Leaving Examinations (which lasted into the 1960s) and the First and Second Year McGill Curricula for Colleges, thus ensuring quality education at those levels. On successful completion of these courses, students from all over Canada could seek entrance to McGill University in the second or third year of the four-year degree course. From Newfoundland to British Columbia his scheme worked and resulted in a tremendous stimulus to education in the new Dominion of Canada. Dawson's McGill was Canada's national university.

Dawson was principal for thirty-eight years and was followed by a man as unlike himself as could be imagined. Dawson was a Nova

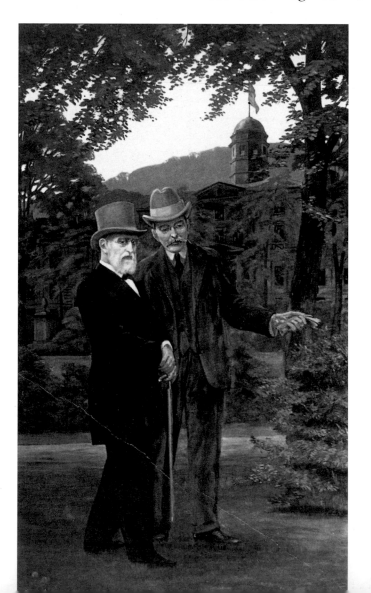

Sir William Macdonald and Sir William Peterson discussing, no doubt, future plans for the university, in a painting believed to be by Percy Nobbs.

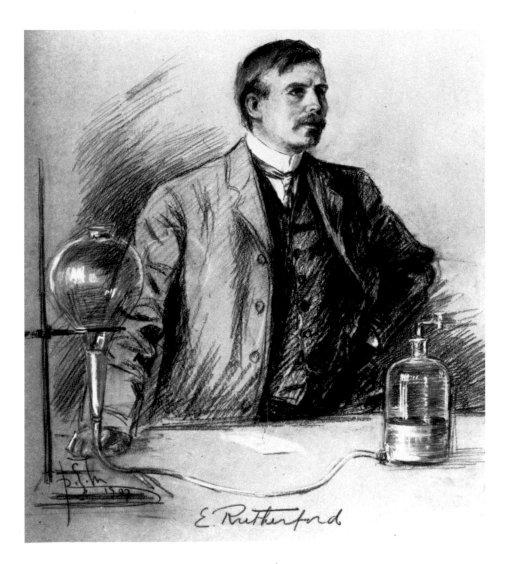

A 1907 sketch of Ernest Rutherford at his lab in the Macdonald Physics Building. Rutherford's deceptively simple looking apparatus can still be seen in the Rutherford Museum on the third floor of the building.

Scotia Scot, as Canadian as his Acadian rocks; William Peterson was also a Scot but a classicist, anglicized by his years in Oxford and thoroughly imperialized by his sense of British heritage. He served Canada loyally – because it was a farflung outpost of empire. For twenty-five years he worked unselfishly and farsightedly for the best interests of McGill, whose essential worth he never for one moment undervalued. In the years prior to World War I, the 1890s and 1900s, the universities of the world were belatedly trying to catch up with Germany in the development of scientific institutions. Peterson, classicist though he was, determined that McGill must lead the way in Canada. In his days, Rutherford was brought to the new Physics Building, a new building was erected for chemistry and mining, new courses were established in applied science, and, after the great fire of 1907, a new complex was completed for engineering. Aided and financed by William Macdonald, and given sound advice by his professors of physics and chemistry, Peterson, without ever losing his love for the classics and the humanities, saw to it, despite bitter criticism from conservatives on

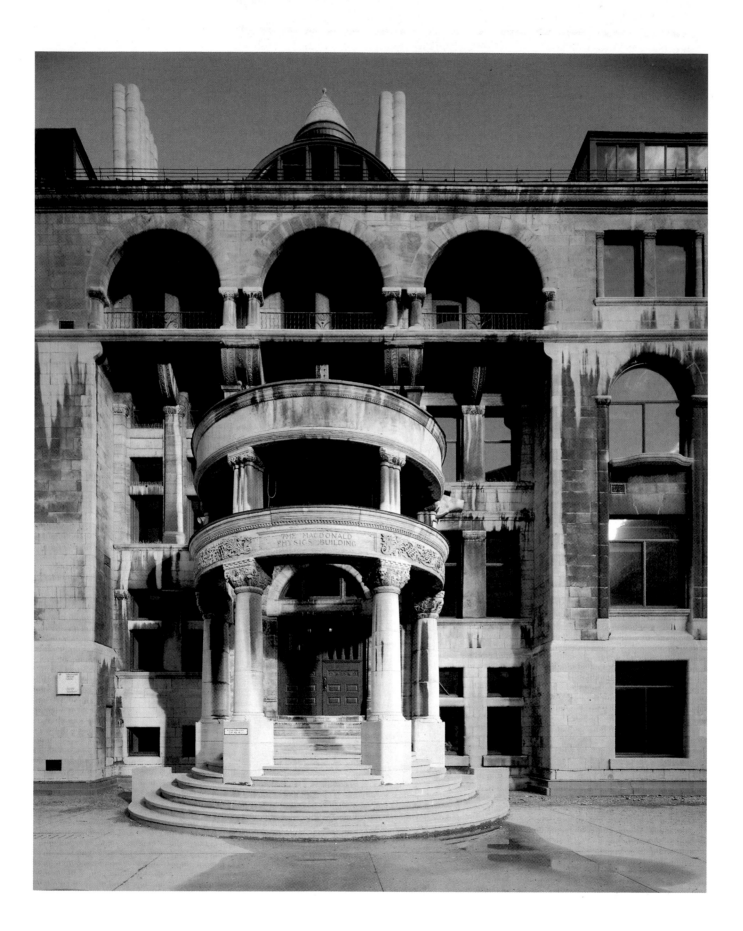

campaign, that in the years leading to 1914 McGill took its place among the foremost scientific institutions of the world.

A stint at school teaching, a few years as a realtor, and an enthusiasm for weekend and summer-camp soldiering hardly seemed a sufficient training for a commanding officer called to endure four years of bloody trench warfare, but Arthur Currie was one of the few generals of the First World War to retain his sanity and his military reputation and, despite detractors in the House of Commons, to return home with a hero's stature. But was all that enough to make him an acceptable principal for a university? McGill took a terrible gamble, and against all the odds events proved that it was. Within a few short months, Currie had won the allegiance of his professors as soundly as he had that of his officers on the Somme, and he showed great tact and generalship in nursing McGill through the difficult postwar years, the stock market crash of 1929, and the beginnings of the Great Depression. His greatest gift was to breed in his students and their professors an immense loyalty to their alma mater.

Currie died in office 1933. And at that point the figures in the principal's spot in the academic procession grow somewhat dim and confused. There is the pale ghost of Arthur Eustace Morgan who lasted only eighteen months, and the now-you-see-it, now-you-don't figure of Lewis Douglas, who came and went in two years; and both are hard to glimpse because the chancellor of the day looms so much larger. The chancellor in question was the redoubtable Sir Edward Beatty, who said at one point, "We don't need an acting principal – I'll do it!"

And so he did, for the best part of a decade, but then a new figure

slipped modestly into the principal's place, a young Americanized Englishman and, of all things, a political economist. In 1939 Frank Cyril James found McGill a place of great traditions, but one inclined to look to the past rather than the future. Even though it was wartime, or because it was wartime, James set about disturbing that conservative sloth, and by the time peace returned he had the university ready for innovative developments on every front. He met the challenge of the returning veterans (who doubled McGill's size in a single year and threatened to overload all its resources) by securing federal grants to cover their overhead costs and by establishing an "instant college." He set up a satellite campus twenty-five miles away at St Johns; he named it, after his great predecessor, Sir William Dawson College, but the students affectionately called it Dawson City because of its remoteness and spartan facilities – even so they loved it. In the fifties, James kept abreast of the postwar knowledge explosion; he founded new departments, encouraged new disciplines, and welcomed new enthusiasms in old ones, from geography to experimental surgery, from psychology to pure maths. For twenty-two years he continued to

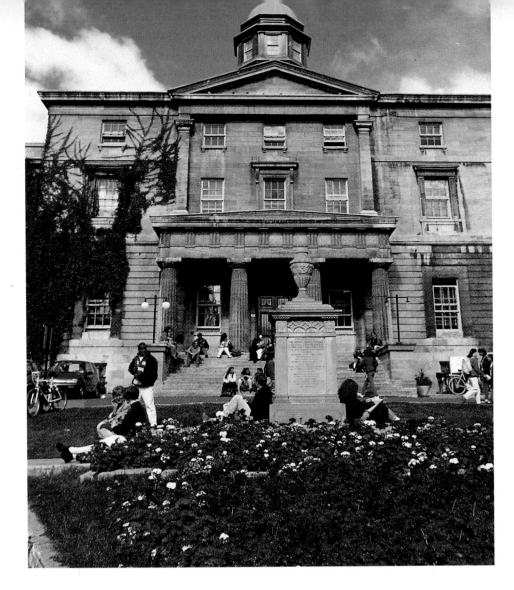

surprise McGill and stimulate its intellectual development in a manner worthy of Dawson himself.

The one thing James was not prepared for was social change, and it was perhaps fortunate for him that his reign ended in 1962. Harold Rocke Robertson was the man for the new hour – or, rather, the new decade. A McGill graduate, a war-tested veteran, surgeon-in-chief at the Montreal General Hospital, Robertson was a man with his roots deeply in Canada, a man with a sense of humour, and a man who had learned how to be patient. He came to the principal's job with great dreams for the university's academic advancement. In medicine, law, engineering, the wet and dry sciences, great progress was indeed made in the Robertson years. But academic achievements were overshadowed by the social upheaval on campus, and by the political reverberations echoing in Quebec. All over the world, as the aftermath of two global conflagrations and of continuing brushfires in scores of countries but especially in Vietnam, students were in revolt and the movement spread inevitably to Canada and to McGill. This was the force which broke down the doors of the governors' closed meetings and ended the

above left
James McGill's tomb stands in front of the Arts Building. The original sandstone deteriorated over the years and in 1971 a granite replica was erected.

above
Harold Rocke Robertson
As principal from 1962 to 1970, he guided the university through the difficult sixties.

the fore, for there are some notable shots to be taken there. At the head of the procession are the young, cocky assistant professors, well aware that they are the wave of the future and therefore inclined to break ranks – but they are kept in due order by the seasoned university marshal in his robes, and by his Scarlet Key helpers, in their scarlet gowns. (It used to be Scarlet Key men in red and white woolly football sweaters and the Red Wing women in red blazers and white skirts but nowadays we are all one honour society together.) After the assistants come the associate professors, a bit bruised and battered after twenty years in their chosen profession, pretending to have a hard job fighting off cynicism, but in reality trying to suppress any overt expression of the enthusiasm which will keep welling up within them, especially on a day like this, when (as they will hasten to tell you) they have only come "because some of my graduating students expect to see me." But the reality is that they have come to see for themselves their students receiving the reward of success and to share in their joy, and to indulge a private regret at seeing these students go, even though they know that a new class, possibly even better and more promising, awaits them in the fall.

"Scarlet Key men in red and white woolly football sweaters."

And here are the full professors, discipline by discipline, faculty by faculty, grave and reverent men and women, pondering whether their

doctoral candidates will fulfil that earlier promise, whether the inter-
viewing committee in Wisconsin will read sufficiently between the
lines to know what that carefully worded judgment on a former student
really signifies, and, above all, whether the idea newly conceived is
really important enough to start one on the drudgery and the loneliness
and the unparalleled thrill of giving birth to a book – but the lines are
beginning to move and they must give their attention to the convo-
cation. They must be awake enough to applaud their own students as
they cross the stage, and who knows, the convocation speaker may even
say something worth hearing!

　　We recognize some of those faces. Many will pass in the general
blur, but those to whom some personal memory is attached stand out. A
student forgets all the professors he ever listened to, except the one
who stopped long enough one day to say: "That last paper of yours, the
first half wasn't bad but you threw away your opportunity to write a
really first-class answer by skimping the research in the second half. I
expect you were under pressure, so I marked you on the first half. But
that's the last time, mind!" Then there are the teachers who stay in the
memories of many students because they were endowed with show-
manship. Generations of McGill students, from 1910 to 1936, found that
their memories gathered around Stephen Leacock because of his

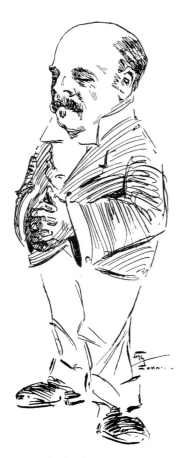

Charles Ebenezer Moyse

infectious humour, his engaging grin, his readiness to enter into schemes, whether for a new number of a campus publication of doubtful reputation or a new society of impeccable academic propriety. Once Leacock found he could write humorous books which sold well, his enthusiasm for devising a profound new political philosophy went into serious decline, but his enthusiasm for his students' well-being was fully sustained. A little farther back in the line is Charles Moyse. His lectures in English language and literature greatly impressed one of his students, Hugh Graham, who went on to found and edit the series of newspapers which became the *Montreal Star*. When the Arts Building was reconstructed in 1925, Graham offered to pay for a large lecture-cum-concert hall which the university badly needed. The one condition was that the hall should bear the name of Charles Ebenezer Moyse, the teacher of the language which had brought Graham his wealth and reputation.

One of the most significant facts about today's long line of professors is that the vast majority of them are members of the McGill Association of University Teachers. When it was first introduced in the 1950s it was seen as a radical, anti-establishment group, but by the early 1960s it had grown respectable. When the students attacked the privileges of the board in the late years of that decade the association drew up a paper embodying the professors' ideas on how the university should be governed – that is, how the interests of the governors, the professors, and the students should be accommodated and given their equitable place in the whole. Maxwell Cohen of the Faculty of Law was one of the moving spirits. A conference of representatives of the Board of Governors and the Senate was appointed to receive this and other briefs – one was presented on behalf of the Students' Society – and out of these deliberations the new order emerged. Since then further modifications have been thought desirable from time to time, the latest changes having been adopted in the spring of 1990. The statutes of McGill University are not cast in stone, but are re-examined and reshaped every few years. The great change came in 1968, however, when the prominence of the professoriate on campus was formally recognized and the academic staff was given its rightful place on the governing board.

Of course, the older professors said that it did not really change things. The professors always had been, and always would be, the sine qua non of the university, whatever the statutes might say. As Frank Scott used to put it, a university is a community *of* scholars run *by* scholars *for* scholars – he had no doubt who really ran McGill.

IF YOU LOOK HARD, and you know where to look, you will also see in the convocation procession representatives of the university's "fourth estate." They are not very many and not very prominent; they are members of the university's non-academic staff, the secretaries, clerical workers, administrative assistants, professionals, tradesmen, technicians, library assistants – the men and women without whose skill and expertise the modern university could not function. Some of them are represented by the McGill University Non-Academic Staff Association, others belong to trade unions, and yet others to no association. The "fourth estate" is a very heterogeneous group, but it is right that they should be represented on the Board of Governors, for their careers and their financial prospects depend just as much on the well-being of the university as do those of the professors. Moreover, down through the years they have exhibited a great respect for and an immense loyalty to the university they serve so well. They have truly earned their place in the convocation procession, from the time of Margaret Ward, who was appointed the university's first "typewriter" in 1891, to Bill Gentleman, the omniscient Arts Building janitor of the 1930s and 1940s, to George Grimson, who handled the university's finances superbly in the building boom of the 1950s and 1960s, to Margery Paterson, who had served in the Registrar's Office "with love" for more than forty years when she retired in 1987 – we salute them and their colleagues as they too pass in line.

WHO REALLY RUNS THE UNIVERSITY? The answer, of course, is that they all do. No one part of the university, which has that other glorious title, "The Royal Institution for the Advancement of Learning," can claim it is the whole, not even the Board of Governors. But as long as all those who are represented in the convocation procession, whether they wear academic gowns, lab coats, overalls, or blue jeans, know that the title belongs to them as much as to any other, the university will continue faithfully to fulfil its high purpose, and those who join the line in good faith will find deep satisfaction and a rare enjoyment in their participation.

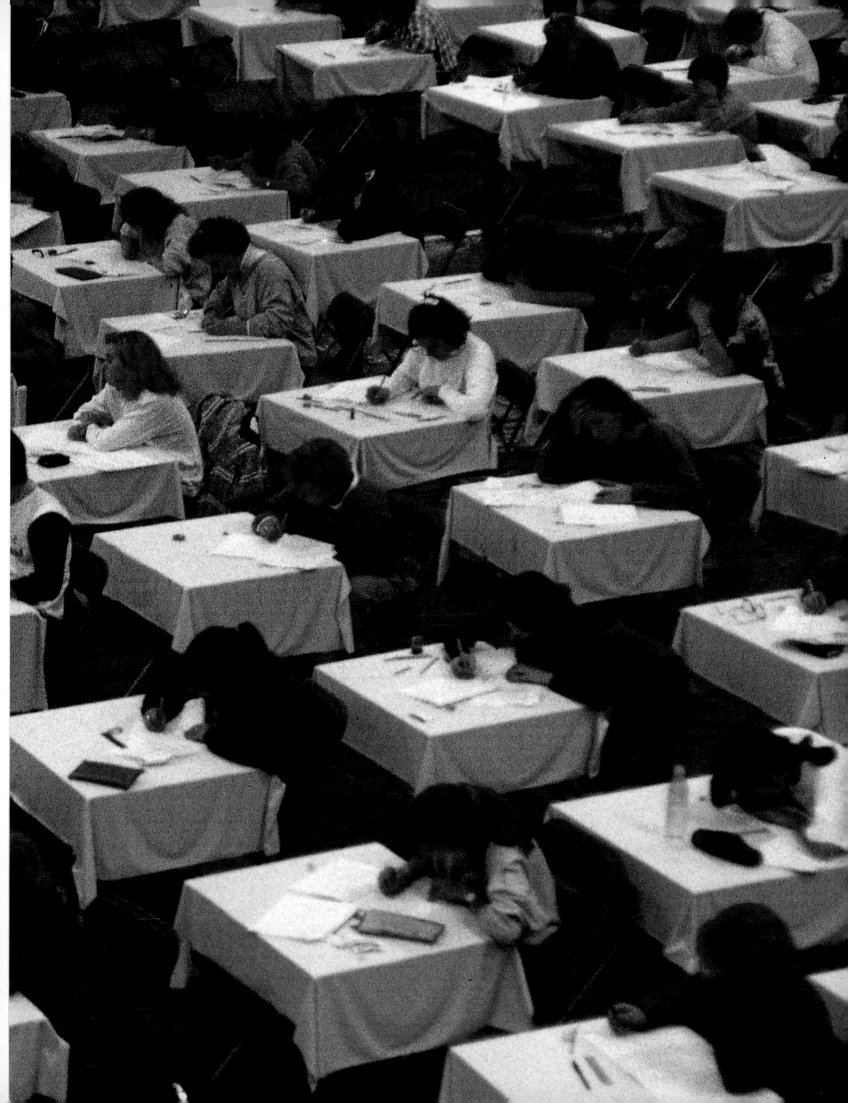

with the help of a bursary loan from McGill, they launched me into the second year of the Honours English course, with the idea that I might eventually qualify as a high school teacher. Alas, fame and fortune as a writer had turned out to be more elusive than expected. I was now eighteen, and my literary works consisted of one prize essay, a number of botched beginnings, and a novella rejected kindly but firmly by a New York agent. Becoming a great author was clearly going to be a little more difficult than I used to think. It might also be less lucrative. (The essay prize, a book on the lives of great composers, was my total profit to date.) So, though I continued to "scribble, scribble, scribble," I plodded towards a teaching career.

It was 1942 when I entered McGill, so male undergraduates were very thin upon the ground. Most of our instructors were women or grandfathers, and many a sigh went up when the attractive young Professor Ted Newton resigned, abandoning Romantic poetry to join up. However, these conditions perhaps made concentration easier. At the end of that year I won a faculty scholarship.

. . .

In my third year, I took four English courses, two of them taught by Professor H.G. Files. This mild New Englander was not a flamboyant lecturer, but he illustrated with every quiet word, every modestly proffered line of speculation, what a first-rate humanist scholar is. A classmate told me that he gave a course in creative writing for fourth-year students – only fifteen of the many applicants were chosen. So much did I want to be one of them that somewhere I found the courage to approach him with a story I'd written. It was a family joke that as a toddler I'd been too timid to step off the paved path onto the grass, and since then I hadn't changed much. But Dr Files not only approved of the story, he passed it on to that year's editor of the campus magazine, *Forge,* where it duly appeared.

One of the stories that I wrote while in Files's creative writing class was a little sketch called "Martha and God." This became my first published work that actually brought in cash: *Saturday Night* paid a dazzling $50 for it. Mightily heartened by this, I started work that summer on my first full-length novel, *The Unreasoning Heart.* It had not been long under way when I read in the *Star* that Dodd, Mead and Co of New York were opening their annual Intercollegiate Literary Fellowship of $1200 to Canadian as well as American students; so as soon as my manuscript was finished, I sent it off to them.

Meanwhile, I completed my fourth year, paying off my bursary loan by working in the library and tutoring. This last year was enriched

CONTENTS

FICTION

Hunger Constance Beresford-Howe, B.A. 3 4
The Mirror of Valiki Joy Powles, B.A. 3 8
The Uninvited Martha Chadwick, B.A. 4 . . 13
Fugue for Five Fingers . . . Ralph Notman, Med. 2 20
Father Lameau Douglas Archibald, B.Eng. 2 26
Cocktail Nocturne Dorothy Taylor-Stoll 29
Vengeance Mona Adilman, B.A. 3 36

POETRY

Nationalism Anthony Frisch, B.Sc. 4 . . . 6
Curve of Life Irwin Shulman, B.Sc. 1 7
Two Translations Irving Massey, B.A. 4 12
Moonlight Allan Thomson, B.A. 4 17
Intimations of Spring Irwin Shulman, B.Sc. 1 24
Hypothesis Anthony Frisch, B.Sc. 4 . . . 25
Hymn of the Unknown Soldier Helen Leavitt, B.A. 3 35

ARTICLES

Gershwin's America Richard Goldbloom, B.Sc. 4 22

Forge *1944*

facing page
The stained glass windows in Redpath Hall.

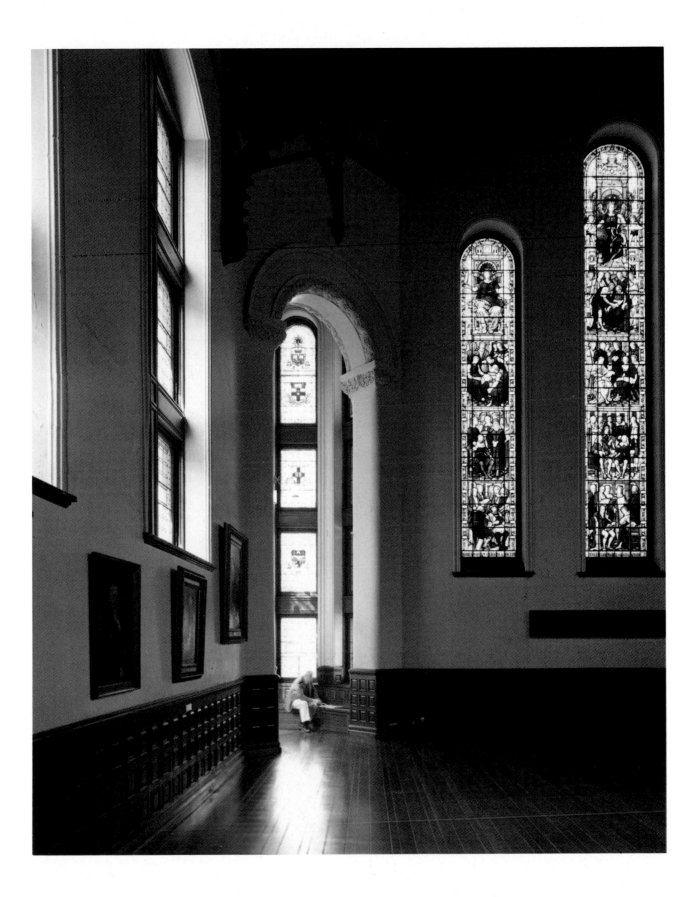

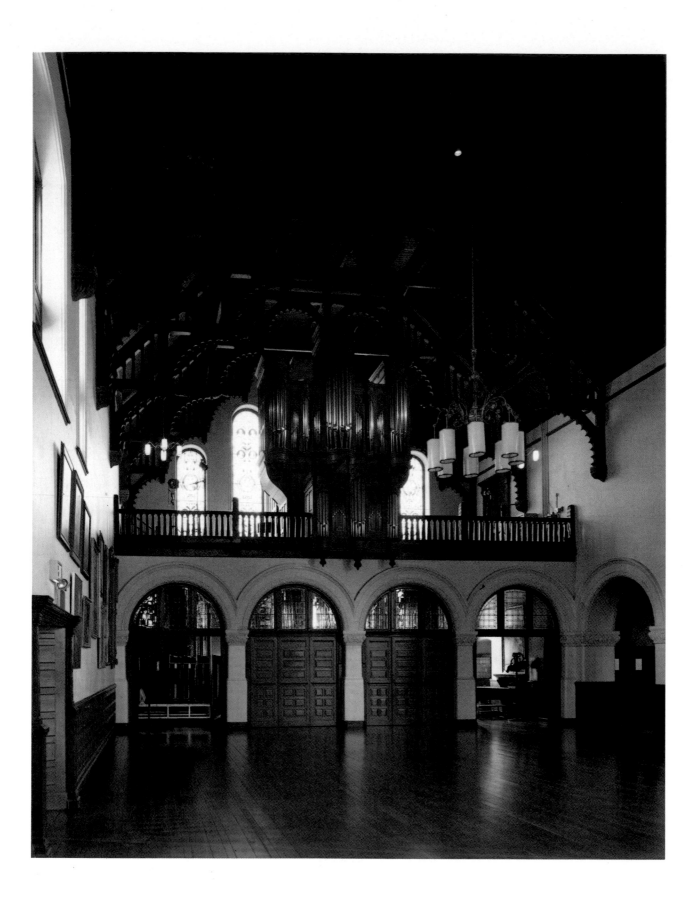

94

by the growing friendship with Harold Files and also enlivened by a new young instructor, Gertrude Mason. She breathed such passionate life into Anglo-Saxon literature, Chaucer, and the Jacobean dramatists that her students couldn't easily avoid becoming infatuated with them – and sometimes with her. The stimulus of working with these two had the interesting if peculiar result that I actually enjoyed writing the final exams they set.

By this time my half-hearted plan to become a high school teacher had melted away. Partly because I wanted to be, like Gertrude, a university instructor. And partly because when, out of a sense of duty, I sat in on a lecture on the philosophy of education (a required course for secondary school teachers), I found to my dismay that I couldn't understand a word of it.

The telegram from Dodd, Mead was phoned in one May morning while I was brushing my teeth. Mother appeared at the bathroom door looking stunned. "You've won. Go to the phone. You've won," she said. "Won *what?*" I demanded. During the fever of final exams, I'd truly forgotten all about the Literary Fellowship. The operator had to read me Edward Dodd's wire twice before I could believe it.

Only a few days later, Gertrude rang to say, "I shouldn't be telling you this, but you've got a First. And that *ain't all.* Come you downtown at once and I'll give you a boozy lunch at Aux Délices."

A week or two later, capped and gowned, with a little cluster of white roses from my parents, I crossed the platform to be granted my degree. The "ain't all" consisted of the Shakespeare Medal for highest standing in English and the Peterson Prize for creative writing. What with my long name and all the rest of the announcement, I had to stand before the chancellor and the other dignitaries for what felt like hours. Perhaps amused by the tiny size of the new graduate, the audience gave her a warm round of applause – her first.

…

It was 1949. I had a brand-new PH.D. from Brown University and an appointment as lecturer at a salary of $2400 a year. Confronted with the thought of standing up in front of a class, I also had a pair of very cold feet. I was still so shy and looked so juvenile that my first days on the McGill staff were full of absurd and embarrassing encounters. When I turned up for my first day of faculty duty, I was beset by a crowd of senior students who tried to invest me with a large green freshman badge and a beanie with a propeller on top. Then, when I took refuge in the staff room, I received stern glares from the elderly professors in the big armchairs there. How to explain my intrusion? I crept away,

facing page
The beautiful organ in Redpath Hall, built by the Laval organ-maker, Helmutt Wolff, in 1980. One of the first of its kind in North America, its design is based on that of the French classical organs of the eighteenth century and its sound recaptures the distinctive voice of that period's music.

"A male fortress"
A sketch by Arthur Lismer in the
Faculty Club.

unable to do it. Soon after that, I acquired a long black academic gown and wore it everywhere on campus, even to the washroom. And before long, to my relief, I found I could actually face a class without sinking through the ground or rousing anarchy. It was the beginning of a long and happy teaching life.

The most enjoyable part of the workload was a new course in creative writing I'd been asked by Harold to construct for second-year students. I met these classes twice a week, and saw each student once or twice a month for a tutorial conference in my office – a small room off a flight of iron stairs backstage at Moyse Hall. Louis Dudek had the room across the landing. Our students had to make a long subterranean trip through the Arts Building locker rooms, or ooze through Moyse Hall itself, braving the fury of whichever professor was lecturing there at the time. And once arrived for their appointment with Louis or me, they found themselves partly immersed in floating tides of economics lectures or rehearsals of the McGill Chamber Orchestra, but also isolated, in an almost dreamlike way, from everything else going on in the building.

In those postwar years, McGill was full of ex-servicemen completing their education on government grants. Many of my creative writing students were men my age or older, and this naturally led to a number of romantic complications very bothersome to all concerned. With my master's gown, I'd adopted what I hoped was a forbidding, cool, impersonal manner, but neither of these defences proved worth a damn. A French-Canadian radio operator and a lame RAF veteran were among the various persistent haunters of my backstage hideaway. In fact, the RAF man followed me to England when I made my first trip there next summer and was discovered waiting on shore when my ship docked. And of course, I'd left my monastic gown at home...

At that time, McGill's faculty was predominantly British in origin and outlook. When senior academic posts were advertised at all, it was in the *Times Ed. Supp.,* and Principal James interviewed applicants on his annual trips to the U.K. These homesick recruits from England and Scotland lived at or frequented the Faculty Club, which for years they

Royal Victoria College
*"Dedicated with wonderful zeal to
the preservation of virginity."*

preserved as a male fortress. Female members could use only a small upstairs lounge and dining room. The panelled main dining room, the pool room, the ballroom, were all barred to us. This led to absurdities like having to ask the porter for permission to cross the ballroom if you were a woman on a committee scheduled to meet at the club. Of course, the third-floor bedrooms were also forbidden territory. A sternly worded notice to that effect was posted in the ladies' cloakroom, and I used to wonder what lady could ever be needy enough to rush up there bent on seduction.

The Royal Victoria College was another place dedicated with wonderful zeal to the preservation of virginity. When a student returned with her date to the residence (she had to sign in by eleven), a powerful light bulb over the door discouraged any lingering goodnights. Male students could be invited to chaperoned teas or dances, but on these occasions the elevator to the rooms upstairs was locked.

Most of these peculiar McGill conditions amused me, but some were less funny than others. Our salaries, for instance, in those days were indexed to gender. It was blandly assumed that female members of faculty were more or less temporary staff. After all, women were unstable creatures, more than likely at any time to marry and resign to raise a family. Those who remained single lived inexpensively at home with their parents until they married and resigned, etc. The fact was that in our department, three of the four women did live cheaply at home with their parents, and one of these did eventually marry and resign. My own salary was kept particularly low because the administration (always hard-pressed financially) knew that I could and did supplement it by writing. Understandably, women were among the most active founding members of the McGill Association of Univer-

97

sity Teachers, a union formed in the 1950s. Some of us benefited quite dramatically from its good work in establishing floors for salaries at the different ranks.

...

The 1960s brought social turmoil to McGill of a kind that surprised and disconcerted me. I wasn't ready at all for the sudden emergence of student activism or the pervasive smell of pot on campus. Even more disturbing was the political tension developing in Montreal. Separatist bombs, real and imagined, began to create a sense of nightmare. My husband, Chris Pressnell, with his colleagues daily checked their high school classrooms in response to phone threats. Even in primary-school playgrounds children had to be herded into the cold where they could be heard plaintively asking, "What's a bomb?"

...

One autumn night, the city police walked out on strike, leaving Montreal open to hours of looting and violence. By this time we were the parents of a baby boy asleep in his crib upstairs. Not long after that night we made the reluctant and difficult decision to leave Quebec.

Most of our friends thought we were taking too dim a view of the future, and as if to prove them right, Robert Bourassa was elected premier just before we left. But it was barely three months later that James Cross was kidnapped and Pierre Laporte murdered by cells of the FLQ. Now, whenever I'm tempted to feel homesick for Montreal and McGill, I think of the security guards posted at the Arts Building pillars searching handbags and briefcases; or Joyce Hemlow's letter describing the roof-top sharp shooters watching for violence during Laporte's funeral.

We have enjoyed bringing up our bilingual son in relaxed, cosmopolitan Toronto. In 1969–70, I had a year of leisure in which to write *The Book of Eve,* the first in a series of three linked novels. After that I joined the staff of Ryerson Polytechnical Institute, where I still teach English literature and creative writing.

Often, of course, I dream that I'm back at McGill. I see the campus golden in October, crowned by that absurd little cupola on the Arts Building where the red and white martlet flag flies. I wander in and out of the inky, old-fashioned classrooms where I taught and was taught. What the place means to me is still very hard to put into words. But some of them go back to my thirteenth year – *Fides. Caritas. Spes.*

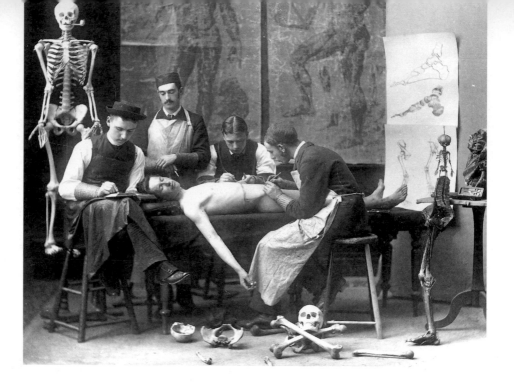

above
William Osler, 1877

above right
A group portrait of the dissecting class of 1884 displays the typically macabre humour of early class photos of medical students.

facing page
The McIntyre Medical Sciences Building on Pine Avenue. Its circular tower and striking panhandle annex make it one of Montreal's most notable buildings.

were usually medical students ... The usual price for a subject was from thirty to fifty dollars, paid in cash."

Two early figures, in particular, were to have a significant and long-lasting influence on medical research at McGill, an influence that was felt well beyond the university itself.

In 1872, a young student from Toronto, William Osler, graduated in medicine from McGill. He went on to do postgraduate work in Europe, but returned two years later to begin his practice and to teach at the university. Osler was an early advocate of getting students out of the classroom and making visits to the patient's bedside a seminar for teaching and research. It was during his teaching days at McGill that Osler developed the ideas which would form the nucleus of his influential book, *The Principles and Practice of Medicine,* published in 1892 and the most authoritative text in the field for more than thirty years.

Sir William Osler, as he became, had a life-long love of books and libraries and was an ardent collector of publications related to the history of medicine and science. He wrote movingly of this passion:

> It is hard for me to speak of the value of libraries in terms which would not seem exaggerated. Books have been my delight ... and from them I have received incalculable benefits. To study the phenomena of disease without books is to sail an uncharted sea, while to study books without patients is not to go to sea at all.

On his death, Osler's precious collection was left to McGill University where a special library was built to house it in the Strathcona Medical Building. In 1965, the library, complete in every detail, was reconstructed in the new McIntyre Medical Sciences Building. Concealed

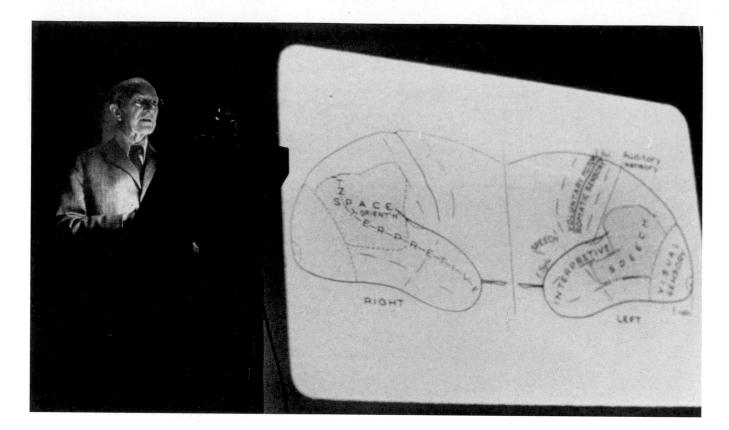

Dr Wilder Penfield delivering a
lecture on human memory
mechanisms. His dedication to the
importance of the inter-relatedness of
teaching, research, and treatment
had a fundamental effect on the
development of the Montreal
Neurological Institute.

behind a panel in what is known as the Osler Niche lie the ashes of Sir William Osler and his wife, surrounded by the books he loved so well.

Osler left McGill after eight years to take up a series of appointments in the United States and Britain. He spent the last fourteen years of his life at Oxford where he taught many of the next generation of doctors. One of these students would go on to become a seminal figure in McGill's history.

In 1916, a young American doctor named Wilder Penfield was returning to Oxford where he was a Rhodes Scholar. A torpedo struck the ship and Penfield was seriously injured. He, along with others of the wounded, was invited to recuperate in the Oslers' home. There a friendship developed between the two men that was to last a lifetime. After completing his studies, Penfield returned to work in New York, but in 1928 he accepted an offer from McGill and, with his close collaborator William Cone, took over the neurosurgical work at the Royal Victoria Hospital. It seems likely that his friendship with Osler played a part in this decision which was to be so important to the future of medical research at McGill.

Very early in his career, Penfield had become interested in the treatment of epilepsy and what it revealed about the working of the brain. In Montreal he began a systematic mapping of the brain's anatomy, work for which he later received many awards and honours. But

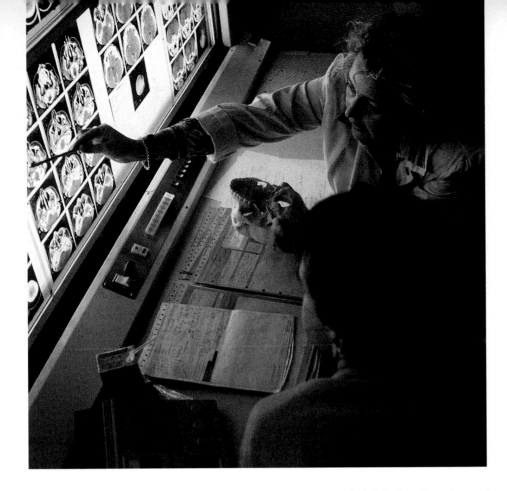

Penfield was a man of many talents, and later in his life he developed a second career as a writer. His autobiography, *No Man Alone,* reveals a warm, generous, intuitive man whose early goal in life was to "make the world a better place to live." In this fascinating book, he explains how he came to the belief that only through the co-operative efforts of neurologists, surgeons, and laboratory researchers could neurological patients be properly treated. This co-operative approach became the foundation of his plans for the Montreal Neurological Institute.

In 1934, with a grant from the Rockefeller Foundation, the institute for the teaching, treatment, and research of diseases of the nervous system was founded. Penfield had been offered the grant with the freedom to build his institute anywhere in North America. He chose to stay at McGill. He and his family had come to love Montreal and the exciting bilingual character of the city. This was where they wanted to remain. Penfield took pains to encourage co-operation between the French and English hospitals and after the institute had opened, patients from the Hôtel-Dieu and the Hôpital Notre-Dame were frequently brought to the institute for neurological treatment.

The MNI, as it soon became known, was the first of its kind and became a model for other such centres around the world. It has continued to be in the forefront of the treatment and study of the brain, with epilepsy as a major area of research. More operations on

above left
Two members of the "neuro team" examine brain images.

above
Magnetic resonance image of the brain.

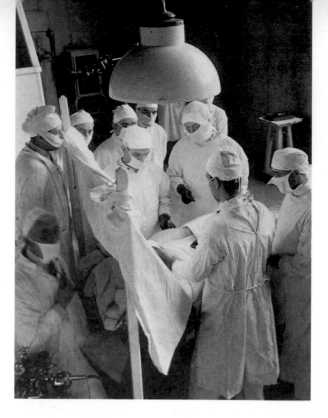

focal epilepsy are performed under its roof than anywhere else in the
world. Its treatment and research programmes continue to serve each
other in the way that Dr Penfield had envisaged.

Penfield's interest in bilingualism and his knowledge of the way
the brain works also led him to take an interest in the teaching of
language, and he developed a number of widely respected theories:
"All children should hear a second language before the age of six or
eight if they are destined for something more than elementary educa-
tion. And indeed if they are not. If they are to join the less-educated
class, bilingualism will still serve their purposes well, and it is so easy
to acquire!"

In spite of the breakthroughs made by Penfield and his team, he
understood well how much there remained to learn, but his view was
optimistic: "Do not be discouraged that the light of our knowledge is
so feeble, the darkness of the unknown so vast. Keep this torch lit.
Hand it on, a torch for all time."

At about the same time as the MNI was getting under way, another
surgeon who was to gain world-wide fame was working at the Royal
Victoria Hospital and teaching in the Faculty of Medicine. Norman
Bethune became interested in tuberculosis after suffering from the
disease himself. He came to McGill in 1928 and soon gained a repu-
tation for rapid, sometimes unorthodox, surgical techniques and the
invention of a number of surgical instruments – some of them still
used today. Bethune has been described as an angry man who did not
suffer bureaucracy, stupidity, or cruelty lightly, but this was more than
balanced by his compassion for the sick and dying and his intense

personal care for his patient's welfare. As his social conscience developed, he became increasingly active in attempting to solve some of the problems he saw around him in Montreal. He helped to establish TB clinics for the poor. He inspired an informal association of health workers to work towards a form of socialized medicine. He even started an art school for underprivileged children. His strongly held beliefs took him to the Spanish Civil War in 1936 and then to China. Three short but event-filled years after leaving Montreal, Norman Bethune died in China, a hero of its Communist Revolution.

The Allan Memorial Institute was founded in 1943 and soon became one of the most important psychiatric research facilities in North America. Its first director, Dr Ewen Cameron, was an enthusiastic and inspiring leader with a passionate belief in the power of psychiatry to improve people's lives. He was lionized by some of his co-workers, but others saw his haste and his unquestioning belief in his own methods as a danger. Dr Penfield, who had been instrumental in his appointment, had hoped that the two would have a close working relationship, but this never developed. Throughout the war the institute carried out important research on the effects of stress, fatigue, and seasickness. In the years after the war, Cameron's interest in sensory deprivation experiments designed to wipe clean the minds of troubled patients, so that a new start could be made, coincided with the attempts of the United States' Central Intelligence Agency to perfect brainwashing techniques. As a result, the CIA, through a third organization, began covert funding of the institute's experiments – a situation that has come to light only in recent years. While the treatments undertaken by Cameron have to be judged in the pioneer context of the period, the stories of the memory collapse of patients who underwent periods of total sensory deprivation and massive electro-shock therapy remain deeply disturbing.

From Konrad Gesner's Historiae animalium liber III: qui est de avium natura, *published in 1555.*

More recently, the institute has carried out important work with children and adolescents and is well known for its studies of memory impairment in the ageing.

McGill continues to be a leader in a broad range of medical studies today with its work on cancer, menopause, Parkinson's disease, Alzheimer's disease, and AIDS, and with Dr Ronald Melzack's significant investigations into the phenomenon of pain.

WHILE McGILL'S LONG AND CONTINUING involvement in medical research seems to have developed quite naturally from the interests of its early doctor-teachers, it is surprising to discover that these same doctors

gave the university its start in the sciences. Medical students of the day were given a grounding in geology, botany, climate, and other natural sciences. This was particularly true of the Scottish educational system, where many of Montreal's early physicians received their training.

Curiosity about the natural world – plants, animals, rocks, fossils, and weather – was running high throughout the educated world in the first half of the nineteenth century. Charles Darwin was at work on his startling new theories, and all over Europe and North America "societies of gentlemen" were seriously pursuing studies of the natural sciences. It was the heyday of the dedicated amateur, and it was amateurs who were responsible for most of the important early collections of rocks, plants, insects, shells, and fossils.

Many of these early natural scientists were physicians; and certainly in Montreal some of the most important figures were those first teachers at McGill. In 1827, the Natural History Society of Montreal was formed. The aims of this group, which included a number of these medical men, were to collect specimens and to study and make an inventory of the natural life around them. One of the founders of the society was Andrew Fernando Holmes, a McGill physician and teacher, and the first dean of the Faculty of Medicine. Holmes had a well-developed interest in botany and geology and had amassed a large collection of plants and minerals.

When William Dawson was appointed principal of McGill in 1855, he was already an enthusiastic collector and observer of the natural world. He brought with him an extensive collection of rocks, minerals, and fossils. In Montreal he found a like-minded community of collectors and scholars in the Natural History Society, and shortly after his arrival became its president. During his lifetime, in addition to his

above

Andrew Fernando Holmes
An accomplished chemist, botanist, and mineralogist, he was the first dean of the Faculty of Medicine. His early collections now form a part of those in the Redpath Museum and at the Herbarium at Macdonald College. The Holmes Medal, one of the oldest of McGill's awards, has been presented annually since 1865.

right

Quartz on hematite from the Ferrier Collection of 7000 specimens which are the basis of the mineral collection in the Redpath Museum. Dr Walter F. Ferrier, a geologist and mining engineer, graduated from McGill in 1887. The mineral Ferrierite is named for him.

left
One of the 4000 shells in the Redpath Museum which were collected by the early Montreal naturalist, Philip Carpenter.

below
A mantis from the Lyman Entomological Museum at Macdonald College.

work as principal, Dawson found time to write some twenty-five books and literally hundreds of papers on the natural world.

Dawson's specimens formed the nucleus of what became a growing collection at McGill. In 1858 Dr Holmes's minerals were purchased, and four years later a valuable collection of shells assembled by the Montreal naturalist, Philip Carpenter, was added. James Barnston, one of the Scottish-educated doctors, had returned to Montreal to set up his practice in 1853. He developed a special interest in botany and helped to found the Botanical Society of Montreal. He actively promoted the collection of botanical specimens, some of which were already beginning to disappear from the Quebec landscape, and in 1856 he was appointed to McGill's new chair in botany. He died suddenly and tragically two years later – only 27 years old.

Hand and hand with this interest in collecting and studying the natural world came the growth of natural history museums. Elaborate "cathedrals of science," as they have been called by Susan Sheets-Pyenson, sprang up throughout the British empire from London to Bombay. They had a double mandate: to aid research and to satisfy the newly awakened public interest in the subject. In 1880, in part to encourage Dawson to resist an attractive offer from Princeton University, Peter Redpath, a long-time supporter of McGill, donated the funds for the construction of the Redpath Museum. When the museum, an elegant example of neo-classical architecture, opened

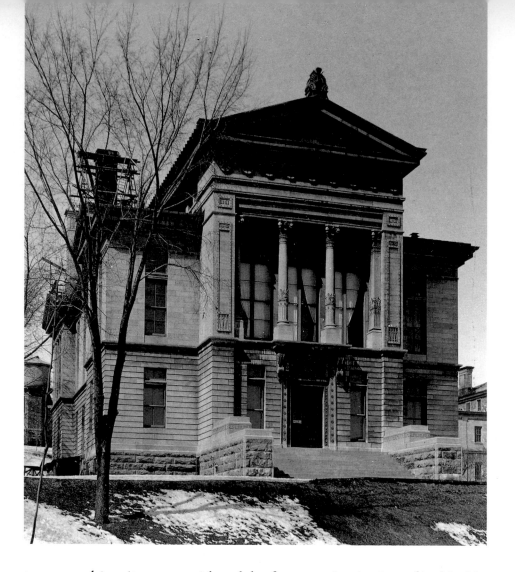

two years later, it was considered the foremost institution of its kind in Canada. The Montreal Natural History Society's museum continued to provide displays for the public, but when the society disbanded in 1925, its collections too came to the Redpath.

Another major expansion of the university's natural history collection had come in 1914, when the *Empress of Ireland* sank in the St Lawrence estuary taking with her Henry Lyman and his wife. Lyman had been a dedicated amateur entomologist. He willed his 20,000 specimens, mostly butterflies and moths, to the university, along with his entomological library and a $40,000 bequest for their upkeep. The Lyman Collection continued to grow over the years, and in 1960 it was transferred to Macdonald College, as the Lyman Entomological Museum. Today, its specimens number over two million, and the collection is enhanced by an extensive library.

The Holmes plant collection continued to expand as well and, in 1972, it too moved to Macdonald College. There, an internationally recognized collection of Arctic and sub-Arctic plants had been collected and maintained under the curatorship of Dorothy Swales, one of the earliest women graduates in agriculture. The two collections

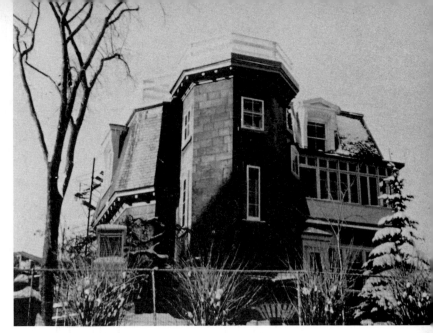

together became the McGill University Herbarium, an increasingly valuable scientific resource at a time when so many specialized natural environments are threatened.

Maintaining meteorological records was another part of the training given early physicians – primarily for the purpose of assessing the connection between weather and disease. So it wasn't too surprising that Charles Smallwood would begin recording temperatures and weather changes when he emigrated to Canada from England in 1833 and set up his medical practice at St Martin, a few miles outside Montreal. But Smallwood's interest in climate soon expanded to more than a hobby; at his private observatory, he recorded detailed weather information four times a day, and before long his records became an important collection of scientific data.

Smallwood who later would receive an honorary LL.D. from McGill was, by 1856, teaching classes in meteorology. Seven years later, the McGill Observatory was built for his use. The observatory included a system that could send storm warnings across the country by telegraph and, in times of emergency, ring the bells in Montreal's churches. Smallwood's successor, C.H. McLeod, a former student, developed a particular interest in time. His time signals eventually became the North American standard and were telegraphed to railways and major cities in Canada and the United States. This standard was the basis for the Dominion Observatory Official Time Signal of the late 1920s and beyond.

The discovery of x-rays in 1895 opened a period of exciting new research in physics. McGill's most important contribution to the field came a few years later when Ernest Rutherford was hired to come to Canada to work in the Physics Department. Rutherford was fascinated by radioactivity and the possibilities of sub-atomic research. In his early experiments he was assisted by a recent McGill graduate, Harriet

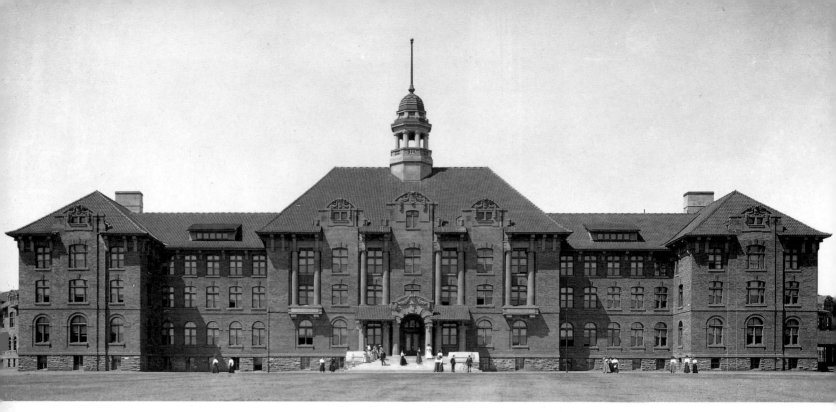

Macdonald College, about 1908.

Brooks. Rutherford considered Brooks to have the makings of a brilliant scientist, and she would later do research for a short time at the Institut Marie-Curie in Paris before her scientific career ended with her marriage in 1907. Shortly after Brooks left Montreal, a young chemist, Frederick Soddy, arrived at McGill from Oxford. What began as an antagonistic relationship between him and Rutherford soon led to fruitful collaboration. The paper they published two years later, "Radioactive Change," heralded the atomic age. In 1908 Rutherford received the Nobel Prize in chemistry for this and other momentous discoveries, while Soddy went on to win the prize in 1921.

EVEN BEFORE MACDONALD COLLEGE opened its doors in 1907, McGill had begun agricultural experiments with the breeding of grain and corn, the first undertaken in Quebec and among the first in all of Canada. One of Principal Dawson's earliest interests was in what he termed "agricultural chemistry." These experiments have continued and expanded over the years, with the college breeding important new strains of plants, such as Macdonald rhubarb and the rust-free Marquis wheat. By the 1930s, the study of pasture land and its healthy maintenance had been initiated, and breeding studies were extended to cattle and hens. In 1932, the Institute of Parasitology was established, fulfilling an early dream of William Osler's, who had had a special interest in this field. This has become an increasingly important area of study at Macdonald College whose current research includes studies in sustainable agriculture, in human and livestock nutrition, in food storage, and in fish and livestock management.

ALTHOUGH NORTHERN STUDIES HAD BEGUN at McGill as early as the late nineteenth century, it was some fifty years later that they took on major importance. The presence of the Arctic Institute of North America on the McGill campus from 1948 to 1975 was an important stimulus. As early as the 1920s, James Gill of the Department of Geological Sciences had discovered massive iron ore deposits in northern Quebec, and when these were opened up for development in the 1960s, McGill scientists followed hard on the heels of the miners. When the massive James Bay hydro project was announced in 1971, McGill anthropologists were still the only group working on social development in the area. Current studies include an assessment of the effect of this project on the northern Cree.

In 1963, Maxwell Dunbar had undertaken considerable research in northern waters as an ecologist aboard the RMS *Nascopie*. When serving in Greenland as Canadian consul, he was asked to establish a Marine Sciences Centre to co-ordinate all oceanic research related to the university. Dunbar had joined the McGill faculty in 1946 and shortly thereafter began to investigate Arctic waters on behalf of the Fisheries

The annual Woodsmen Competition at Macdonald College.

Research Board of Canada. As a part of this task he was involved in the designing of the first vessel specifically for use in northern marine research.

The work Dunbar began has expanded over the years and continues today through the Arctic Biological Station, located at Macdonald College. The station now operates as a part of the Canadian government's Department of Fisheries and Oceans, but its work is carried on in close collaboration with the university. McGill's own northern research is co-ordinated through the Centre for Northern Studies and Research on the main campus. From there it maintains field stations in the sub-Arctic and the High Arctic.

THESE ARE A FEW OF THE STORIES of the development of research at McGill during its first century. Expansion continued and increased as the years went by.

The Pulp and Paper Research Institute of Canada, building on work begun in 1913, was established in the 1920s in co-operation with the Pulp and Paper Association and the federal government. It went through a rapid expansion during the war years, with research concentrated on such war-related items as gas mask filters, paper that would resist secret writing, paper that would dissolve when chewed, and durable paper inner soles for shoes. In more recent years the work of Stanley Mason in colloid chemistry and the chemistry of cellulose has been of major importance.

The Bellairs Research Institute, opened in 1954, was the result of an

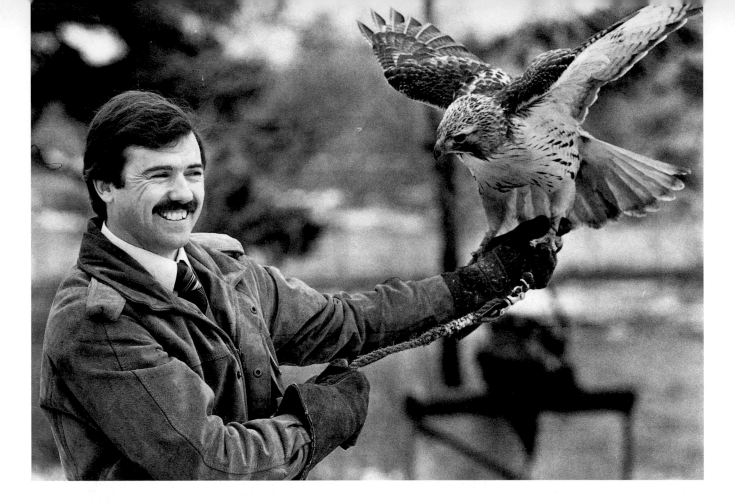

unexpected bequest of property in Barbados. The marine biology research station built there has allowed a number of disciplines to expand their studies to include the tropics.

The Raptor Research Centre, housed at Macdonald College, was founded in 1973 to promote the conservation of birds of prey. Here the aptly named Dr David Bird and his colleagues help to ensure that these dramatic and powerful birds will survive the effects of environmental change.

At the downtown campus, in the McGill Research Centre for Intelligent Machines, researchers work on space-age robotics – developing machines that come closer and closer to thinking, and in the process learning more and more about how the human brain works.

Weather continues to be a major source of interest at McGill. The Centre for Climate and Global Change Research is at work creating a global oceanic circulation model that will help us to understand more fully the greenhouse effect and how the earth might best cope with the global changes in store.

At the McIntyre Medical Building, the McGill Cancer Centre co-ordinates research activities related to cancer in all its forms – a field in which McGill has long excelled.

These are just a few of the specialized centres at McGill, a local reflection of the immense increase in research centres, institutes, schools,

Dr David Bird
With Piggy, a red-tailed hawk. The Raptor Research Centre, directed by Dr Bird, has developed a breeding colony of about 350 American kestrels for use in its studies of North American raptors.

117

above
The McGill cyclotron was built in the 1940s through the initiative of John Stuart Foster for whom the Foster Radiation Laboratory was later named.

right
The Puma 560 robot, part of a research project developed by the McGill Research Centre for Intelligent Machines under a contract with NASA.

and museums spawned by the exponential expansion in research and discovery that occurred world-wide after 1950. Responding to these changes over the following forty years, McGill now is home to some ninety interdisciplinary units operating under the Faculty of Graduate Studies and Research or reporting directly to their related faculties. Each year brings new interdisciplinary bodies, created in response to new questions and problems.

In the early sixties this development was encouraged by the large increases in research and development budgets in North America. In Canada, until the mid-eighties, much of this funding came from government: industry contributed in the form of contracted research or joint industry-university programmes. Then federal budgets were frozen and increases for basic research from governmental funding bodies became available only on an industry-matching basis, even where pure research was concerned. More than ever, therefore, support from industry has become necessary to the continuation of research – even in areas where immediate returns are unlikely. McGill and its supporters have responded well to this situation, and McGill continues to attract more research funding per faculty member than any other Canadian institution.

A new development in the nineties has been the establishment of fourteen federally funded Networks of Centres of Excellence to consolidate basic and applied research throughout Canada. McGill is involved in nine of these national networks and heads three of them: Neural Regeneration and Functional Recovery, the Institute for Telecommunications Research, and Respiratory Health.

Today, from that small group of nineteenth-century medical scholars, McGill has developed an excitingly diversified body of teachers, practitioners, and research scientists devoted to shining light into the darkness of the unknown. William Osler's "torch for all time" still burns brightly.

Writers at McGill

Bruce Whiteman

If Catullus returned to us, I would not guarantee that a large proportion of the Faculty Club could tell him honestly that they were acquainted with his poetry, but they would at least be able to entertain him without embarrassment. They would certainly understand what a poet needs before, during and after his dinner and would be happy and able to provide him with it.

Hugh MacLennan

Our century has been the time of the "writer-as-something-else," and that something else has often been a university professor. We are so used to finding poets and novelists professing English literature or creative writing inside the academy that we scarcely give the phenomenon a second thought; but it was not always so, and until the First World War it was rare for a scholar and an imaginative writer to inhabit the same corpus. From Chaucer to Oscar Wilde it is hard to think of any important writer who put bread on the table by teaching in a university save perhaps John Ruskin, whose teaching career at Oxford lasted only ten years and who was of independent means in any case, or Charles Kingsley (of *Water Babies* fame) who taught history at Cambridge during the 1860s. But to imagine Jane Austen, or William Blake, or Herman Melville taking classes in creative writing or Jacobean drama makes one pause – if it does not

facing page
Davis House, interior

make one giggle. The academy has nonetheless become a common place of refuge for writers in our time, perhaps in the way that journalism used to be; and whereas Defoe and Johnson, or Jerome K. Jerome and George Gissing made ends meet with newspaper writing and pamphleteering, our writers – from Robertson Davies to Irving Layton, from George Bowering to Hugh MacLennan – have paradoxically allied themselves with "those who can't," and teach. Most writers in Canada need a day job, as Huntly McQueen, the unattractive capitalist in Hugh MacLennan's *Two Solitudes,* pointed out:

> McQueen leaned back and his grey eyes seemed to be looking through the solid fog beyond the window. "You know, I've lived in Canada all my life. I've been in every city in the country, and I think I can say I've met everyone of any importance in it. But apart from Ralph Connor and Stephen Leacock, I've never met a single writer who could live by books alone."

It is not on the basis of the Faculty of Arts that McGill's international reputation was established or remains high. William Dawson,

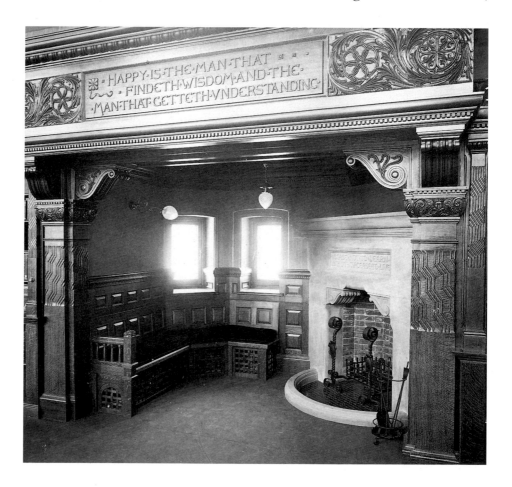

Reading corner in the Redpath Library, 1893.

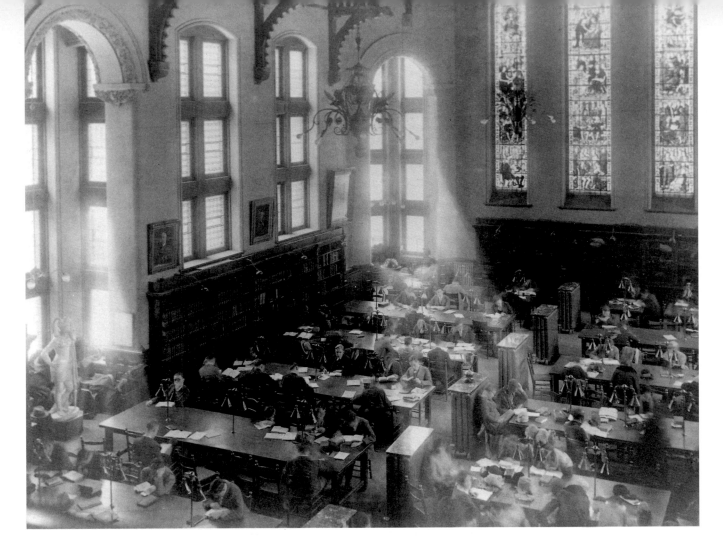

The reading room in the Redpath Library before it was converted into Redpath Hall in 1953.

McGill's earliest great principal, did much to build the university's standing in science and the professions, but his remark that "the world has worshipped art too much, reverenced nature too little" was reflected in his comparative neglect of the arts at McGill. William Peterson, who followed Dawson as principal and was himself a classics scholar, could not manage to ameliorate that neglect, despite Dawson's advice on retiring that "a principal was now needed who would give the work in arts a larger role than it had." F. Cyril James, during whose principalship McGill underwent a tremendous amount of expansion, failed even to mention the arts in his chapter on the university in the postwar period in *McGill: The Story of a University,* save for a reference to the portico and cupola of the Arts Building itself. One fears that Stephen Leacock's imploring pentameters in *College Days* were never paid much heed: "When next the stream of benefaction starts, /Pray, pour it on the Faculty of Arts!"

And yet – there is always "and yet" – and yet several of Canada's most distinguished writers have taught at McGill, a much larger number have been students there, and one of the central episodes in the development of Canadian modernism took place literally on the campus. To a degree these facts reflect a more general truth, namely, that

Montreal has been an unexpectedly central locale for certain remarkable developments in Canadian writing, particularly poetry. Indeed Louis Dudek once opined epigrammatically that "it is the destiny of Montreal to show the country from time to time what poetry is." From its earliest days McGill has seen writers in its classrooms in remarkable numbers, on both sides of the lecture podium.

Indeed, the record commences with McGill's first principal, George Jehoshaphat Mountain, who was appointed professor of divinity and principal in 1824. Among Mountain's distinctions was a minor facility for verse, a facility for which in the main he had little time. But long weeks spent "lounging in the canoe" taking him through the Hudson's Bay Company's territory during the summer of 1844 gave him the opportunity to write the poems which make up *Songs of the Wilderness,* his only published volume. Unsurprisingly, the poems themselves are rather conventional, but accomplished enough in the amateur Victorian manner:

> What doest thou here, fair rose, on rocky shore
> Opening thy pure and scented breast to blush
> In these rude wilds, where, with eternal roar,
> Of thundering Winnipeg the waters rush?

Mountain may have been the first writer at McGill, but it was not until the next century that he had a successor, in that role at least. It is true that the historical novelist, William McLennan, was briefly honorary librarian in the 1880s and William Douw Lighthall whose literary and historical interests were polymorphous, almost omnivorous, had close connections with the library and the McCord Museum. But neither of these writers, both of whom did their baccalaureate studies at McGill, was ever on faculty.

It is with the arrival of the new century and of Stephen Leacock, then, that McGill's roster of important writers really begins. Hired by Principal Peterson to teach part time in 1901, Leacock became a full-time professor in 1903, "temporary" chairman of the Department of Economics and Political Science in 1908 (the "temporary" only became permanent in 1933, three years before he retired), and gradually established himself as a McGill character. The Leacock iconography of tatterdemalion gown, raccoon coat, and walking stick was instantly recognizable on campus and at the University Club, and many witnesses have attested that the words McGill University uttered in farflung places on the globe instantly elicited the words "Stephen Leacock" in reply. Leacock of course had two writing careers, as humorist and as

political scientist and economist, and though his reputation as the latter was distinguished (his textbook, *Elements of Political Science,* was much used and went through many reprintings), it was as the former that he was famous.

Teaching and university life were fruitful sources for Leacock's humorous writing, though his impulse to pull the collective leg of the academy did not mean that he took his teaching responsibilities lightly or executed them without pleasure. "I know no more interesting subject of speculation, nor any more calculated to allow of a fair-minded difference of opinion, than the enquiry whether a professor has any right to exist," begins "The Apology of a Professor: An Essay on Modern Learning" in *Essays and Literary Studies,* only one example from dozens in which Leacock wreaks havoc in the hallowed halls. The classics were a favourite target, witness "Homer and Humbug – An Academic Suggestion" from *Behind the Beyond:*

> When I reflect that I have openly expressed regret, as a personal matter, even in the presence of women, for the missing books of Tacitus, and the entire loss of the Abracadabra of Polyphemus of Syracuse, I can find no words in which to beg for pardon. In reality I was just as much worried over the loss of the ichthyosaurus. More, indeed: I'd like to have seen it; but if the books Tacitus lost were like those he didn't, I wouldn't.

One of Leacock's most accomplished send-ups of academic life occurs in *Arcadian Adventures with the Idle Rich,* in which Plutoria University (whose iron gates and arts building with an imitation

Greek portico give away the identity of its model) and its president, Dr Boomer, play a wicked but hilarious role. Dr Boomer and Dr Boyster, a professor of Greek, escort the newly wealthy Mr Tomlinson on a campus tour, naturally with malice aforethought:

> The two had the Wizard of Finance between them, and they were marching him up to the university. He was taken along much as is an arrested man who has promised to go quietly. They kept their hands off him, but they watched him sideways through their spectacles. At the least sign of restlessness they doused him with Latin. The Wizard of Finance, having been marked out by Dr Boomer and Dr Boyster as a prospective benefactor, was having Latin poured over him to reduce him to the proper degree of plasticity.
>
> They had already put him through the first stage. They had, three days ago, called on him at the Grand Palaver and served him with a pamphlet on "The Excavation of Mitylene" as a sort of writ. Tomlinson and his wife had looked at the pictures of the ruins, and from the appearance of them they judged that Mitylene was in Mexico, and they said that it was a shame to see it in that state and that the United States ought to intervene.
>
> As the second stage on the path of philanthropy the Wizard of Finance was now being taken to look at the university. Dr Boomer knew by experience that no rich man could look at it without wanting to give it money.

The story concludes with Mr Tomlinson giving his entire fortune to the university, a fortune which unbeknownst to him is about to become

The original McGill Library, seen here in 1895, was located in the Arts Building.

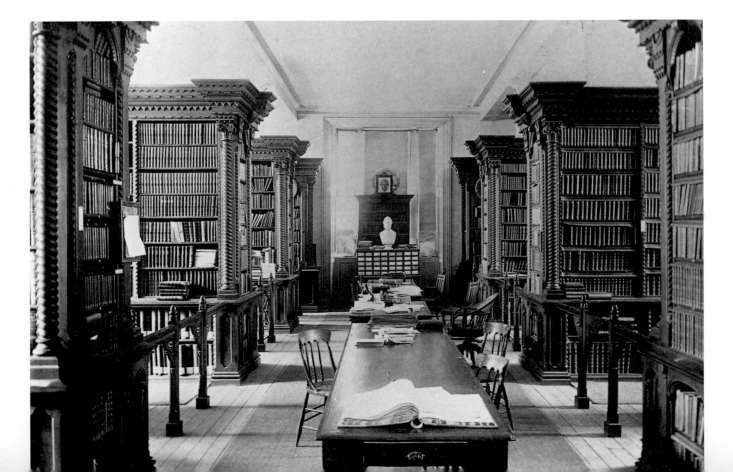

worthless, in exchange for an honorary degree and the admission of his son – who has not finished grade school – to senior studies in electrical science.

Leacock retired under duress in 1936. He did not want to stop teaching, but Principal Morgan held fast to the rule of retirement at age sixty-five, and he was forced to go. Leacock resented it (he took to saying that he had been McGillotined) and remarked furiously to the *Montreal Star:* "I have plenty to say about the Governors of McGill putting me out of the university. But I have all eternity to say it in. I shall shout it down to them." Reflection and time, however, softened his anger into regret, as a piece entitled "When Men Retire," collected in *Too Much College* published after he left McGill, suggests:

> But as to this retirement business, let me give a word of advice to all of you young fellows round fifty. Some of you have been talking of it and even looking forward to it. Have nothing to do with it. Listen; it's like this. Have you ever been out for a late autumn walk in the closing part of the afternoon, and suddenly looked up to realize that the leaves have practically all gone? You hadn't realized it. And you notice that the sun has set already, the day gone before you knew it – and with that a cold wind blows across the landscape. That's retirement.

With Ernest Rutherford, Wilder Penfield (himself a published novelist), F.R. Scott, and one or two others, Leacock remains among the most distinguished of McGill's faculty members, and certainly the most widely known.

> To all who read Literature with delight
> Here is a suggestion which I hope is right:
> Enjoy the McGill Fortnightly Review.

So wrote Harry Barker in *Simple Rhymes for Simple Folk,* a pamphlet of poems published in 1928 by Shakespeare Harry, the janitor in the Arts Building who could quote Shakespeare by the yard and was universally denominated the Poet Laureate of McGill. The editors of the *McGill Fortnightly Review* would have found Barker's lines encouraging, but probably unworthy of publication in the journal. For the *Review* was determinately devoted to modern poetry and was in fact one of the first literary magazines in Canada to publish poets who had read T.S. Eliot, Ezra Pound, W.B. Yeats, and other writers of the day. This was remarkable for a student publication which started off as a literary supplement to the *McGill Daily.* When the supplement published a poem by Aldous Huxley with the word "spermatozoa" in it, however, its

Sketch by Arthur Lismer

funding was revoked. And so the *McGill Fortnightly Review* took its place as an independent student magazine in 1925.

The editors – A.J.M. Smith, F.R. Scott, Leon Edel, A.M. Klein, and others – formed a remarkable group of writers and poets, almost all of whom went on to have significant careers in literature and who are now known to literary historians as the McGill Movement. The meeting of Scott and Smith was especially fruitful; they would later collaborate on the important anthology, *New Provinces,* the collection which is usually cited as the first book of modern Canadian poetry. Scott once described himself as a young man as "an Anglican on ice" and praised Smith for pulling him – in literary matters at least – into the modern world.

Smith and Edel spent their very active literary careers in the United States, sent into exile by the Depression and the scarcity of academic posts in Canada, and Klein became a lawyer (though later he taught part time at McGill). It was Scott who stayed – as a professor of law

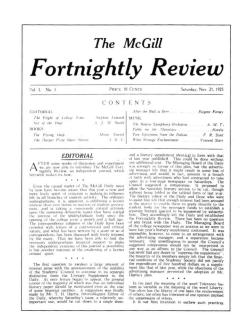

A.M. Klein
One of Canada's finest poets, he
graduated from McGill in 1930.

beginning in 1928 – and whose distinguished career as poet, lawyer, constitutional expert, politico, and teacher mark him as one of McGill's greats. Like Leacock – like all great teachers, perhaps – he was not a little sceptical of the process of education, and slightly scornful of hard and fast rules:

> The routine trickery of the examination
> Baffles these hot and discouraged youths.
> Driven by they know not what external pressure
> They pour their hated self-analysis
> Through the nib of confession, onto the accusatory page.
>
> I, who have plotted their immediate downfall,
> I am entrusted with the divine categories,
> A B C D and the hell of E,
> The parade of prize and the backdoor of pass.

Leacock made a similar point, though he put it more lightly:

We actually proceed on the silly supposition that you can "examine" a person in English literature, torture it out of him, so to speak, in the course of a two hours' inquisition.

...

The truth is that you cannot examine in English in this way, or only at the cost of killing the very thing that you wish to create. The only kind of examination in the subject I can think of would be to say to the pupil, for example, "Have you read Charles Dickens and do you like it?" and when he answered that he didn't care for it, but that his uncle read it all the time, to send a B.A. degree to his uncle.

Scott's involvements with literary politics and literary magazines did not end with the demise of the *McGill Fortnightly Review* in 1927. He was a founder of another short-lived magazine, *The Canadian Mercury* (1928–9), and in the 1940s was involved with Patrick Anderson's *Preview,* one of the vital poetry outlets of that lively decade. (Anderson taught briefly at McGill at the end of the forties, and when he left rather abruptly, Louis Dudek was hired to replace him). The McGill Movement itself dispersed as its members left the university for jobs or further study; but as Leon Edel once remarked, "we ploughed a few acres or rode our covered wagons a short distance; but we carried a lot of civilization with us and it was life-enhancing."

The recrudescence of Montreal poetry in the 1940s did not originate at McGill, but the poetry scene certainly included a number of writers with McGill connections. Harold Files, later the chairman of the

facing page
Hosmer House, interior

Hugh MacLennan in conversation

English Department, was not a writer himself, but his courses in what we would now call creative writing attracted many undergraduates with writerly sensibilities. Some of them worked on *Forge,* McGill's student literary magazine, and a few – like John Sutherland, Audrey Aikman, and Robert Simpson – became involved in publishing *First Statement,* the "rival" Montreal magazine to *Preview* until their merger in 1945. Files compiled an anthology of McGill student verse, and though it failed to find a publisher, a number of the contributors became well-known poets later on, Irving Layton and Louis Dudek included. The novelist Constance Beresford-Howe was a Files student (he supervised her thesis on Virginia Woolf) and was later hired by him for the English Department, where she taught until the late 1960s. Three of her four early novels bear eloquent testimony to her student days at McGill, particularly *Of This Day's Journey,* which concerns a young woman with a freshly minted doctorate who leaves Montreal to teach in the United States. Cam, the central character, is no doubt modelled in part on the author herself, in whom *Old McGill* noted "a fatal charm for budding poets" shared by her fictional creation.

In 1951 two now widely respected writers arrived in the English Department, the novelist, Hugh MacLennan, and the poet, Louis Dudek. MacLennan was already an established novelist when he agreed to the part-time position offered him by Cyril James, as he had won the Governor General's Award three times. (He would win it twice more during the 1950s). He was trained as a classicist, but taught seventeenth-century prose and the modern novel until 1964, when he became a full-timer. *The Watch That Ends the Night,* published in 1958 and probably MacLennan's best-known novel, is redolent of Montreal from beginning to end, and its main character, George Stewart, teaches part time at McGill. Though MacLennan once remarked in a convocation address that "as I never studied English formally when I was young, I have never been able to regard myself as a true academic," he was a devoted teacher and a McGill monument; and although the McLennan Library (where some of his papers reside) was not named for him, the aural congruence of names is an appropriate one. It was unfortunate that, like Leacock, MacLennan felt that he was forced out of McGill when a space crisis necessitated his leaving his office in 1985. A little like Ovid in Pontus, banished or choosing exile (depending on one's point of view), MacLennan's last months in a faculty office were spent at Concordia University.

Of all the writers at McGill, Louis Dudek has managed most fully to combine the roles of scholar and writer. As a poet, culture critic,

The McLennan Library

reviewer, editor, and publisher, he is a true man of letters whose contributions to the university and to Canadian literature have been multifarious and long-standing. He taught for over thirty years (he was appointed Greenshields Professor of English Literature in 1972), and many of his students have become writers themselves: from Leonard Cohen, Daryl Hine, and Doug Jones in the 1950s, to Seymour Mayne, Pierre Coupey, Peter Van Toorn, Ken Norris, and Ray Filip in the 1960s and 1970s. Dudek established the McGill Poetry Series in the mid-1950s, and through it brought into print several important books, beginning with Leonard Cohen's first published collection, *Let Us Compare Mythologies.* Several of his students won McGill's Chester Macnaghten Prize for creative writing. (One of them, Daryl Hine, whose book, *The Carnal and the Crane,* Dudek published in 1957, has written exten-

The poets' corner at Ben's has been a meeting place for McGill's writers for decades. Louis Dudek is seen above at a reception in his honour.

sively about his undergraduate years at McGill in a long autobiographical poem entitled *In and Out).*

The writers mentioned in this brief essay are only some of the many who have left their mark on McGill and on the history of Canadian literature. Many others have perforce had to go unmentioned; Colin McDougall, for example, whose fine novel of World War II, *Execution,* won the Governor General's Award in 1958, or the short-story writer and novelist Norman Levine, who studied at McGill in the 1950s. And of course the story does not end with the dead, the retired, and the emeriti; George Szanto, Jean Ethier-Blais, and Darko Suvin are among the current faculty members who are published novelists and poets. They, like their predecessors, have presumably discovered a way to avoid metamorphosing into Professor Footnote (as F.R. Scott typed it), to maintain the life of the imagination inside the scholarly world. The roster of writers whom McGill has taken in (and sent out) demonstrates how congenial that relationship can be.

*The McGill Bookstore moved around
the corner in the summer of 1990
from its crowded home on
Sherbrooke (left) to expanded
quarters in a new building on
McTavish (below).*

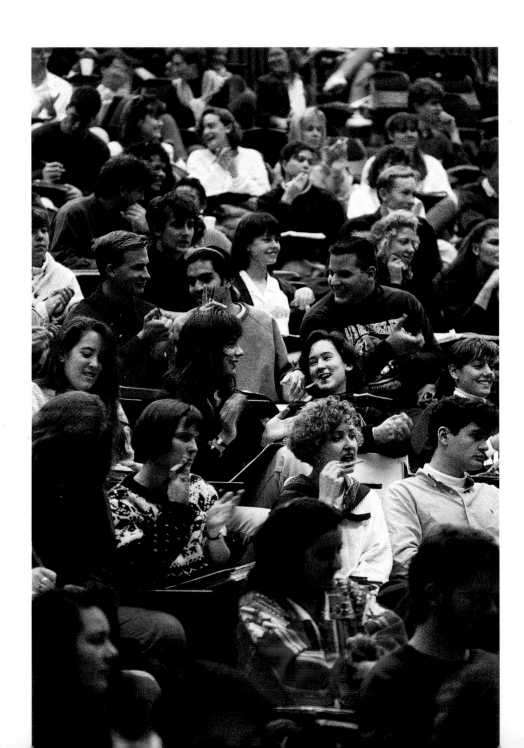

The Classroom

When I saw the students coming in
with their warm, intelligent faces,
 ready for another bout
with great ideas, analogies, interpretations, facts
 and the theories that always defeat us,
each of them independently fighting
 for his own bit of ground
against embattled knowledge, against the karate of reason:
when I saw their patience, silence, meekness
before the imminent stream
 of accumulated lore, pouring down from glaciers
of unassuaged desire, the mountainous stupefactions of tradition –
I sat down in pity, and held my head in my hands,
until love opened my eyes, and I bent listening to the chatter
 of those enquiring minds.

Louis Dudek

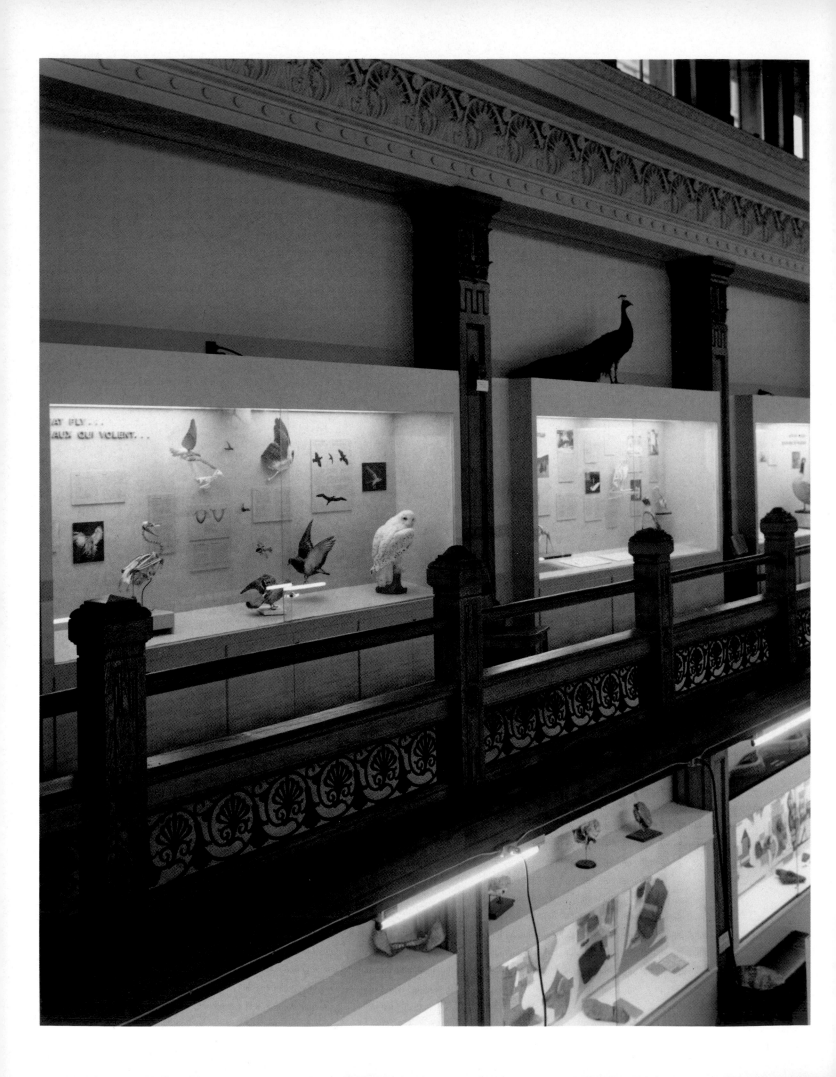

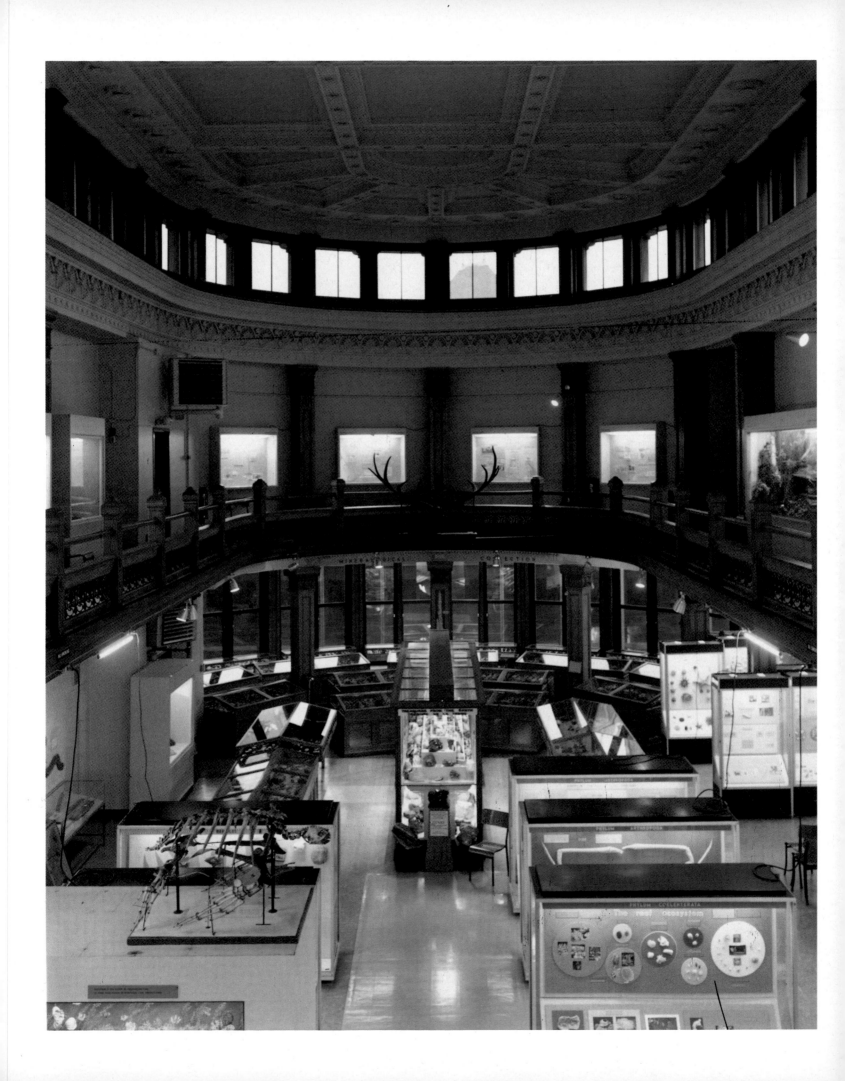

ARTHUR LISMER
R C A — LLD

above
This charming sketch was Arthur Lismer's reply to a request for his gown size, at the time that McGill was preparing to award the artist an honorary degree.

him as a sensitive, soft-spoken person with sparkling eyes and magnetism in his personality. Lismer was introduced as a painter, an important member of the Group of Seven and a pillar of Canadian art of which I then knew little. I set about to discover Lismer the creator and fell in love with the work of the Group, with their colours, their dynamism, their forceful brush strokes, and their ideas. McGill's Visual Arts Collection, which now comprises more than three thousand works, includes Canadian landscapes and drawings by Lismer and other members or followers of the Group. Among them is *Red Sleigh, Yellow House* by Lawren Harris who exerted a significant influence on the development of Canadian art. This canvas draws the viewer in with its play of colours and mysterious feeling of space. The yellow house is seen in the distance through the decorative snowladen leaves and branches in the foreground; the partly hidden barrier below the branches serves to isolate the main subject from the viewer and to create a feeling of tension; this sense of isolation is also found in Harris's book of poetry, *Contrasts.*

My next discovery was a curious one. One day I met a charming and kind lady, Isabel Dobell, who invited me to the Hodgson house, which stood beside the Stewart Biology Building on Drummond Street, to see something of the McCord Collections which were about to be moved to the one-time Student Union on Sherbrooke Street. The artifacts I saw that day opened a new world for me. The historical, archaeological, ethnographic, and artistic values of the priceless treasures of the McCord Museum were only to be discovered slowly in the course of the coming years, for the museum needed space before it could make its holdings accessible to the student. Another time, exploring in the Redpath Museum, I walked to the basement to be confronted with hundreds of photographs. Here was the history of Montreal. I could link human faces to names of streets and find another identity for buildings in these portraits. These were the archives of William Notman, the first Canadian photographer to attract international acclaim. Today 400,000 Notman images are to be found in the photographic archives, now housed in the McCord Museum.

In writing these lines, my intention has not been to record the reminiscences of the early years of a young professor at McGill but to provide a frame for the tremendous changes that have occurred in the McGill Collections in recent years and to give readers a taste of the fascinating character and diversity of these collections. Today the McGill student, and the campus visitor, do not have to search out treasures. As the student goes to a class, to the library, to a professor's

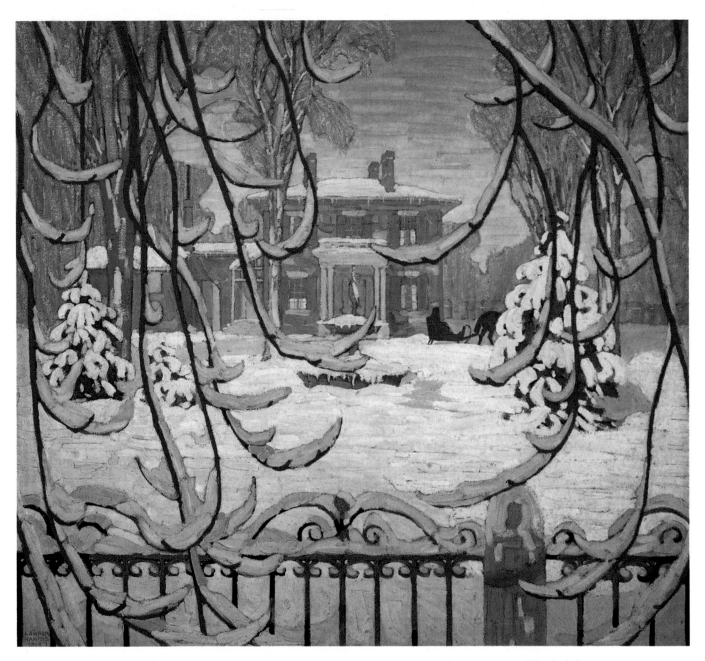

Red Sleigh, Yellow House
by Lawren Harris.
A "mysterious feeling of space."

David Ross McCord spent a lifetime collecting books, objects, and documents recording the history of Canada. He gave his magnificent collection to McGill in 1919, and three years later the McCord Museum of Canadian History opened its doors. Other acquisitions were added over the years and in 1956 the priceless Notman Photographic Archives came under its roof. Native Canadian material culture and art, costumes and textiles, paintings and prints, even toys, are included in the McCord Collection.

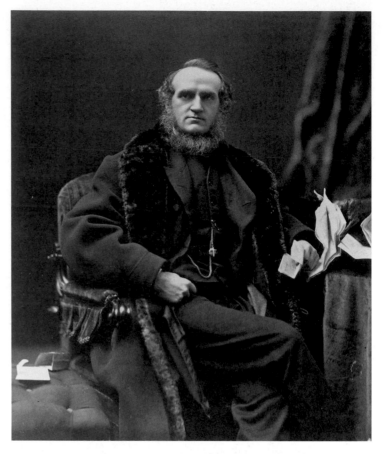

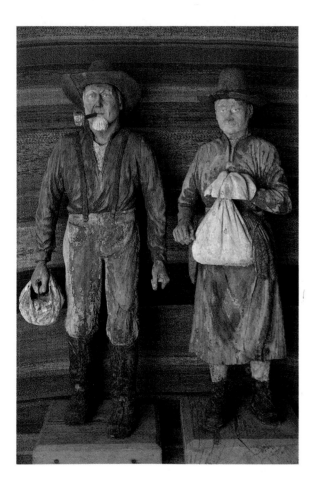

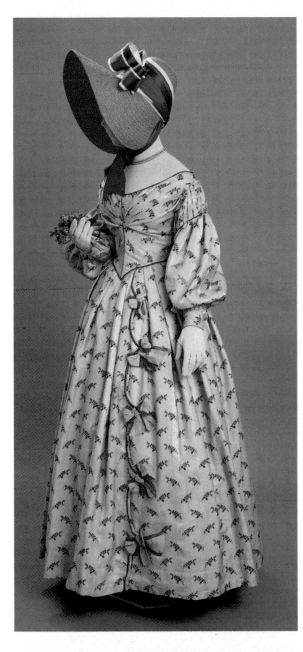

Clockwise from left:
- a self-portrait of William Notman, the extraordinary nineteenth-century photographer and businessman. Notman's studios (there were at least twenty) sprang up from Toronto to Halifax and Boston. He was the official photographer for McGill, and the archives contain both individual graduate photographs and group and composite pictures.

- A day dress and bonnet of the 1830s from Quebec City.

- Inuit sculpture by Abraham Elungat, Cape Dorset, 1978.

- a detailed model of a Haida canoe collected by George Mercer Dawson, son of William Dawson, on his trip to the Queen Charlotte Islands in the 1870s while working with the Geological Survey of Canada.

- The acrobats, an educational wooden toy of the 1860s. Its removable parts helped to develop dexterity in younger children. The McCord's collection of toys in use in Canada in the nineteenth century is the largest of its kind.

- painted carvings of a Quebec farmer and his wife by Armand Bourgault, about 1940. The backdrop is an early twentieth-century Quebec catalogne.

*The Falcon by Robert Tait McKenzie
stands on the terrace outside the
McLennan Library. McKenzie
graduated from McGill as a physician
and was medical director of physical
training until he left in 1904. His
statues, medallions, and war
memorials are on display throughout
Canada, Great Britain, and the
United States. A number of his
sculptures can be seen in the
museum he created in a restored mill
near Almonte, Ontario.*

*An annual publication since 1988,
under the editorship of Hans Möller,*
Fontanus *publishes scholarly research
on the McGill Collections.*

office, to one of the museums to do research, or just walks the campus, he is constantly confronted with wonders. It may be a bronze bust by Jacob Epstein or abstract geometric forms by Barbara Hepworth. It may be Catherine Widgery's imaginative mobile with its motif of a man attempting to fly, or *The Falcon,* a bronze statue by Robert Tait McKenzie, a McGill graduate and a member of its teaching staff at the turn of the century. The inspiration of both these pieces lies in the old Icarus image which the Romans, following the Greeks, had painted in their houses in Pompeii and elsewhere. It may be an Indian or Inuit artifact or an Inuit sculpture which is distinguished by its closed forms, its solidity, and, despite its small size, its great monumentality. One such

piece is *The Woman and Narwhal Tusk* by Oshoweetook of Cape Dorset, a present of the McGill Graduates' Society, which is in the Redpath Library.

The wanderer might stumble on Greek manuscripts and Italian illuminated books in the Rare Book Department, a diploma of the University of Padua or a chronicle of the city of Nuremberg in the Osler Library, famed for its holdings in the history of medicine, a specimen of Arabic calligraphy in the Islamic Library, and many other important documents and works in special collections in the libraries. Some of these hidden treasures have become better known through the pages of *Fontanus,* an annual publication of McGill University.

All these thousands of objects coming to McGill reflect the tastes and passions of their various donors. The great diversity in the nature of these works, in their scholarly and aesthetic values, has a beneficial effect on the viewer. The student is thus exposed to the concept of taste and the message of these objects slowly penetrates the consciousness and remains there. This is how tradition is formed.

There is no way that I can present all the McGill treasures or even suggest their richness. Nor can I do justice to the collections or to the labours of all the scholars who care for these collections and to whom we are all grateful. I can only indicate their quality in the personal selection which follows.

An illustration from Champfleury *by Geoffrey Tory. This famous work on the proportion of letters was published in 1529 and is in the William Colgate History of Printing Collection, Department of Rare Books and Special Collections.*

Seventeenth- and eighteenth-century medical diplomas from the universities of Padua, Venice, and Rome – a part of the Osler Library's scholarly collection of medical books and artifacts. The nucleus of the collection is the 8000-book library left to the university by William Osler.

THE McGILL UNIVERSITY MUSEUM COLLECTIONS began in 1855 when the new principal, William Dawson, brought to the university his own scientific specimens which were to form the nucleus of the collection eventually housed in a proper museum building presented to the university by Peter Redpath. In subsequent years several gifts – an outstanding collection of minerals, the superb Carpenter collection of shells, and many items of archaeological and ethnographic value – were added to the Dawson nucleus.

The Egyptian mummies are a special attraction. They still keep some of their secrets in their eternal silence. One of them is that of an elderly female who lived in the Eighteenth Dynasty, approximately 1500 years BC, during the period of the New Kingdom and the great temples at Karnak and Luxor. Her name must be on a piece of papyrus, probably still inside her. Once she must have had a copper mask on her face. Strangely enough, she is buried in a coffin covered with colourful hieroglyphs which belonged to a man. The preservation of the body in this form relates to the Egyptian cult of the dead and their view of the future life. Although the spirit left the body at the moment of death, it was believed to have the power and the desire to return to it from time to time. So the body had to be preserved by embalming to enable the dead person to live in tranquillity without disturbing the living. The *Book of the Dead* which accompanied the departed contained hymns, prayers, magic formulas, an account of the origin of things, which would help the dead person on his journey and his appearance before Osiris, the god of the underworld sometimes identified with the sun. A fragment of such a papyrus can be seen in the Redpath Museum. The mask on the face had a particular function. It caused that which had vanished to reappear; it made it present again. It was a way of preserving the personality of the departed for eternity. The mask changed in the course of time to become one of the antecedents of the Byzantine icon, the holy portrait. This should not be confused with the secular portrait known to the Greeks, adored by the Romans, and firmly established in European societies by the aristocracy and the bourgeois classes alike. A series of portraits, several by Robert Harris, hang on the walls of Redpath Hall; all are of people related to the university and its history. Most of these likenesses, dark and solemn, look like modern icons hanging there to solemnize the Baroque concerts given by the Faculty of Music in that beautiful hall. For us, death masks may not have the magic properties they had for the Egyptians, but they continue to make present that which has vanished, as can be seen in the death mask of Alban Berg, the Viennese composer whose operas *Lulu* and *Wozzek*

above
A fossil crustacean from the English Challenger Expedition of 1873–6, the first sea voyage undertaken primarily for the purposes of research. The illustration is from the Blacker-Wood Library of Biology.

facing page
One of the most popular objects on display in the Redpath Museum is this richly decorated coffin of an Egyptian mummy from about 1500 BC.

enjoy great popularity today. Here the stiffness of death is more alive than life itself.

The wooden figures from Zaire or from Angola are yet another manifestation of religious life. The influence of these sculptures on twentieth-century artists like Picasso, Epstein, Brancusi, and others is well known. The figures are splendid examples of the meaning of representation. For primitive peoples art has a practical purpose. One cannot do as one likes with men and creatures; one cannot control them for one's own benefit or protect oneself from them. One must instead fix in an image the movement in which the creature is engaged. This image represents a second form of the creature and whatever happens to the image happens to the creature which the image represents. The fixation of the movement can be best perceived if the viewer compares any of these figures to *The Falcon Man* by McKenzie mentioned earlier. In other words, these wooden figures had magical powers; they could destroy an enemy or they could protect a person from sickness or death. This is a religious function which makes an individual another creator. Through art a new world, a second world, another reality with its own powers is constructed.

The other world so firmly accepted by the Egyptians had certain features which are also found in the worlds shaped by the Greek, the Christian, and the Islamic traditions. Their common landmark is a garden with a miraculous tree. And, indeed, there is such a tree in the Redpath Museum. For those uninitiated in the mysteries of nature, this

right
The Redpath Museum's cross-section of the "miraculous" Douglas fir that grew in British Columbia from 1345 to 1867.

facing page
Kongo figure from Africa Originally donated to the Natural History Society of Montreal in about 1860, it came to the Redpath Museum when the society disbanded in 1925. Figures of this kind from Angola and Zaire were considered to be very powerful and were kept in the community to protect its members.

153

154

tree is indeed a wonder. According to the reading of the rings of its trunk, this Douglas fir began to grow in British Columbia in 1345. The rings provide a fascinating voyage in history: the tree stood when Columbus discovered America in 1492, when Jacques Cartier discovered the island of Montreal in 1535, when McGill was founded in 1821, and at the end of its life, the tree witnessed Canada's Confederation in 1867. Certainly this tree was oblivious to all these great events of human history, but any time I see it I cannot help thinking that this might have been one of the trees that grew in Paradise on top of the Masha Mountain of the Babylonians where the gods lived, or, perhaps, the tree of the enchanted garden, decorated with precious stones, that Gilgamesh, the great Babylonian hero, encountered after his frightful wanderings in darkness. At other times I think of the tree bearing golden apples in one of the islands of the blessed described in the *Voyage of Maelduin* by an unknown Celtic writer, perhaps of the ninth century. Still the idea that Volsa, the hero of Germanic mythology, fixed in such a tree a stout sword intended for the strongest alone, for his son Siegmund to help him in adversity, fascinates me – a fascination that perhaps has much to do with the music of Wagner. Of course none of this is possible. This is only the trunk of a tree that lived for many centuries. But paradise in the traditions is distinguished, among other features, by precious stones and magic plants.

They are to be seen in the Redpath Museum. For the living plants, one has to go to the Herbarium at Macdonald College, but in the Redpath, the world of the water is nonetheless spread out to be admired: white and blue corals, helmet shells, often used for the production of the cameos so dear to the Venetians of today, many-chambered shells, strange flowers of the sea. There is also the priceless mineral collection of James Douglas. Here are amethysts, magic rock crystals, yellow, white, and dark green stones. Malachites, beryls, aquamarine, tourmaline, copper, and silver. The flood of light creates a phantasmagoria. Indescribable colours seem to fly into the air. Every

facing page
Initiales d'un Rouge #91
by Jean McEwen
This painting is part of a collection originally owned by the Montreal Star. *It was donated to the university in 1980 when the newspaper ceased publication.*

time I see the beauty of these objects I cannot help musing. Here are the magic plants growing invisibly in the water that restore vigour, mentioned by Gilgamesh when he reached the fields of the blessed. Here are the stones of which the New Jerusalem was made, described by St John in his Revelation. Above all, I am led to think of a woman, an extraordinary spirit who lived in the Rhineland valley in the twelfth century, Hildegard of Bingen. Among the many books she wrote is *Physica,* in which she speaks at length of stones, trees, plants, and herbs and of their medicinal properties. Hildegard observed the brilliance of stones but also of everything that was under the rays of the sun. She believed that all living creatures were sparks from the radiation of God's brilliance and that these sparks emerge from God like the rays of the sun.

right
A silver Greek coin from the time of Alexander the Great. It is one of more than 2000 in the McGill collection of Greek and Roman coins.

facing page
A surgical travelling kit used by the Vederalas, physicians and surgeons of early Ceylon (Sri Lanka). This is among the items donated to McGill by William Osler.

The McGill collection of Greek and Roman coins reflects the economic importance attached to the minerals of silver and copper. Among them is one of the earliest examples of the coinage of Alexander the Great. This silver coin of the fourth century BC portrays the great conqueror, whose beauty could be explained only through his divine descent, wearing a skin headdress which changes him into the Greek semi-god, Heracles. His features are idealized – rich unruly hair, wrinkled forehead, slightly open mouth – and his head is slightly uplifted gazing at heaven to suggest divine connections, a pose later adopted for the same reason in portraits of the first Christian emperor in Byzantium. Alexander's portrait reflects the creations of Lysippus, the great Greek sculptor who worked at Alexander's court and whose work

shaped the art of that great period in European civilization, the Hellenistic world. This coin, like our own coins and stamps, was to disseminate the image of the ruler among his subjects.

The constantly moving light that so clearly emanates from stones has always captured the imagination of man. The Egyptians and the Greeks introduced the movement of light into their religious rites and theatrical performances. With the help of lamps they reproduced it and then intensified its effects with the use of coloured glass, prisms, and various reflective surfaces. Here are the roots of Luminism, the art of moving coloured light which is practised today by many artists in various countries. The poetry of colour, light, and movement may explain man's fascination with everything that relates to glass – its fragility and its solidity, its transparency and its translucency. Stained glass is one of the manifestations of man's attraction to light and colour. McGill has a collection of domestic stained glass and glass paintings, unique in Canada, that once decorated the house of Charles Hosmer, a prominent Montreal businessman at the turn of the century. They are now set up in the School of Architecture. Flemish, Dutch, German, and Swiss in origin, they represent a remarkable anthology of styles. One of them comes from Switzerland and was made in 1678, the period of the Baroque in Europe, probably after engravings. Its large central panel tells the story of Jacob and the flock of Laban. A farm with buildings, a well, and trees form the setting. Jacob in the foreground sets the green rods in front of the flocks going to drink water so that they may conceive among the rods and Jacob may be able to choose the best for himself. According to the text on the upper panel, God brings prosperity to him who honours God and hope never fails. Faith and Hope are represented by the female figures set in the side panels and identified by their respective symbols, the anchor and the dove. The theme indicates clearly the importance the Lutherans gave to the doctrine of justification by faith. The formal arrangement of this painted glass, a central piece framed with smaller panels of allegorical and decorative subjects, is also found in fresco painting, in engravings, and in book illumination. Some splendid examples of book illumination are housed in the Department of Rare Books. Both the glass and the illuminations exaggerate the application of ornament to a certain degree. There is something contrived in all this, manifesting an artistic will which is bound to lead to the creation of curiosities like the Featherbook in the Blacker-Wood Library of Zoology and Ornithology. Complete scenes made of birds' feathers!

Best described as a treatise on birds, a type of book known since

above
Title page from a book in the Lande Canadiana Collection, one of the treasures of the Department of Rare Books and Special Collections. A McGill graduate and notary, Lawrence Lande, made a series of donations to the university, including works on William Blake, the Book of Job, and English literature of the eighteenth through twentieth centuries. His Canadiana collections, along with the two bibliographies he published on that material, have contributed to making McGill one of the country's most important resources of Canadiana.

facing page
One of the thirty-nine priceless painted glass miniatures discovered by a fine arts graduate student, Ariane Isler, in Hosmer House. Painted by a variety of European artists, the panels come in all shapes and are from six to twelve inches across. The scenes they portray are amazingly detailed. The panels are now mounted in a special display unit in the Macdonald-Harrington Building.

159

the Middle Ages, this feather book, acquired by McGill in 1923, is most unusual. Made in 1618 by the mysterious Dionisio Minaggio, a gardener of the governor of Milan, it presents a gallery of rare and common birds, mostly of Lombardy, as well as hunting scenes, characters of the Commedia dell'arte, minstrels, and artisans, all in costumes of the early seventeenth century. In modern parlance these feather compositions are "collages" which display the taste and the imagination of their creator. But feathers were used at the time in various ways, particularly in costumes for productions of Baroque dramas and operas. Feathers have their own fascination outside the theatre and have always been used for adornment as shown by some of the superb costumes in the McCord Museum – a somewhat different aspect of the great Canadiana collection which forms its principal component.

Among the McCord treasures are some jewels by Cornelius Krieghoff, the Dutch-born painter who spent most of his career in Quebec and gave us fine depictions of the life of the Indians and their hunting activities. Above all, in works like *Maison rustique au St Maurice,* or *French Canadian Habitants Playing at Cards,* he understood and immortalized French-Canadian everyday life in the nineteenth century.

Like every other century, the twentieth century has witnessed various revivals of styles and types of art. One of these revivals was the art of tapestry, and the guiding spirit of this adventure was the French painter, Jean Lurçat, who fell under the fascination of the great masterpieces of French tapestry such as the fourteenth-century *Apocalypse of*

Persian Rug *by Saul Steinberg*
One of the modern tapestries
presented to McGill by a graduate,
Regina Slatkin, hangs just outside the
entrance to the McLennan Library.

St Jean of Angers and the fifteenth-century *Lady and the Unicorn* in the Musée Cluny in Paris. Lurçat wanted to make the tapestry the mural of the post-World War II age, as it had been in the Middle Ages, when the walls of dark churches were covered with them. In this art form the painter needs the collaboration of the weaver who is going to reproduce his work by means of an artisan's material, wool. McGill has some very beautiful examples of this art, the gift of Mrs Regina Slatkin, a McGill graduate. One of them, *Abstraction,* is by Roy Lichtenstein. Seen and admired by everyone who goes from the Arts Building to the Leacock Building, it is an example of Pop Art, which uses the techniques of advertising and the representation of banal objects. Lichtenstein manages to lift the banal to a high level. He gives a bird's eye view of the world. A huge yellow sun rises to warm the deep brown earth and wake it from its slumber. The blue of the sea and a dark airplane flying above speak of man's explorations and conquests. On the left an Ionic column recalls the Classical tradition and makes the past present. Next to it is the bust of a Greek Archaic kouros, a young man who begins to rediscover the world around him. Two other tapestries (now in the Faculty of Music) are by Picasso: one is entitled *Jacqueline,* the name of his second wife, and the other is *Ombres.* A

face, a blue house, a balcony, trees, shadows, blue and white; only the essentials are to be seen. I would call them Mediterranean.

Another type of revival, in style and message, is a modern icon, a painting entitled *Christ's Entry into Jerusalem* by the celebrated Greek painter and novelist, Fotis Kontoglou. As in all his creations, Kontoglou has translated into a modern idiom the eternal language of the Byzantine icon which has dominated the spiritual life of eastern Europe and has contributed to the works of some great spirits of this century like the German poet, Rainer Maria Rilke. Flat forms, an abstract concept of space, dematerialization of the body by means of colour and line bring us another reality: the immutable world of God. I once visited Kontoglou at his place of work, a Byzantine church in Athens. He was on a scaffolding, painting or restoring the face of Christ Pantocrator, Christ as he who holds everything in his hands. He was up high and I was below striving to see Christ's face, and in this way we carried on our conversation. Before I left, Kontoglou, brush in hand, had started chanting a hymn about the beauty of the Lord. To me Kontoglou is the twentieth-century's Andrei Rublev, the celebrated Russian painter of icons.

Another modern development is the art of the poster, the *affiche*. It began with the French painter, Jules Chéret, who produced the first

Christ's Entry into Jerusalem
A modern icon by Fotis Kontoglou, it hangs in the chapel of the William and Henry Birks Building.

Ecunda etas mūdi principiū a Noe babuit post diluuiū:qd fuit vniuersale p totū Anno sexcē-
tesimo vite Noe a pncipio aūt mundi bm be. Millesimosexingentesimoquinquagesimosexto.
Sed bm.lrr. interptes quos Beda et ysido. approbāt Dis mille ducenti r. rlij. r durat vscz
ad abrabam bm be.292.annis. Sed bm.lrr.842.annis. Ante diluuiū vo p.100. annos
Dominus apparuit Noe id e quingentesimo anno vite Noe.

Oe diuini bonoris et iusticie amator fi-
lius Lamech. ingenio mitis r integer in-
uenit grām coram dño. Cū cogitatio ho-
minū pna erat ad malū, Omi tpe omes in viam
recta deducere satagebat. Cūcz instaret finis vni-
uerse carnis precepit ei dñs vt faceret arcam de li-
gnis leuigatis bituminatā intus et extra. que sit
trecetor cubitor geometror longitudinis. Oro-
sius r post eū Augusti. r Hugo. Cubitū geome-
tricū ser cubitos vsuales facere dicūt: quā pticaz
noiant. Sit itacz trecetor pticar lōgitudis:qn-
qginta latitudinis r triginta altitudinis. i. a fun-
do vscz ad tabulatū sb tignis. Et i cubito cōsum-
mabit illā. In ꝗ māsiūculas cenacfa fenestrā r osti-
um i latere deorsum facies. Noe igit post cētus r
rr.ānos ad arcā fabricatā. ꝗ p solatio vite erant
nccria cōportauit. Cuctorūcz aialiū ad buādū ge-
nus eor masclos silr feminas piter introdurit.
Ipe denicz r filij eir vror r vrores filior primo
die mēs april ingressus e. Facto diluuio cuz dñs
oēm carne deleuit. Noe cū suis saluatr e. Stetit
cz arca sup altissimos mōtes armenie. Qui locr
egressor vocat. Egressi deo grās egerūt. Et alta-
re facto:deo sacrificabant.

Oc signū federis qd vo inter me et vos r ad
omnē animā. Gñ.ir.

Arcus pluuialis siue Iris licet dicatur bre ser
vel quatuor colores. tñ duos colores pncipa-
liter babet. ꝗ duo iudicia repntant. aꝗus diluuiuz
pteritū figurat ne amplir timeaf .igneus futurū iu-
diciū signat per ignem vt certitudinaliter expectef

Illo diluuij Anno prima seculi etas termiata e
ab Adaz vscz ad diluuiū inclusiue. Etas scda ince-
pit r ad abrahe natiuitatē vscz perdurat.

Oe vna cū filijs r vrore ac filioru vroribr er
archa egresso:pfestim altare edificatode cūcti
pecorib' volatilibuscz mūdis bolocausta dño ob-
tulit. Et eir odore suauitatj odorat' est dñs. Pro-
pter qd eidem dñs benedirit ac filijs suis dicens.

HONEST ABE TAKING THEM ON THE HALF SHELL.

three coloured, lithographed posters in about 1870. McGill includes among its treasures original paintings by Chéret in a mixed technique, maquettes for posters to announce important events of entertainment: *L'Enfant prodigue,* a pantomime in three acts by Michel Carré with music by André Wormser, and *La Patineuse.* Colour and drawing convey in the one case the tragic content of the pantomime – blue is here the predominant colour – and in the other the exhilarating experience of skating through a vibrant red.

IN MY WANDERINGS I have touched upon thousands of years – a sign of the great diversity of the McGill Collections. There is no unifying thread but this is a positive feature. The student is thereby exposed to all these different tastes and may marvel at the world of nature and at those creators who, from the dawn of time to the present, have attempted to stop time – humanity's worst enemy – and conquer eternity. The McGill treasures mirror all this.

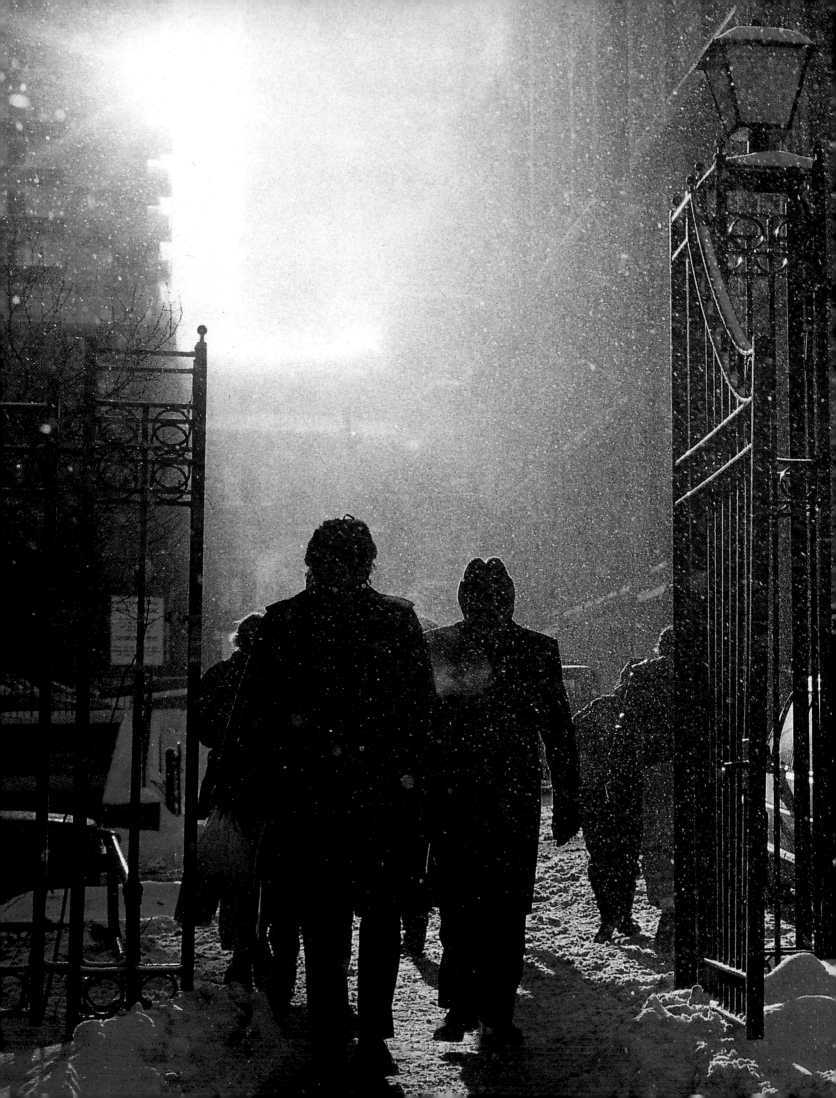

McGill and the Community ... and me

Donald MacSween

Mother had had it. Her enunciation was immaculate – the clipped, razor-sharp diction of a wilful parent. "Those boxes depart my basement this very year!" This was not an open invitation. A marriage or two, a job or three, a child or five – a score of years had subsided into posterity since last I laid me down to sleep in maternal custody. Thus, to my mother's Lutheran way of reckoning, she was quit of further obligation to warehouse her child's university lecture notes. Even an only child.

I had chased a non-honours B.A. through the early fifties at a pace which can most sympathetically be described as "measured." I drove on – no change of gear – to be graduated a second time: law, the kind of robust certification designed to stand one in an employer's good stead should it ever come down to having to earn one's own living. I was, moreover, the sort of student who wrote everything I heard at university down. Provided, of course, it had been said in a loud, authoritative voice, in a modern language I understood, and by someone who appeared to have a part to play in fulfilling my parents' hopes for their family's academic accreditation and worldly welfare.

My friends thought of me as insecure. My maternal grandmother thought me prudent; she hung out in the room next to mine and, of an evening, could hear me studying to the radio. Either way, by the time

Real Life caught up with me I had noted down a great deal of forgettable information. Remember those hard-covered khaki-coloured notebooks with the big black "McGILL" stamped intimidatingly into the cover, defying you to write any word that would besmirch your alma mater's hitherto untarnished name? Remember how, as you pried them opened for the first time, slowly so as not to crack the binding, there would be this agony of thin, prolonged creaking – a faint preternatural lamentation over the wanton holographic abuse about to be remorselessly gouged into those chaste pages? You do remember don't you?

I transferred my matched set of decomposing grocery boxes into their new basement. But I couldn't just let sleeping dogmas lie, as I remember an abnormally jocular dean once wheezing. So I took a random peak. ORG-CHEM 201. My, my, look at all those carbon chains! There was a time son, I said to my awestruck self, when you knew what every one of them meant. I closed the box. Academic bygones are as bygone as things ever get. Or as Stephen Leacock has computed: "An education, when it is all written out on foolscap, covers nearly ten sheets."

IN 4000 WORDS OR LESS, describe what McGill has meant to the community. (One has only to turn the examination over and read the first question for the mind to relax – utterly.) *You may begin.*

Compacting the story of McGill's connections with its several communities into the space stipulated has the same potential for comfort as reducing the *Kama Sutra* to a single sonnet. Not impossible; easier, however, if one is by Augustine out of Shakespeare. My sense of inadequacy will be immediately understandable to the entire McGill French Department circa 1955.

Things, however, could be worse; the book might have been called *McGill: a cerebration*. A salutary typo means I am not out of bounds for simply picking a small, distinctly at random, purely private posy out of an intellectual ecosystem at least as fertile (pre-*homo sapiens rapiens*) as any tropical rain forest. What we have here, then, is a celebratory sampling of the people, programs, and policies that have made James McGill's university one of mankind's vital organs in its increasingly urgent search for knowledge and understanding or, failing that, a job. But first, a word about our sponsor.

THE SEVEN YEARS' WAR (Leacock the computer) "lasted nine years, from the first shot fired to the pen and ink of peace." But when Montreal fell

facing page
Memorial stained glass window designed by Percy Nobbs for the Strathcona Anatomy and Dentistry Building. It commemorates three members of the teaching staff of the Faculty of Medicine who died in World War I: R.P. Campbell, John McCrae, and H.B. Yates.

170

171

to the English in 1760, *adieu* two hundred years of exploration, exploitation, conversion, and colonialization, the mortal blow to France's North America had been struck. Last rites were administered by the Canadian-born Marquis de Vaudreuil, terminal governor of New France, with his signature to the articles of capitulation early on the morning of 8 September. The next month, James McGill turned sixteen.

He had been born at Glasgow the year – framing a reference – that Edinburgh University refused the 33-year-old sceptical empiricist, David Hume, appointment to the chair of ethics and pneumatic philosophy on grounds of "unorthodoxy." Two centuries on, and for the same reason, the deanship of the McGill Law School would be denied another empirical sceptic, himself a frank Scot. The adult

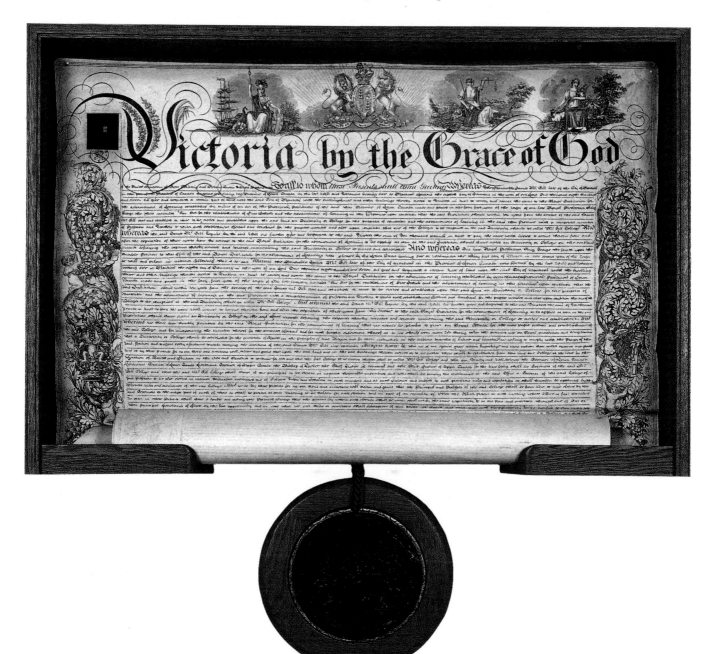

James McGill would have supported both decisions; as Stanley Frost estimates, "McGill was both by nature and from business considerations not predisposed to sympathize with revolutionaries."

James turned two as the Highland hopes of Charlie Stuart were laid "dead on Culloden's shore." He matriculated at twelve, not then an abnormally early age, and attended Glasgow U., leaving without qualifying for a degree (as Hume did Edinburgh!). He went west and at twenty-five had been based in Montreal for some three years, when Watt patented a steam engine, Cavendish dissolved water, and Mozart at twelve wrote his first opera. The future founder of a New World university grew up with the science of the European Industrial Revolution and in an age of remarkable musical creativity. McGill, praise be, was in no way deflected from the pursuit of commercial achievement by either of these influences.

As Britain took over from France, there was a rapid build-up of the city's English community and, for better than a century and a half, Montreal was a city shared, if not equitably at least functionally, between French and English. Among the earliest British settlers in Montreal, McGill spent his first decade "in the canoes," a trader-voyageur in the physically and commercially risky business of bartering for furs with the on-site suppliers. By 1776 he was well enough off to marry and settle into the life of a Montreal merchant – "a businessman ready to undertake pretty well any 'commission for a commission'." Montreal was a town of seven thousand when James McGill arrived, fifteen thousand when he died.

James McGill, spirit and body, was a big man. In *Leacock's Montreal* (1948), the author adds him up this way: "If early adversity makes for courage and character McGill was blessed indeed." I linger so long over McGill the man because his struggles and achievements are such an apt metaphor for the life of the university he conceived and founded. What Leacock observed of the founder has proven true of his institution.

This appears strikingly when one considers McGill's impact on his/its community. In contrast to most of his fellow merchants and traders, James McGill took a full part in the life of his city and his province: municipal magistrate responsible for roads, markets, taverns, etc; at various times commissioner for prisoners, foundlings, and the insane; thrice elected member of the Legislative Assembly; commandant of the 1st Battalion Montreal Militia. Like the university he endowed, James McGill was "a public servant."

America has invaded Canada, militarily speaking, only twice – so

above
James McGill

facing page
The McGill Charter as amended in 1852. The university became, in effect, a private institution, rather than an extension of the government, and a new era in McGill's history began.

173

174

far; both times McGill (the man) was in the thick. When Montgomery attacked Montreal during the Revolutionary War in 1775 and Carleton tactfully retreated to Quebec without a fight, McGill (aged 30) was among the twelve merchants assigned to negotiate the city's surrender. Thirty-eight years later, during the 1812–14 flare-up, McGill was chairman of the Montreal Committee of Lower Canada's Executive Council and, as colonel of the Montreal Militia, commanded the brigade which supported de Salaberry and his Canadian Voltigeurs in the rout of a superior American force at the battle of Châteauguay (26 October 1813). With the threat to Montreal averted, McGill had lived to see the military fortunes of his beloved city come full circle.

Two months later he was dead. Dr Frost cites the *Montreal Gazette:* "aged 69 years, after a short illness the Honorable James McGill … venerable and respectable citizen … deservedly filled the most elevated stations in his community … eminently qualified … acquitted himself, in a manner highly honorable to himself, and useful to the country … accompanied to the grave by an immense concourse of citizens, of all classes." His legacy to his community was and continues to be immense.

DISCOVERY. WHAT A UNIVERSITY CONFERS IS DEGREES; but what it makes is discoveries. And the more it makes, the better off we all are – an article of faith fundamental to our contemporary doctrine of civilization. The

facing page
The "Founder's Elm" stood on the front campus from before the days of James McGill until recent years. When it had to be removed, it was replaced with a cement replica and a plaque recording its long history.

below
A favourite Notman setting, in front of the McGill grounds, where Montreal families came to have family portraits taken.

university community – the clerisy – is an élite phalanx in humanity's perpetual struggle against the forces of darkness on one flank and the incredible lightness of being (to pilfer a phrase) on the other – an hypothesis which the community itself finds entirely plausible.

Its members – as they themselves with no encouragement and less circumspection are the first to suggest – are an armada of cerebral Vasco da Gamas beating their joint and several ways down a universe of unexplored intellectual latitudes in lustful, at times frantic, frequently unpublished, forever underfunded pursuit of that most elusive and chimaeric of all this earth's riches – Fact.

The fact is, however, that it has not been the craving for noble metals, sparkling gems, shimmering filaments, hairy pelts, junk bonds, or biochemical stimulation that has put our successive civilizations in greatest jeopardy. The real source of worldly woe, what brings us all to the heart of darkness (pilfer, pilfer), is an unseemly, unashamed, and unremitting addiction to the search for Knowledge – the zealous pursuit of Truth, plain or varnished. This is not, to be sure, an un-mixed curse; from time to time, obstacles to a better life are removed. The devil of it is, of course, that so many of these obstacles have been the answers to earlier questions.

From the Nobel laureate, certifiably "accomplished" but whirling through worlds too recondite for all but the most powerful mental muscles to grasp, to the dampest freshperson, anxiously queuing before an indifferent library assistant in quest of initiation into the mysteries of the computerized catalogue – everyone, the entire university community, does nothing whole lives long except dig for answers. But – it has not gone unnoticed – the outcome of any serious research can only be to make two questions grow where only one grew before. Under a strong light, the whole process can be rightly seen as a vicious straight line. Students concentrate on the particular breed of answer that corresponds to questions likely to appear on the examination papers they will be invited to endure on the way to being either graduated, *cum* or *sine laude,* or invalidated, finally and forever. This approach is publicly excoriated as egregiously pusillanimous and pri-vately acknowledged to be altogether sensible.

Aquarius be damned, this is the Age of Education – primary, secondary, undergraduate, postgraduate, and continuing. Pre-school schools, institutes, academies, conservatories for the artistic, seminaries for the righteous – the groves of Academe are now a vast industrial subdivision of information factories and the examination-passing classes are the accredited bulwark against the barbarian. Light-

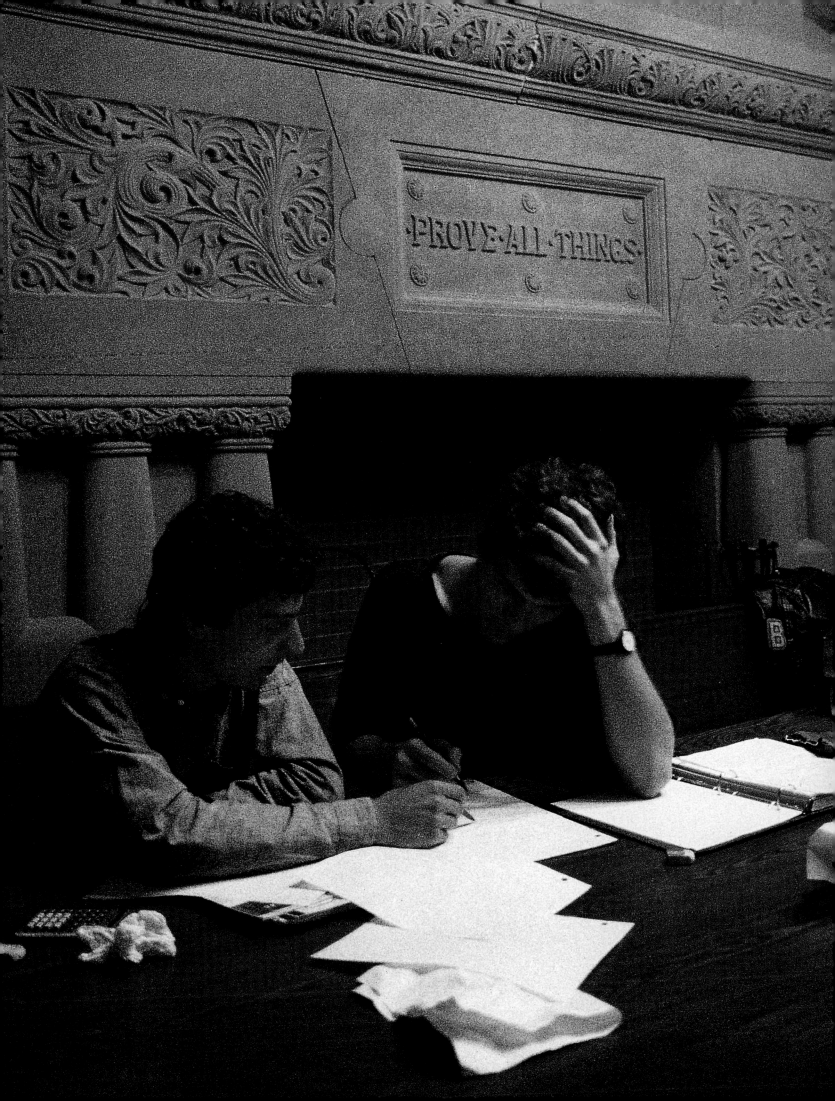

years have flashed by since something resembling your Uncle Max first discovered you can't catch the downtown bus sitting in the trees. But no more than six minutes have elapsed since the dawning of the Education Age. Still plenty of answers left undiscovered, including the big one: why does the "woe factor" increase geometrically every time another answer is unearthed?

TEACHING, RESEARCH, ADMINISTRATION; but the greatest of these is teaching. Or is it research? The interminable *causus belli academiae,* the impenetrable poultry (chicken/egg) problem, the first item on the hidden agenda of every university budget committee. *Au fond,* effective teaching is as much a process of discovery as productive research. On first looking into Shakespeare's *Hamlet,* one is immersed in revelation no less deeply than the frequent-flyer research fellow discovering, after umpteen attempts, a proof of his hypothesis to be Q.E.D.

For me personally, however, if McGill was one particular thing, it took the form of a teacher – the kind who justifies the proposition that

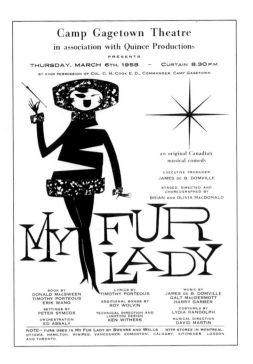

tuition be refunded to students allowed to graduate without having been exposed to at least one member of faculty to whom they can relate, life-long, as Alexander did to Aristotle, Frederick to Voltaire, and Trudeau to Trudeau. We all need one genuine guru. Mine – and his was a very extended ashram indeed – was Frank Scott. Fall into a Scottian orbit and you were ruined for life, or at least the unexamined life of convenient conformity, sensible respectability, and practical prosperity.

His personal interest in a student rose in direct proportion to what one did beyond mere studying and the extent to which it corresponded to his sense of how the best of all possible worlds should turn. For the four students who wrote and composed most of the *Red and White Revue* of 1957, *My Fur Lady,* the show was our entitlement to Clarke Avenue martinis and supper with Marian. The risk was, of course, that this would do more for your ego than it did for your marks. (We suffered only one casualty – and I was eventually rehabilitated.)

A decade at the bar of Quebec and it was suggested to me that I should quit law and accept appointment as director general of the National Theatre School of Canada, along with a lifetime income drop of some several thousand points. I went to Frank for advice. Not, you understand, about which career would be the more rewarding, but as to whether one should take on a job having serious doubts about one's competence. Law may well be just another branch of show business, but would that be enough? "My boy," he said, fixing me with the good eye and the crest of his nose, tumbler balanced precariously

My Fur Lady
The 1957 version of the Red and White Revue *became the first "fringe attraction" at the Stratford Festival and eventually gave 402 performances in 82 centres across Canada. Above, the program from the Camp Gagetown appearance and the flag, designed by Gordon Webber, which served as the stage curtain.*

on an otherwise unoccupied knee, "there's a human right everyone neglects. It's the *right to fail*. Give it your best shot; if that's not enough, we'll shoot the idiots who chose you. Besides, you didn't let the issue of competence deter you from practising law!"

Towards the end, Frank was in the Ross Pavilion of the the Royal Victoria Hospital. I dropped by one autumn afternoon on my way to the monthly meeting of McGill's Board of Governors. I met Marian on the way in. She warned me not to expect too much, what with pain and painkillers, and just to chat about things the way we'd always chatted. Frank knew about my appointment to the board. He didn't know I had been made chair of the Committee on Social Responsibility – a device installed in the late seventies to dampen, though not necessarily extinguish, the energies of the students and faculty then vigorously demanding McGill rid itself of shares in corporations whose dividends flowed in part from profits earned in South Africa. So I told him:

> Lawrence MacDougall was the chair who negotiated a divestment policy accepted by all sides including, *mirabile dictu,* a majority of the board and most senior administrators – some more enthusiastically than others. His personal integrity, good sense, and patience kept the lid on a tight situation and divestment was now officially possible – a first for Canadian universities. Of course lots of room was left for companies to correct the record or change their ways before any boom could actually be lowered. The sort of process on which Canada holds the patent: divestment if necessary but not necessarily divestment.

It was warm and sunny outside. But the window faced east and, late afternoon, the room was in shadows. Frank sat erect, hands on knees, in a straight-back chair and the regulation hospital chemise. He was quite still for a long moment. I couldn't see his face and began to wonder if he'd heard anything I'd said. Then from the gloom, that sharp, oddly treble voice, lowered and hollowed for effect, full of mock consternation, building to the punch, timing impeccable: "Were McGill ever to dispose of all its property about which there was some moral question ... My God, there'd be nothing left!" (And then the laugh.)

Apart from his work as a professor of constitutional law (and dean of the faculty – belatedly!), Frank Scott was a partisan politician, a human rights activist, and a poet. The freedom and security of the individual person; the beauty of the clear thought – elegantly, economically, wittily, tenderly expressed; the land he knew as a child and

Eugene Forsey
A lecturer in economics and political science 1929–41 and, along with Frank Scott, one of the radicals of the thirties. McGill gave him an honorary degree in 1966.

Frank R. Scott
"Fall into a Scottian orbit and you
were ruined for life, or at least the
unexamined life of convenient
conformity, sensible respectability,
and practical prosperity."

over which he roamed throughout his life: among his public passions, these three topped the list.

He was a lawyer who went to court sparingly – not, to be sure, a desirable practice if one wishes to avoid a sharp drop in support for alma mater funds and an equally alarming rise in the tide of human happiness. When Frank did plead a case, the consequences were immeasurably gratifying to his client and consequential for his country. At his urging, the Supreme Court of Canada has held that: the state cannot padlock property in order to suppress wrong thinking; heads of government, even acting in their official capacity, are not above the law; the state cannot withhold a writer's vision of life from those who wish to see it.

Frank Scott – like James McGill – was a beneficent and courageous participant in the life of his community. They personify the university which the one founded and to which the other dedicated his life. In this *causerie éphémère,* they stand as representatives of the hundreds of thousands of men and women – faculty, staff, students,

Student Union Building on McTavish

graduates – who by serving McGill have served their community for nearly two centuries.

"Men," said David Hume (in an age when the masculine still embraced the feminine), "cannot change their natures; all they can do is change their situations." Quite credibly, the same may be said of human institutions. McGill University is true to its nature in so far as it remains dedicated to changing its situation, to improving the community in which it lives and thrives.

SYMBIOSIS IS DEFINED (Chambers) as "a mutually beneficial partnership between living organisms of different kinds, especially such an association where one lives within the other." The relationship between a university and its community is – in a word – symbiotic. In

182

its social sense, community refers to "a body of people organized into a social or political unity" (OED) – a neighbourhood. For McGill, the question – and it's one of enormous consequence to the university's future – is where does it draw the boundaries of its neighbourhood, in which community does McGill live?

First and last, McGill is a Montrealer. By location and history, by weight of student enrolment and graduate distribution, by faculty and staff residency – its claim to that coveted quality is indisputable by every criterion known to demographers, anthropologists, and other soft scientists. However, after a protracted gestation and painful delivery, the university was born and grew up at a time when to be a Montrealer was to belong to *British* North America. One of the consequences was a lurking danger that, in the selection of leadership for the infant institution, the provincial snobbery endemic to colonies would prevail. Its first two principals were clerics, so a blind eye was presumably turned to whatever deficiencies arose from birth and/or education outside the "mother country." Its third turned out to be less than met the eye – he was a lawyer, a profession where these optical illusions aren't always that easy to detect. He was shortly to excuse himself from office, student enrolment having dipped from 20 to 13. The fourth was also a lawyer, but only interim.

William Dawson, 1895

Then the governors hit gold – reluctantly. A native of Pictou, Nova Scotia, was recommended and – to McGill's eternal good fortune – was accepted as its fifth principal. In 1855, at age thirty-five, William Dawson – latent *Sir* but as yet holding no university degree – began a 38-year stewardship that was to earn him fame as "the man who made McGill." Edgar Andrew Collard – eminent journalist and historian of Montreal's yesteryears – describes the scene: "The governors were 'both startled and disappointed' ... They had consulted the Governor-General, Sir Edmund Head, a man of university connections and literary tastes. They had expected him 'to indicate some man of mark in England.' Instead, [he] urged them to choose ... a young colonist in Nova Scotia. *Few, if any, of the governors of McGill had even heard of him.*" [emphasis added]

No doubt, this approach to corporate management is known to today's experts as "serendipitous vacuity." Successor governors, however, have honoured the precedent far less assiduously than certain upstart elements on faculty would have you believe. Even so, not until the tumultuous 1960s – when McGill students sang the siren song of academic democracy in unison with their homologues across North America and Europe (well after my time, harumph) – was

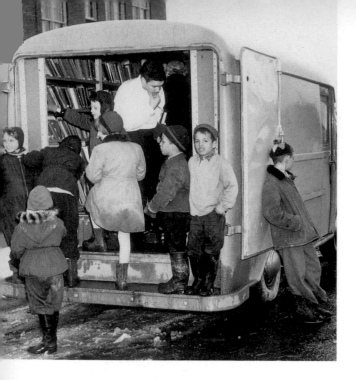

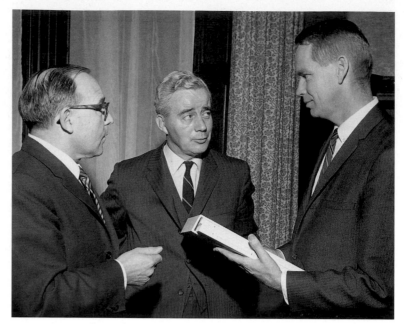

McGill formally to renounce the theory of benign but monied oligarchy as the instrument of choice for university governance.

In 1967 – during, but not intentionally part of, Canada's centenary celebrations – the governors decided that "the self-perpetuating character of the Board under the present Statutes probably [*sic*] can only be justified henceforth, if *the general composition of the Board represents the wider community which McGill in fact now serves and on which it depends.*" [emphasis added] More than one governor may have wistfully, but ever so softly, sighed, "où sont les neiges d'antan?" – may, that is, had they been more conversant with all two of Canada's official languages. But in adopting this radical amendment to the formula for appointing governors, another bridge between the university and the community had been opened. Another instance of McGill – sometimes goaded, more often spontaneously – adjusting its symbiotic relation with the community in favour of increasing intimacy.

BORN A MONTREALER, the university is, naturally, a Quebec native with roots a century and a half deep. While beginning life as an English-speaking *Qwee-beck-ur*, McGill's social, professional, and linguistic relations with French Canada have followed the same evolutionary path that the majority of the English community in Quebec has travelled, some more readily than others. McGill will never claim to be a *Kay-beck-qwauze pure laine* (*une Canadienne,* as the style once was in those not-so-long-gone days). Even so, the university currently boasts a student population 22.2 per cent of whom speak French as their mother tongue and who, overall, are 71.8 per cent from Quebec.

The Montreal I grew up in was the world's largest French-

speaking city after Paris. Nevertheless, the confessionality of Quebec's system of public education ensured that the sounds of classroom French striking English-speaking ears [*sic*] would issue only from Protestant – therefore English-speaking – mouths. I emerged from high school capable of conjugating the most irregular French verbs but unable to ask, except in English, for a transfer on the 3A streetcar.

McGill to the rescue – sort of. I immersed myself in the French summer school and noticed an immediate improvement in the ability of my French friends to make themselves understood. Only one snag: I got better service ordering a *café filtre* in *Les deux magots* on *la rive gauche* than in *Chez Horsmidas* on *La Main* picking up *un hot-dog steamé*. McGill's French Department, when I was a customer, was imported *en entier* from east of Brest. They were all first-rate academicians; but the curriculum was not an embarrassment of riches, assuming an intent to live the rest of one's life in Quebec. This and other similar deficiencies have been long since corrected. Short of mutation into a francophone university – hardly a useful move considering the quantity and quality of the institutions already on tap – McGill is today a proud and productive citizen of the community in which it resides, deeply responsive and fully committed to the distinct Quebec society of which it is a widely respected, if comparatively underfunded, member.

James McGill, after all, was functionally bilingual. He was also a Protestant who married a French-Canadian Catholic, supported both the Anglican and the Presbyterian churches, and also served on the commission supervising the building of Catholic churches. There were separate bequests in his will for indigent Catholics and indigent Protestants. One wonders how mild the Canadian political climate would be today had all British immigrants been as sensible. The university he founded is working very hard to make up for lost opportunities.

above
Model of a housing design project developed by the School of Architecture as a part of the Human Settlements Training Program in India.

left
The Dairy Herd Analysis Service, created and administered on behalf of the Quebec government and 800 Quebec dairy farmers, is considered to be the best of its kind in the world. Its computerized service provides data on and to the owners of some 8600 dairy herds and 126 goat herds in Quebec, the Atlantic provinces and Saskatchewan.

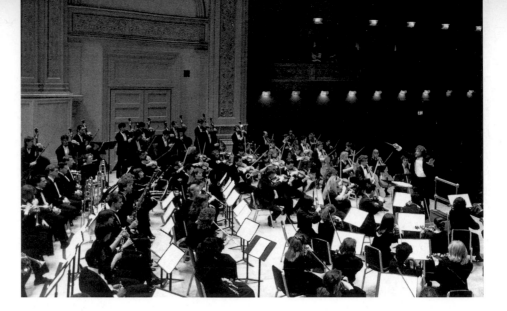

Conductor Timothy Vernon and the McGill Symphony Orchestra playing at Carnegie Hall in April of 1989. The orchestra played there again in November, 1990. Both performances received standing ovations.

Enrolment
(1989–90 winter term registration)

Students	100.0%	30,314
Full-time	62.7	19,003
Non–full-time	37.3	11,311

By geographic origin

Canadian	90.0%	27,270
Quebec	71.8	21,759
Other	18.2	5,511
Visa	10.0%	3,044
United States	3.0	898
Other	7.1	2,146

By mother tongue

English	56.9%	17,248
French	22.2%	6,730
Other	20.9%	6,336

By gender

Female	52.6%	15,945
Male	47.4%	14,369

Canadian students, by residence

Totals	100.0%	27,270
Quebec	79.8	21,759
Montreal	61.8	16,847
Other	18.0	4,912
Other	20.2	5,511
Ontario	12.2	3,332
British Columbia	2.1	584
Newfoundland	0.3	72
Territories	0.1	22
Prairies	2.1	586
Maritimes	1.9	510
Reside abroad and unknown	1.5	405

(continued facing page)

HOWEVER MUCH WE NATIVES MAY APPEAR indifferent to the possibility, beyond Montreal and Quebec there lies the rest of Canada and the world. As a Canadian citizen of the world, McGill's credentials are impeccable. Generations of teaching and research have brought this Montreal university to global pre-eminence among the things that Mankind has done that are also worth celebrating.

Statistics in this essay have remained well below the one part per million level at which they normally become life threatening. In support of a concluding thought, however, I will spoil my record – not I hope your digestion – with some numbers (see side bar) that are one measure of the strength of the bond that exists between McGill, the Canada outside Quebec, and the world beyond.

Committed though an institution of higher learning must be to the society which is its immediate strength – recognizing its responsibility to the governments from which it draws most of its funding and acknowledging that McGill would be an intellectual vagrant were it not at home in Montreal, in Quebec, and in Canada – it remains nonetheless universally and perpetually true that the search for knowledge, the transmission of learning, and the education of the next generation are not ideally suited to, or profitably circumferenced by, the arbitrary and ephemeral boundaries with which history, from time to time, divides humanity.

McGill and its various communities, in their search for fair and fruitful mutual relations, might do worse than contemplate the words which Frank Scott left behind under the heading "Creed":

> The world is my country
> The human race is my race
> The spirit of man is my God
> The future of man is my heaven

Visa students, by country, 1989–90

		all students	graduate students	countries
Totals	100.0%	3,044	1,294	126
United States	29.5	898	169	1
Far East	25.3	770	499	20
China		326	290	1
Japan		81	26	1
India		68	52	1
Hong Kong		56	10	1
South Korea		44	22	1
Australia and New Zealand		17	12	2
Other		178	87	13
Western Europe	15.5	472	198	19
France		169	60	1
Britain		75	30	1
Greece		55	33	1
West Germany		40	24	1
Other		133	51	15
Near East	9.0	273	151	14
Iran		86	44	1
Lebanon		58	19	1
Saudi Arabia		52	46	1
Other		77	42	11
Africa	7.8	237	136	34
Kenya		39	26	1
South Africa		12	11	1
Supra-Sahara		55	33	5
Other		131	66	27
South America	4.6	143	60	11
Central America	4.1	124	34	9
Mexico		67	23	1
Canal Zone		25	6	0
Other		32	5	8
Caribbean	2.6	79	27	11
Trinidad & Tobago		22	8	1
Other		57	19	10
Eastern Europe (incl. USSR)	1.5	46	18	7
Poland		24	7	1
Other		22	11	6
Stateless	0.1	2	2	–

– abstracted from
McGill University statistics

On Saying Goodbye to My Room
in Chancellor Day Hall

Rude and rough men are invading my sanctuary.
They are carting away all my books and papers.
My pictures are stacked in an ugly pile in the corner.
 There is murder in my cathedral.

The precious files, filled with yesterday's writing,
The letters from friends long dead, the irreplaceable evidence
Of battles now over, or worse, still in full combat –
 Where are they going? How shall I find them again?

Miserable vandals, stuffing me into your cartons,
This is a functioning office, all things are in order,
Or in that better disorder born of long usage.
 I alone can command it.

I alone know the secret thoughts in these cabinets,
And how the letters relate to the pamphlets in boxes.
I alone know the significance of underlinings
 On the pages read closely.

You scatter these sources abroad, and who then shall use them?
Oh, I am told, they will have a small place in some basement.
Gladly some alien shelves in a distant library
 Will give them safe shelter.

But will there be pictures of J.S. Woodsworth and Coldwell
Above the Supreme Court Reports? The Universal Declaration
Of Human Rights, will it be found hanging
 Near the left-wing manifestos?

And where are the corners to hold all the intimate objects
Gathered over the rich, the incredible years?
The sprig of cedar, the segment of Boulder Dam cable,
The heads of Buddha and Dante, the concretions, the arrowheads,
 Where, where will they be?

Or the clock that was taken from my 1923 air-cooled Franklin?
The cardboard Padlock, a gift from awakened students?
The Oxford oar, the Whitefield Quebec, the Lorcini?
 These cry out my history.

These are all cells to my brain, a part of my total.
Each filament thought feeds them into the process
By which we pursue the absolute truth that eludes us.
 They shared my decisions.

Now they are going, and I stand again on new frontiers.
Forgive this moment of weakness, this backward perspective.
Old baggage, I wish you goodbye and good housing.
 I strip for more climbing.

F.R. Scott

Celebrating the Future

Margaret A. Somerville

West Berlin 1985. A cocktail party. The World Peace through Law Conference. Two hours earlier, Checkpoint Charlie and "The Wall" – with its startling graffiti – had become a reality, for many of us for the first time. Security was discreet, but tight. Two American servicemen had been killed in a night club bombing only days before. A tall, well-dressed, black man with a complex face moved quickly towards me and held out his hand: "You're Margo Somerville?" "Yes." "You're from McGill. I noticed that on the program. I am also from McGill. I graduated from the Institute of Comparative Law in 1950s." We became friends over the time of the conference. We talked and I learned about his life. He was a human rights lawyer in Addis Ababa. He had been jailed for two years for his human rights work but was now back in practice. He told his story with equanimity and sorrow – the suffering he had endured was obvious, but he was enthusiastically hopeful for the future. His bond to McGill was deep and strong. My thoughts were: what an extraordinary privilege McGill – and that is all of us – had in contributing to this courageous man's mission, both through the study opportunities that the university provided and the support that the bond with McGill so obviously constituted. The Japanese philosophy of "On" came to mind. The concept that the giver of a gift owes an obligation to the recipient, because the recipient does

facing page
Chancellor Day Hall

a favour to the giver in accepting the gift. McGill contributing and receiving.

Montreal 1988. A telephone call to my office. Dr Aileen Ross asks for an appointment. Now in her late eighties, Dr Ross wants to make sure that persons can make "living wills," that is, give directions to make certain that they will not be subject to medical treatment that constitutes "officious intermeddling" at the end of life. She now lives in a home for aged persons and tells me that many of the people who are her companions there worry that they will not be able to ensure that they are not treated contrary to their wishes through efforts to prolong their lives (or, often, their dying) when it is, as they see it, time for them to die. She tells me the story of her road to McGill – how in the 1930s she went to Russia on a trip led by Professor Frank Scott. The impact of what she saw caused a radical change in her life. She left Montreal to study economics at the London School of Economics. She went on to Chicago for a doctorate in the then new discipline of sociology. She came back to McGill to join the academic staff. Through such persons, McGill intensely involved in living the "examined life."

Sydney 1986. The annual conference of the International Federation of Women Lawyers. The Australian Broadcasting Commission requests an interview on reproductive technologies, the subject of my address at the conference. The producer of the program asks whether I would meet her daughter, a young Sydney lawyer. She, in turn, asks whether she can attend the lecture. I notice her standing far away, at the back of the room. Four months later. Montreal. A telephone call from Australia at 2:00 AM. Julie Hamblin is excitedly telling me that she has just learned that she has been awarded a scholarship to pursue a master's degree in health law at McGill. Two years of fruitful collaborative research in the recently established Centre for Medicine, Ethics and Law follow. Julie returns to Australia to set up the first commercial health law practice in that country's largest law firm. Last week, she calls from New York, where she has been seconded to the United Nations Development Program to draft policies for it on AIDS. McGill graduates in action.

Montreal, 7 January 1990, early Sunday morning. A five-alarm fire is destroying Lady Meredith House, one of the beautiful houses of the golden Square Mile of Montreal, which had become the "home" of the McGill Centre for Medicine, Ethics and Law. It is bitterly cold and snowing. Deans and colleagues arrive, not displaying their usual sartorial elegance. Shared horror and sadness. Sympathy and hugs. Assistance well beyond the call of duty from the staff of the Physical

Plant. Jean-Pierre Morin from the University Relations Office handling the crowd of reporters and television camera persons. McGill collegial.

These are all personal anecdotes, but I believe that they are representative of the encounters many of us have in and through our connection with McGill. They capture the essence of an experience that I have daily working at McGill. A sense of awe and wonder (grandiose words, but ones that truly describe my feelings) at the creativity and imagination, intellectual ability, dedication, warmth, caring, versatility, and variety of the persons who "make up," or in some way "belong to," McGill. These people include staff – academic and non-academic – and students. They also include people who range from members of the Board of Governors to graduates, to friends of McGill, to those who take

Lady Meredith House
This was the home of the McGill Centre for Medicine, Ethics and Law until it was gutted by fire in January of 1990.

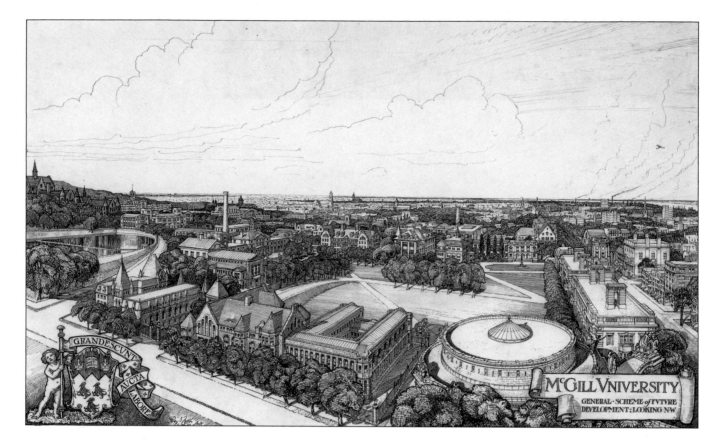

GRANDESCUNT AUCTA LABORE

McGILL VNIVERSITY
GENERAL·SCHEME of FVTVRE
DEVELOPMENT; LOOKING N·W

A 1920 plan for the future by the architect, Percy E. Nobbs. As visitors to the campus will be aware, it was never carried out.

a continuing education course one evening a week, to persons in need both in our country and elsewhere whom McGill seeks to help in one way or another. But while McGill can be seen as a large and complex "family," it is also a large and complex institution, and these two characteristics of its being are not always compatible. Because of its size, McGill is necessarily impersonal and bureaucratic in some encounters with those it meets and serves. Moreover, as for many individuals, there may be incidents in our university's past life which we would rather had not happened, or would like to forget. These should not be buried. They have provided, and almost certainly will continue to provide, valuable lessons for the future.

McGill is a historical institution and a modern reality, part of Quebec and of Canada, and internationally recognized. This is its past and its present, both of which we celebrate. But we must also celebrate McGill's future. To do so, we must have some idea of what that future might look like. Futures depend on dreams and visions – visions are dreams acted out. What are our dreams for McGill? What are our visions for it? Looking at where McGill stands now, where is it going? There are many factors special to each particular university which will play major

roles in determining the future of that university, and this is certainly true for McGill. However, and probably to a greater extent, McGill's future will depend on some factors common to all universities of similar size which, like McGill, include both an international and a global perspective in their mission. These factors concern the development and roles of universities in the twenty-first century.

THE HISTORICAL DEVELOPMENT of universities can be divided into three broad eras. The first culminated in the development of the Renaissance man (women at the university are a very recent event), an individual who was familiar with all the important knowledge of his day. The second era of universities, that of the development of specialists, gained enormous momentum after the Second World War and must necessarily continue. This era has produced persons with highly specialized, in-depth knowledge, often in a very narrow field. Such training is essential, especially to the further development of science and technology. The third era of universities, which I would suggest has just begun, is that of the integration of these highly specialized, parallel streams of knowledge. Several important realizations were seminal to this development. One was a recognition of the need for such integration to address the complex problems which our societies are facing. Although this need might seem obvious, the recognition of it is a radical change in thinking and perception and is fundamental to the development of trans-disciplinarity. A second important recognition was that the lack of consensus on values in our pluralistic societies raises great difficulties in addressing complex societal problems, because most responses to such issues are value-based. This perception led, in turn, to a recognition of the need for a forum within which to deal with these issues, one in which openness and active tolerance are the governing principles. And, finally, we have come to recognize some of the fundamental commonalities among various streams of knowledge, whatever our areas of intellectual search: in particular, the importance of imagination and creativity, of courage – especially to be "right" and to be "wrong," of "examined" risk-taking, of living comfortably with uncertainty and ambiguity, and of wisdom.

In this third era of the university, we will evolve integrated knowledge products or entities, which will be the work of groups of persons from diverse backgrounds who have been carefully selected on the basis of the particular contribution they can make. These knowledge entities should display transdisciplinary synergism: that is, the sum of each whole will be greater than the parts of which it is com-

posed. But the integration which is needed does not simply happen; it requires the use of transdisciplinary methodologies which are in themselves a necessary field for future research. Nor is there consensus on what constitutes integration. Certainly, it is more than streams of knowledge running side by side, but it may not require, or even be desirable to have, a homogenized knowledge product. It could be that the transdisciplinary methodologies which are evolved will include structures within which different knowledge streams can exist in a state of dynamic interaction – an interaction, moreover, which will give rise to continuous change in the knowledge product. The state of this interaction at any moment in time could be envisioned as a snapshot or, even better, a single frame of a movie. The latter conveys the proper image of linked actions leading to continuous development. As such images indicate, integrated knowledge products should be regarded as processes and not as events, and this also is an important insight. These are but preliminary musings on this topic, and there is much exciting exploration to be undertaken.

It is still essential for today's students at McGill to experience the earlier eras of universities – these provide a necessary substrate on which each person builds to arrive at the third era. (My secretary mistakenly typed this as "third ear," which leads to interesting speculation: is transdisciplinary activity and knowledge some form of "third ear," such that we hear the contributions of others in a way that is not otherwise possible, leading to what could be regarded as a new and different dimension of knowledge about a certain matter and not just an incremental increase in our information?) Our students' experience of the full process of development to a third era will occur in a very accelerated form, analogous, for instance, to the dramatically accelerated process of human evolution that each of us undergoes from the time of conception to birth. Undergraduate students, pursuing degrees in the liberal arts or sciences, can be regarded as receiving training as a Renaissance person. Students pursuing graduate or professional degrees are becoming specialists. We have just started to include students in the third era, the transdisciplinary process, both in the way we teach them and in the content and process of the research that we urge them to undertake. We ourselves are still at the early stages of developing this type of knowledge.

facing page
Coach house at Ravenscrag, the former residence of Sir Hugh Allan and now the Allan Memorial Institute.

TRANSDISCIPLINARY CENTRES ARE A PHENOMENON of the third era of universities and essential to the future development of this era. The number of centres at McGill University has recently surpassed the number

David Lloyd Johnston
Principal 1979 –
Marathoner, hockey player, lawyer;
captain of team effort to secure
McGill's leadership into the twenty-
first century. Forty endowed
professorships established since
1980, "an unstoppable benefit
for the future."

of departments – a major change. There is much in a name in this case. In comparison with departments, which tend to have a unidisciplinary focus, centres are transdisciplinary. Centres will not replace departments. In fact, the success of centres depends on even stronger departments because they are an essential substrate for the operation of centres. In short, centres are meant to be complements to departments, not replacements for them. Although the converse is often feared and voiced, centres should promote the strength of departments and in no way be destructive of their work. Stronger departments are also needed in an era of transdisciplinary centres because in transdisciplinary work there is a danger of a loss of authenticity and of high standards of scholarship. Departments have a crucial role to play in ensuring that excellence in both respects is maintained. Transdisciplinary scholarship is essential to our future, but it also runs the risk of being "fashy-washy" – fashionable and wishy-washy. Strong departments buttressing centres ensure the former and avoid the latter. That is, such a combination probably comes as close as possible to the best of all worlds.

FOR MANY REASONS, not least because the community needs transdisciplinary knowledge products, the university has become more important to the community and, in multiple ways, is trying to fulfil its obligations in this respect. The community supports the university. The university must be, and must be seen to be, useful to the community. Sometimes this symbiotic relationship is regarded with fear by persons in the university. They see in it a danger of lowered academic standards and possible conflicts of interest, a loss of academic integrity and, even, of independence. These are real and present dangers, but they can be guarded against. Moreover, the potential losses and dangers are not all on the side of community-university interaction. There are also losses for the university in *not* interacting in an appropriate way with the community and, indeed, dangers in not doing so. One positive development in this respect has been the growth of applied research in the humanities, most notably in the rapidly emerging field of applied ethics, which mirrors the earlier development of applied research in the sciences.

The development of greater university-community interaction must rest on a new recognition of an old reality, namely, that universities are not only the responsibility of government, but also the responsibility of individual members of the community and of community institutions other than government. One consequence of this reali-

zation will be the further development of partnerships, for the purposes of advancing research, knowledge, and teaching, between, for example, industry and universities or industry, government, and universities. Such relationships carry the potential for great benefit, not only in financial matters, but also in the creation of a spirit of community between the university and its partners. On the dark side, concern is often voiced that these new relationships carry a potential danger of abuse and conflict of interest, that they may constitute slippery slopes for a descent from initially laudatory aims and outcomes to those that are reprehensible. The answer, however, is not to keep off the slopes; rather, as with skiing, it is to use control and good judgment as to the routes we take and how fast we go in reaching our destinations.

Those of us involved in these relationships already possess new sensitivities to what is required in pursuing them. These sensitivities are

often manifested as a concern for ethics. This concern exists not only on the part of persons who work in the universities (who are sometimes perceived as altruistically motivated, and as having low levels of conflict of interest or even a self-interest in promoting sensitivity, for instance, in the case of ethicists), but it is also very obvious at the moment among the business community and is a deep concern of government – or at least of some government agencies. The development of the field of applied ethics concurrently with, and as an integral part of, the development of other knowledge, particularly through applied ethics research in the area of science and technology, is an important and major new move. Such companion ethics research is coming to be accepted as an essential component in undertaking scientific research and development. The way in which research funding is being allocated reflects this. Funds for accompanying applied ethics research are being built into research grants for hard science; for instance, 3 per cent of the US $100 million in funds allocated for the "human genome mapping project" by the United States National Institutes of Health will be used for accompanying ethics research.

The development of these new relationships thus opens up a potential for both greater benefit and greater risk and harm in the activities of the university of the future. Because of the latter possibilities, somewhat paradoxically, the need for trust will increase. This must be an "earned" trust (trust claimed on the basis of demonstrated trustworthiness), not a "blind" trust (trust claimed on the basis of authority) as has often been the case in the past.

There are many ways in which trust is important to the university of the twenty-first century. Universities and their partners must be, and must be seen to be, ethically trustworthy in matters ranging from the selection of students to the type of research that is carried out, to sources of funding, to issues of disclosure, to fulfilling responsibilities at the international level, and, in particular, to persons much less privileged than we are.

Trust will also be relevant in another respect. Again, paradoxically, the more we know, the more we know that we do not know. This form of "not knowing" means that we are more aware of risks, especially identified risks. Such awareness raises levels of uncertainty. Individuals and society are often extremely uncomfortable with or even intolerant or hostile to uncertainty. The presence of "active" earned trust will be essential to govern such situations appropriately and ethically. Only in this way can we avoid both wrongly denying the risk and uncertainty (one common response to such situations, especially on the part of

politicians) and reacting with intolerance and hostility (alternative possible responses to denial). Trust means we can acknowledge uncertainty and, while we may not welcome it, we will be able to live with it in relative comfort, both as individuals and as a society.

Universities have an opportunity to become one of the important repositories of societal trust. In the current state of the public's disillusionment with many societal institutions, especially political ones, universities could be seen as a safer forum in which to explore values and moral standards, and to try to formulate ones suitable for a secularized society in which there is no underlying consensus on these matters. Moreover, as our world moves towards even greater interdependence, this role of universities is likely to increase vastly in importance. In this, and many other respects, universities may have a unique role to play in shaping and governing the global village.

McGILL AND ITS SISTER UNIVERSITIES, especially those with "international characteristics" – that is, with a staff and students from diverse backgrounds in international terms, and with international involvements and partners at the institutional level – could, in some ways, be likened to multinational corporations. Universities, like multinationals, may well have a common destiny and common aims. While some may view this analogy as dangerous because of the negative connotations attached to multinationals, it nevertheless may provide some valuable insights. For example, multinationals have both international and national operations. What is suitable training for a person who will operate only in one national context may not be suitable training for a person who needs to operate in another national context or transnationally. We need to consider what by analogy this situation requires of us in relation to our students. Likewise, multinationals are very sensitive to the cultural reactions and expectations of the countries in which they operate. A comparison of their advertising for the same product in different countries provides a good example of this. Similarly, universities may need to be more sensitive than they have been up to now, for example, in recognizing the "culture shock" facing foreign students, or in offering expertise to developing countries.

McGill graduates who later take important leadership roles in their countries will necessarily reflect some aspects of their academic training and experience at McGill. This means that we have both important opportunities and responsibilities not only to our students but, through them, to the world of the future. While this type of future impact has always occurred, it is likely to be of greater importance in a global

village. Universities (including McGill), more than any other single
societal institution, are likely to influence, both directly and indirectly,
the world of tomorrow. The fact that most people now are seen as
needing university qualifications to hold high-level office – a relatively
recent phenomenon – in itself makes this a new reality. One could be
overwhelmed by the impact of this realization and the truly awesome
responsibility that it does and should be seen to entail. However, it is
not meant to be a paralysing insight. Rather, it is a reason to be joyful and
to celebrate that in the company of the humane and sensitive persons of
good will which I deeply believe the members of our McGill com-
munity to be, we have the opportunity to contribute to this future.

McGILL – A CELEBRATION. There is much to celebrate, especially the rich-
ness of opportunity to contribute to the future that the past and present
of McGill have provided for us. The tangible realities of McGill are
impressive, but the intangible ones are more so – the fragile, delicate,
and often indirectly glimpsed gossamers of imagination and creativity;
the richness of spirit in the broadest sense of that word; the bonds that
cross national and international boundaries, disciplinary boundaries,
and those of race, colour, religion, and sex. All are part of the reality and
future of McGill. Concurrently, there is also much struggle; there is

often conflict, some of it not easily, or ever, resolvable; there can be anger and bitterness and destructive competition. We are all subject to these woes, no matter how successful we may be seen to be by the outside world or, indeed, by our colleagues, and no matter how humane and altruistic our mission within and through the university. We need to recognize these "darker" features and to use them as opportunities for growth. It would not serve McGill well to paint some fairy-tale image that does not correlate with everyday life in the university. The university's dreams and visions for itself, and our dreams and visions for it – and it is a nice question whether these can and do differ – must be founded in reality.

One of our greatest gifts as humans is the ability to play. We are all born with this capacity and exploit it as children, vastly tragic circumstances aside. Sadly, many of us lose this gift, possibly because we fail to differentiate between child-likeness and childishness and fearing the latter, suppress the former. In the pure sense of the word "play," the university is a privileged intellectual playground, which is not the same as a playground for the privileged. It is a playground in which we fully experience the extraordinary game of life both as individuals and a community, through conscious and unconscious, cognitive, emotional, and intuitive ways of knowing.

The McGill family crosses vertical barriers of time and horizontal barriers of territory, and has at least a third dimension of intellectual comity open to all. It will continue to create environments in which the wonderful, imaginative, creative, human, and humane gifts of the human spirit can take shape and substance. In this way McGill will help to create our individual, our collective, and finally our one global world. McGill – celebrating the future.

Acknowledgments

Over the past few years the Graduates' Society of McGill has been approached from time to time with the suggestion that there should be a pictorial book about McGill, one that would tell the story of its history and at the same time show the colourful life on the McGill campus today. Early in 1989, the Society responded by calling together a group of people who were interested in seeing such a book produced. *McGill: a celebration* is the result of that meeting.

We would like to thank the people who came to that early meeting and who subsequently made up the committee that continued to meet over the following two years to discuss what form the book should take and to solve the problems that arose along the way. Without them there would be no book. The committee was chaired by JoAnn Meade, Art Curator, Alcan Aluminium Limited, and Honorary Treasurer, McGill Graduates' Society. Its members were: Horst Bitchofsky, Marketing and Merchandising Manager, McGill Bookstore; Philip Cercone, Director, McGill-Queen's University Press; Derek Drummond, Director of the School of Architecture; Dr Stanley Frost, Director, History of McGill Project; Dr Robert Michel, Archivist; Ann Vroom, then Editor, *McGill News*, now Director of Alumni Affairs, Concordia University; her successor, Janice Paskey, current Editor, *McGill News*; and Kate Williams, McGill's Director of University Relations.

We would also like to thank the many others at McGill who gave of their time and knowledge to help.

At the McGill University Archives, in addition to Robert Michel, we thank Phebe Chartrand and the rest of the staff who were always ready to give advice and a helping hand.

At the McCord Museum of Canadian History, Conrad Graham and his staff helped with the selection of material from their collection; and at the Notman Photographic Archives, Nora Hague, Heather McNabb, and Tom Humphreys were always available to answer our many questions and track down appropriate pictures.

At the McGill Libraries, we had valuable help from Gary Tynski, Lorraine Dubreuil, and Richard Virr in the Department of Rare Books, Irena Murray and Cindy Campbell in the Blackader-Lauterman Library of Architecture and Art, Nellie Reiss in the Lande Library, Dr Faith Wallis in the Osler Library of the History of Medicine, and Eleanor MacLean in the Blacker-Wood Library of Biology. Dr Hans Möller, Research and Development Librarian, was particularly helpful in steering us in the right direction.

At the Redpath Museum, Barbara Lawson, Curator, Ethnology, Susan Gabe, Curator, Invertebrate Zoology, and Joan Kaylor, Curator, Geology, helped us to find or to take the right pictures.

Fred Hedgcock of the McPherson Collection of nineteenth-century instruments; R. David Bourke, University Secretary-General; Gordon Maclachlan, then Dean of Graduate Studies and Vice-Principal (Research); Dr Eugene Donefer, Director of McGill International; and Dean Roger B. Buckland and Chantal Paul at Macdonald College all gave us useful advice.

Rolf Selbach and his staff at McGill Instructional Communications Centre were particularly helpful in producing the photographs we used from the Archives.

Robin Farr, Martin Lechowicz, and Vivian Lewin were able to answer questions at crucial moments. To all those others who gave us help and advice along the way, we say thank you.

A very special thanks must go to Dr Stanley Frost, whose two-volume history of McGill was an indispensable resource. He was one of those who came to us years ago to suggest this project and, as usual, he willingly gave us valuable help and advice throughout.

Finally, thanks to "Old McGill" – a venerable institution without which Quebec, Canada, and the world would be a lesser place.

Spring 1991

Gavin Ross, Executive Director,
The Graduates' Society of McGill University

About the Contributors

CONSTANCE BERESFORD-HOWE, the novelist, graduated from McGill University and has taught English at both McGill and Ryerson Polytechnical Institute in Toronto. Her most recent novel is *Prospero's Daughter.*

PIERRE CHARRIER, a Montreal artist and photographer, specializes in the photography of works of art.

DAVID DUCHOW is a photographer based in southwestern Quebec whose work has been exhibited in both Canada and the United States.

STANLEY BRICE FROST, the former Dean of Graduate Studies and Vice-Principal (Administration) at McGill University, is the author of the two-volume history, *McGill University: For the Advancement of Learning.*

GEORGE GALAVARIS, FRSC, is Professor of Art History at McGill University and the author of several works on early Christian and Byzantine art history.

ROSA HARRIS-ADLER is a nationally published freelance writer who lives in Montreal.

ERIC McLEAN, music critic emeritus of the Montreal Gazette, is a graduate of McGill University and served on the Board of Governors of the university for ten years.

DONALD MacSWEEN, a graduate of McGill in arts and law, has been Director General of both the National Theatre School of Canada and the National Arts Centre, and served on McGill's Board of Governors for a decade.

CAROL MARTIN is a writer and publishing consultant who lives in Belleville, Ontario.

MARK RUWEDEL, Assistant Professor of Photography at Concordia University, is a Montreal-based photographer who has exhibited widely in Canada and abroad.

WITOLD RYBCZYNSKI is Professor of Architecture at McGill University. His most recent book is *The Most Beautiful House in the World.*

MARGARET A. SOMERVILLE is Gale Professor of Law and Director of the Centre for Medicine, Ethics and Law at McGill University.

BRUCE WHITEMAN is Head of the Department of Rare Books and Special Collections, McGill University Libraries, and has published a number of books of poetry.

GEORGE S. ZIMBEL is a Montreal-based documentary photographer whose work is to be found in many museum collections.

Credits

POETRY

"Open House, McGill" and "On Saying Goodbye to My Room in Chancellor Day Hall," from *The Collected Poems of F.R. Scott* (McClelland & Stewart, Toronto 1981) are reprinted by permission of the estate of F.R. Scott.

"The Classroom" by Louis Dudek, from *Zembla's Rocks* (Véhicule Press, Montreal 1986) is reprinted by permission of the author.

ILLUSTRATIONS

School of Architecture, McGill University 185 (right)

Blacker-Wood Library of Biology, McGill University 109, 155

Pierre Charrier 5 (courtesy Blackader-Lauterman Library of Art and Architecture, McGill University), 17 (courtesy Department of Rare Books, McLennan Library), 142, 145, 150, 153, 154, 158, 161, 172 (courtesy McGill University Archives), 196 (courtesy Blackader-Lauterman Library of Art and Architecture, McGill University)

David Duchow 19, 22, 25, 57, 70, 71, 78, 105, 135, 174, 182, 189, 195, 199

Faculty Club, McGill University 4, 96, 130, 144

Robin Farr 184 (right)

Margaret Gillett 36

Jack Goldsmith, McGill ICC 163

McCord Museum of Canadian History vi, 8–9, 10, 12 (left), 21, 146 (left and bottom), 147, 156

Macdonald College 111 (right), 117, 185 (bottom)

McGill University Archives 13, 14, 15, 20 (top), 24, 29 (bottom), 38 (bottom), 39 (right), 40 (left below), 44, 46, 47, 48, 49, 52 (top), 65, 68 (left), 69, 75 (right), 76 (bottom), 77, 79, 80, 81 (right), 82, 84, 86, 90, 95, 106, 110 (left), 113 (top left and right), 118 (top), 128, 179 (right), 180, 184 (left)

McLennan Library, Department of Rare Books and Special Collections, McGill University 42, 92, 116 (left), 149 (right), 160, 165

Jean L. Macqueen 76 (left)

Donald MacSween 179 (left)

Faculty of Music, McGill University 186

National Archives of Canada 131 (c64042)

Notman Photographic Archives, McCord Museum of Canadian History 18, 20, 23, 30, 31, 32, 38 (left), 39 (top), 40 (top left, bottom), 41, 43, 46, 47, 58, 64 (left), 67, 74, 75 (top), 104, 108 (left), 112, 114, 124, 125, 129, 146 (top), 173, 175, 181, 183

Osler Library of the History of Medicine, McGill University 42 (top), 108 (top), 149 (bottom), 157, 164

Planned Gifts and Donor Relations, McGill University 116

Joshua Radu 136 (courtesy of *Matrix*)

Mark Ruwedel xii, 45, 50, 66, 73, 83, 93, 94, 122, 133, 140–1, 168, 171, 192, 202

Murray Sweet, McCord Museum of Canadian History 111 (top)

George S. Zimbel ii–iii, iv, viii, x–xi, 2, 3, 6, 16, 26, 28–9, 32–3, 34–5, 46–7 (colour), 52 (bottom), 53, 54, 55, 59, 60–1, 62, 64 (top), 68 (right), 81 (left), 85, 88–9, 97, 99, 100–1, 102, 107, 113 (bottom right), 115, 118 (bottom), 120–1, 127, 134, 137, 138, 148, 152, 162, 166–7, 177, 178, 187, 190–1, 200, 201, 205, 206, 211

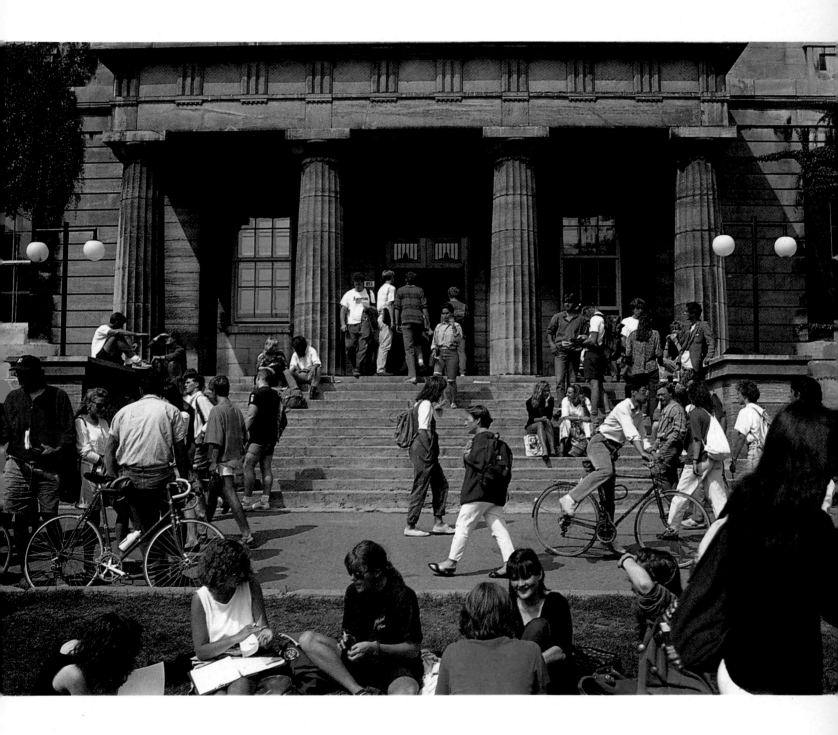

Set in 12/15 ITC Garamond Light
by Metrotype Graphics Limited, Ottawa.
Printed and Bound in Milan, Italy
by New Interlitho S.p.A.